©2014 2/27/17

MEDITATIONS ON Vatican Art

Angels

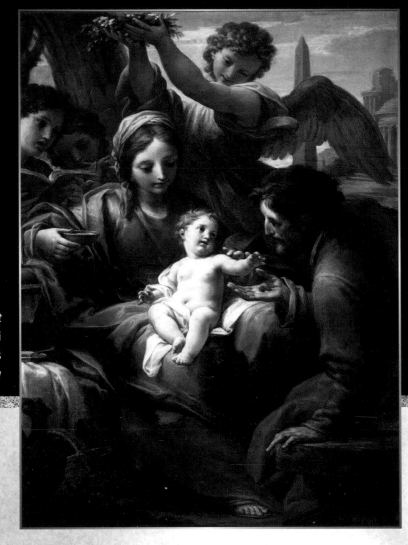

The Rest During the Flight Into Egypt
Francesco Mancini
Vatican Museums
Early eighteenth century

Presented to

By

On

MEDITATIONS ON
Vatican Art

Angels

MARK HAYDU, LC, STL

Liguori

LIGUORI, MISSOURI

DEDICATION

I DEDICATE THIS BOOK TO MY LEGIONARY BROTHERS.
First to Fr. Álvaro Corcuera, LC, who was my gentle spiritual father for fourteen years, before his recent passing. His kindness, humility, and intuition made him like an angel to me. And to all my fellow Legionaries who accompany me day by day in our common life and mission, your "yes" is a gift, your life a treasure, and your brotherhood a consolation. May the angels accompany us as we strive to make HIS KINGDOM COME!

Imprimi Potest:
Harry Grile, CSsR, Provincial
Denver Province, The Redemptorists

Published by Liguori Publications, Liguori, Missouri 63057

To order, call 800-325-9521 or 636-464-2500
Liguori.org

Cataloging-in-Publication Data is on file with the Library of Congress

p ISBN: 978-0-7648-2560-6
e ISBN: 978-0-7648-6871-9

Liguori Publications, a nonprofit corporation, is an apostolate of The Redemptorists. To learn more about The Redemptorists, visit Redemptorists.com.

Printed in the United States of America
18 17 16 15 14 / 5 4 3 2 1
First Edition

CONTENTS

ACKNOWLEDGMENTS

THE VATICAN MUSEUMS, with their unique and rich history, make it possible for countless pilgrims and visitors to Rome to encounter this message through works of art which bear witness to the spiritual aspirations of humanity, the sublime mysteries of the Christian faith, and the quest of that supreme beauty which has its source and fulfillment in God.

—Pope Francis speaking to the Patrons of the Arts of the Vatican Museums, October 19, 2013

Gratitude is a rare virtue, and it shouldn't take the writing of a book to make us realize all the people we need to thank. Yet a book on angels could not happen without its own angels, and in the writing of this text I'm grateful to plenty.

First, I thank our Lord for the amazing privilege to be his priest. This vocation is about bridging the gap between heaven and earth; keeping my feet solidly on the ground while anchoring my heart in heaven. Sometimes the stretch hurts a little, but he has never let me down. Thank you, Lord!

I thank all Patrons, chapter leaders, and friends who read my first book and encouraged me to set out on writing another. Your enthusiasm, emails, and stories of how *Meditations on Vatican Art* helped you pray convinced me I should keep writing. Of course, any book about the Vatican Museums collection requires the support of so many people in the museums. All my appreciation goes to the director of the Vatican Museums, Anthony Paolucci, whose mix of human warmth and professional ability is one of the greatest Vatican treasures. The administrative director, Msgr. Paolo Nicolini, has done much to turn the Vatican Museums into an ever more organized and efficient world-class museum. His attention to all the permissions and requests made this project possible. Thanks goes to Dr. Arnold Nesselrath, delegate for the scientific department and laboratories of the Vatican Museums, who is instrumental in preserving the beauty of the collection so each of us can enjoy the splendid beauty.

Thanks to the curators, the unsung heroes who care for their collections and do so much to share the message of the museums with the world.

My office of the Patrons of the Arts in the Vatican Museums has a staff of angels! All carry out their work with such generosity and grace that it is easy to forget how much they do. Luckily I don't have to keep a list of all their kindness, since our Lord is doing that and will repay each of them more than I ever could. Thank you, Msgr. Terry, for your joyful and serene support; Lorna, for your love for the Patrons; Sara, for keeping the office humming; Romina, for staying on top of so many conservation projects; Carolina, for keeping us on message and moving forward our special initiatives; and Maddie, for arranging the visits of the thousands of Patron visitors! Chiara Lorenzetti was a particular help in picking the book's images and researching the artists. She earned her stripes, and we are glad to have her on staff now. I wouldn't be able to focus on writing without knowing all of you were joyfully contributing your talents and gifts! Each played a role in making this book possible. Thank you!

The Patrons' office is also blessed to have summer interns who bring a wealth of enthusiasm and plenty of qualities that I lack: first and foremost, a grasp of English that hasn't been affected by fifteen years overseas! Their eagle eyes scanned for errors and found more than I would like to admit. I would like to think the reading also did their souls a bit of good! God bless you, Maddie Amos, Thomas Hite, Victoria Kasznica, Grace Linczer, and Stephen Waldorf for your help and suggestions.

Rosanna DiPinto and Filippo Petrignani from photographic archives scrambled more than once to dig up just the right image. Their patience seems to know no limits, and trust me, I should have found those limits by now.

This year also permitted me to continue giving spiritual direction to legionary seminarians as well as our Consecrated Women of Regnum Christi. Their deep prayerfulness and frank conversations fed my own spiritual life this year. More than one idea came from those conversations.

I was blessed to live this past year with the newly formed community of legionary priests studying for their master's in theology and philosophy in Rome. Witnessing their study, prayer, and hard work made procrastinating on writing not an option. Their priestly fraternity and fervor kept me focused.

I am humbled to have been the recipient of so much from so many. I hope each of you find the fruit of your contribution well-presented here.

Any errors herein are mine, while all the good belongs to God and each of you.

Fr. Mark Haydu, LC, STL

INTRODUCTION

Nicolas Marasco is a boy. But not just any boy. He is pen pals with the pope!

Nicolas suffers from a terrible brain illness called encephalopathy. He is unable to speak but was able to send a letter to Pope Francis, with the help of his parents.

Dear Francis,

My name is Nicolas, and I am 16. Since I am unable to write you (because I still cannot speak or walk), I asked my parents to do it for me, because they know me best.

Every night ever since you asked me, I pray to my guardian angel—whose name is Eusebio and who is very patient—to watch over you and help you. You can be sure that he is good at it because he watches over me and is with me every day.

I would very much like to go see you and receive your blessing and a kiss, just that. I send you many greetings and I continue praying to Eusebio to watch over you and give you strength.

Love,
Nico

Pope Francis was deeply moved by Nico's letter. The words of this little angel evidently became a source of prayer and consolation for the pope because this touching experience went into a homily. Just a few days later, Francis shared the story of the young boy during his visit to Assisi on the feast of St. Francis, October 4, 2013, saying, "In this letter, in the heart of this boy, is beauty, love, the poetry of God. God who reveals himself to the simple-hearted, the little ones, the humble ones, those who we often consider to be the last."

It didn't take long for the pope to respond to Nico, either.

Dear Nicolas,

Thank you so much for your letter. Thank you so much for praying for me. Your prayers are helping me to do my work, which is to bring Jesus to the people....For this reason, dear Nicolas, you are important to me.

And I want to ask you a favor. Keep helping me with your prayers, and also keep praying to Eusebio, who is surely friends with my guardian angel, who also watches over me. Nicolas, thanks for your help. I am praying for you. May Jesus bless you and the holy Virgin watch over you.

Affectionately, and with my Blessing,
Francis

Pope Francis and Nico know something that we often forget. Angels are there, watching over us, protecting us, inspiring us! And that is why I wrote this book, to call attention to their presence in our lives and those of our biblical ancestors. You have a whole army of heavenly warriors watching over you and waiting to come to your aid. They are not fluffy, plump, rosy cupids bouncing on clouds and crawling around the

heavens, but strong guardians ready to help us do battle with evil and temptation as we fight to extend God's kingdom in our lives and our world.

It is true that artists over the centuries have presented angels in their purity and delicate sweetness more often than not. Yet Scripture tells another story.

These angels are fierce, amazing, awe-inspiring representatives who serve at the throne of God. When they appear, men fall to their knees overcome with fear. When they are sent, it is to raise hell—literally. Raise as in to utterly destroy. You just have to read a few chapters of Revelation to know that angels take their job as defenders seriously and are well-equipped to do so.

Now, let us meditate, through art and Scripture, on the reality of these fantastic beings and the service they render to each of us. We will begin by looking at the appearance of angels in the Old Testament, starting from the very beginning: Genesis. Then we will continue to the New Testament and see how angels helped Jesus as he came to earth as a man, to sacrifice himself for us. Next we will see how Mary, Queen of Angels, was assisted by these heavenly beings as she prepared to give birth to the Son of God, her grief at his death, and joy at his resurrection. After Jesus' ascension, we will explore how angels continue his mission by giving strength and assistance to members of the early Church. And finally, we will see how angels are still present today, assisting all the followers of Jesus to be strong in their faith and helping us do battle with temptation every day. Angels are not just mythical creatures of ancient history, they are a real presence in our lives today. All we have to do is pray for assistance.

Mental Prayer

Like *Meditations on Vatican Art*, this book, *Meditations on Vatican Art: Angels* is based on the classic structure of Ignatian Mental Prayer. Each daily meditation should only take fifteen to thirty minutes to complete, but you can always spend more time meditating on the artwork or reflecting in silence. Spending time with these exercises will give you grace and transform your day.

Mental prayer is all about turning our attention from the mundane and immediate to focus our hearts and minds on the sublime and permanent. Nothing is more real and lasting than the presence of the Holy Trinity in our souls. Each of us are temples of God's presence and grace. The whole reason God created you and me is so that he could be with us and we could know and serve him. This relationship begins here on earth and, barring a conscious choice of ours to turn from him definitively, will continue in his mercy and love for all eternity.

If we open even a little space to him in our daily lives, his transforming light will change our shadows into sunlight. He lives in you and wants to burst through in every area of your life, and often the only thing he needs from you is your willingness. A few moments of your day spent in mental prayer, focusing on his presence, on his action in your life, is all it will take. This is what these meditations on Vatican art are meant to help us achieve.

Certainly, turning inward with God's grace is not easy for us since we are often not used to it. Yet we have a whole family tradition of brothers and sisters who have gone before us and learned the best practices of prayer. Learning from these spiritual greats is the best

way to learn how to do it. And using our patrimony of beautiful artistic creations can only make things easier. Add to the mix the help of our heavenly protectors, the angels, and who can stop us?!

Beauty makes meditating easier because it captures our senses and leads us toward contemplation. Using works of beauty with passages of Scripture will help focus your exterior and interior senses and help you succeed in your time of prayers. Calling on the help of the angels to bless your efforts is just icing on the cake.

How to Use This Book

Find a time within your daily routine that will enable you to spend time alone with God and yourself. There are many places of prayer to choose from, whether it's your local prayer and adoration chapel, a beautiful park, your bedroom, or your study. And just as important as the physical space is the mental space. Find a time that will allow you to set aside the worries of the day and focus fully on God's presence.

Each angelic reflection is intended to lead you into contact with God, Christ, the Holy Spirit, and the truths revealed. It is essential to start by considering the presence of God, asking him to share this time of prayer with you and open the treasures of his heart to your heart. Lift your heart in praise, blessing, and gratitude for the multiple gifts, graces, and even crosses that have been part of your life. Focus on God, an action that will release you from your daily concerns and activities and draw you to contemplate the beauty of the Blessed Trinity, tuning you in to what the Lord is speaking in your heart.

Each day features a work of art, its name, the artist, and when it was created. The meditations begin with a brief explanation on the piece of art and the artist in order to familiarize you with the period and context wherein the masterpiece originated. It is not intended to be a full art history lesson but rather a springboard for understanding the piece of art along with the meditation for the day.

For each day, a theme and a focus for the meditation are provided. The focus will help you assimilate the motif of that day's prayer while connecting it to the whole retreat. This focus also relates to the Scripture passage and work of art and so will be a natural preparation for reflecting on both.

Scripture related to the angels in the lives of Old and New Testament figures is provided to focus your prayer, allowing you to center more on the word of God than just the reality of angels alone. Read through each Scripture passage with an open heart and mind. Using the Scripture alongside the art should help the retreat to be always new, bringing in new elements or reflections to your dialogue with God.

Once you have entered into God's presence and read the Scripture passage, use your imagination to place yourself in the scene by using the senses of sight, touch, smell, taste, and hearing. If you are touched by a word, passage, or your imagination of the scene, spend time talking with the Lord about it.

Then you should use the sacred image to help you in this imagination and allow the two to play off of one another. The notion of sacred artwork and contemplation is often lost on us in a digital age where images constantly bombard us. However, traditional Catholic mental prayer focuses our senses to enable us to see what is beyond the physical realm. In fact, liturgical and sacred art were intended to lead the soul to contemplate the spiritual truths that were painted

or sculpted therein. Distractions challenge our prayer, often invading our hearts and minds when we set aside time to pray. Allowing our eyes to see the beauty created by each artist will assist our prayer by engaging our sense of sight, a powerful gift for understanding the goodness of God. As our culture is animated by the senses, we must fine-tune them to know the things of God.

As you contemplate each piece of art, let your eyes wander naturally to where the color and form take them. If you find that too much is happening in a piece of art and it is distracting, allow yourself to focus on just one aspect or detail. At times fixing on one element can anchor you in the whole piece, allowing you to then assimilate the whole work little by little. This same practice can also be applied to reading the Scripture passage. By reading slowly and letting each word speak to you, the whole passage can take on greater meaning.

The Meditation

The written meditations will help you focus your own reflection on the sacred Scriptures and the artistic selection for the day. There should be a constant back-and-forth among the meditation, the Scriptures, the painting, and your own prayer. Let the meditation guide your thoughts and prayers. Read it calmly and take time to reflect as the Spirit moves your heart. Like art, prayer has its own rhythm. Open your heart and let the Holy Spirit lead you.

Don't be in a hurry to finish the meditation or read the whole thing. If something strikes you, stop, take it in, and pray over the thought, question, inspiration. There is no timetable on when God will speak, so take your time, open your heart, and be amazed at how he

works. When the reflection runs its course and you feel distraction or tiredness setting in, pick up the written meditation again and move on. The questions at the end of each meditation can provoke greater thought and prayer in case you are a bit dry and feel the need for a little help. But if you are doing fine on your own, there is no need to use them.

At the end of the meditation, you will almost spontaneously want to place your thoughts and reflections into the form of prayer. You may feel called to repent, to thank, to intercede, or to simply praise God for the truth you contemplated or discovered. You may use the prayer provided after each meditation or one that comes to you while reflecting.

Let It Grow

Prayer is like the seed Jesus refers to in the Gospel. It can fall on all kinds of interior soil (Matthew 13:3–9). If you have picked up this book or it was given to you as a gift, then the seed has already fallen into the soil. By using this book for a time of daily prayer, you will be preparing the terrain so that not only will this seed bear fruit, but many other seeds of God's inspiration will fall into your heart each day.

The daily time of prayer you are embarking on with *Meditations on Vatican Art: Angels* is no doubt a great step in letting the seed find the right soil. In our spiritual life, we need all the help we can get so that this seed produces thirty-, sixty- or a hundredfold. Jesus says the angels are like the harvesters who will come to collect the fruit this seed produces (Matthew 13:39). Let us invite them into our prayers and learn from them so these messengers will bring us to the abundance of a rich harvest.

The Creation of the Sun and the Moon
by Michelangelo, Sistine Chapel, 1511

ANGELS IN THE OLD TESTAMENT

"ANGEL," as a name, does not indicate the nature of these creatures but rather their function. The Hebrew *mal'ak* and Greek *angelos* mean "messenger." The angels are "spirits sent to serve, for the sake of those who are to inherit salvation" (Hebrews 1:14). The ancient world had no problem believing in angels and their efficacy, as the spiritual world seemed closer and more reasonable to them. This might be why our ancestors in the Old Testament had no trouble accepting the presence and intervention of angels in their lives. Even in our modern world we must make room in our lives for angels, accept their presence, even long for them, pray for them to come, and rely on their help.

In the Old Testament, there is a development in the doctrine on angels. First and foremost, there is a fundamental distinction to make. There is the *angel* of Yahweh and there are the *angels* of Yahweh. The Old Testament writers, in communicating their understanding of the one God, have often had recourse to the ancient visions of God as points of departure for their understanding and reflection. The scriptural truths that followed from this are not reduced to merely mythological concepts, but they are used as a foundation for understanding. So, God is often seen as a sovereign (1 Kings 22:19 and Isaiah 6:1) and the members of his court are his servants (Job 4:18), his holy ones (Psalm 89:6), and his sons (Psalm 29:1). Cherubim, the angels of Yahweh, support his throne (Psalm 80:2, 99:1) and draw his chariot. They sing of his glory, protect the entrance to his house by keeping out the impure (Genesis 3:24), surround the ark, accompany God's Chosen People in battle, and establish a bridge between heaven and earth. Then there is the angel of Yahweh (Genesis 16:7, 22:11; and Exodus 3:2) who is different from Yahweh and distinct from these other angels and makes himself seen visibly on earth.

The angels of the Old Testament, before the exile, were assigned a multitude of tasks, both good and bad (Job 1:12). They protected Israel but did so through death. Even Satan, as a fallen angel, had access to God's court in order to talk with him. Old Testament writings after the exile portray angels as having more defined roles, and these roles are more fitting to their lofty vocation. There were good angels serving God within his heavenly court and fallen angels with Satan below, with constant opposition between these two factions (Zechariah 3:1).

Even if there are some changes in the Old Testament understanding of angels, their mission is consistent. They watch over humanity, present their prayers before God, monitor the destinies of nations, and assist the prophets in understanding their visions. They even receive names according to their functions, as is the case with Raphael (Tobit 3:17), Gabriel (Daniel 8:16), and Michael (Daniel 10:13).

As we meditate on the Old Testament and these beautiful, artistic creations inspired by the word of God, we will see the angels present in many important moments of our salvation. Indeed, angels are all around us and have been from the beginning.

Allow yourself to see the presence of these spiritual beings from the past in order to have a renewed vision of them in your spiritual life today.

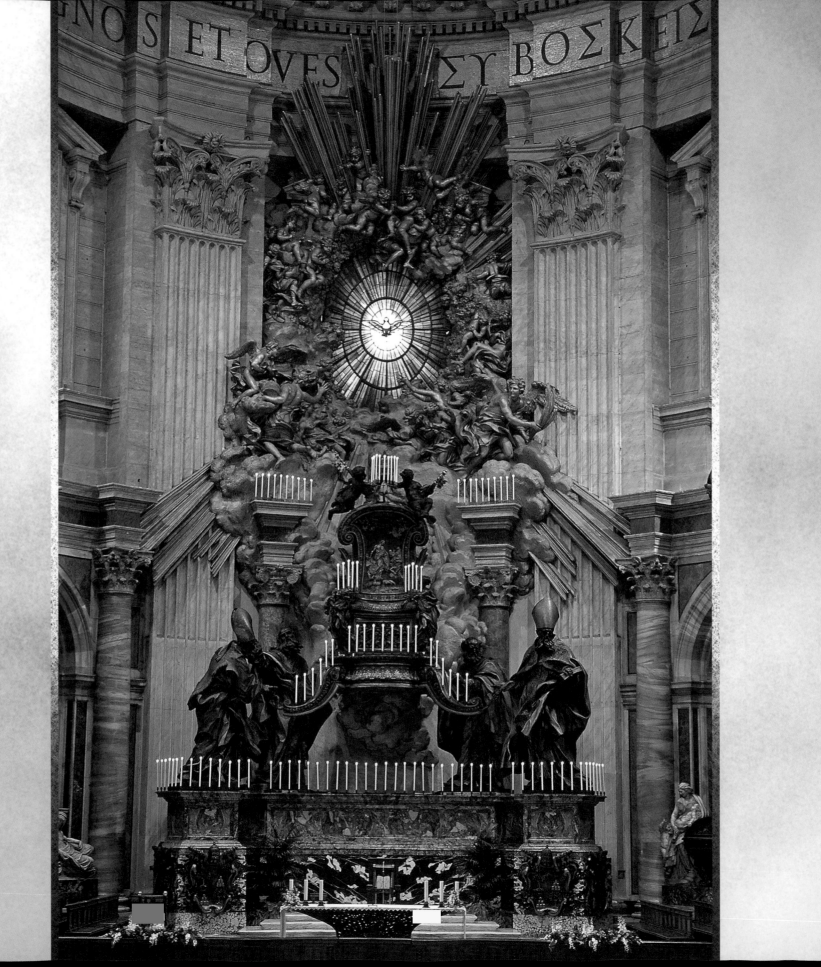

THE THRONE OF ST. PETER

Gian Lorenzo Bernini
1657–1666

THEME: Angels surround God in his glory.

FOCUS OF THIS MEDITATION: Meditating on the beauty of being in God's presence, basking in his beauty, experiencing his power, adoring his majesty

◀ *The Throne of St. Peter* (*Cathedra Petri*) was designed by Gian Lorenzo Bernini between 1647 and 1653. It is located in St. Peter's Basilica in a sculpted gilt-bronze casing. The *cathedra*, Latin for "chair" or "throne of a bishop," was once used by the popes. In fact, inside the outer chair is a wooden throne, which, according to tradition, was used by St. Peter (although it is now thought to have been a gift from Charles the Bald to Pope John VIII in 875).

The work of Bernini (1598–1680) is located in the lower part of the apse of the Vatican Basilica, standing out with dramatic effect from the architectural frame of pilasters. At the center is the throne in gilded bronze, which encases the wooden chair. On a drape front is the *traditio clavum*, the "handing over of the keys," the act, in Catholic doctrine, of Christ conferring upon Peter the papal primacy.

Four colossal statues, also in bronze, representing the four doctors of the Church (St. Augustine and St. Ambrose in the foreground representing Latin Church, and in the background St. Athanasius and

St. John Chrysostom for the Greek Church), are shown holding the chair, which seems to hover weightlessly on clouds of golden stucco.

Large, angelic figures flank an openwork panel beneath a highly realistic bronze seat cushion that is empty on purpose: The relic is encased within. Above the throne, in a halo of golden stucco, there is a window of alabaster with the depiction in stained glass of a dove (with a wingspan of sixty-four inches) that stands as a symbol of the Holy Spirit who guides the successors of Peter in their office. It is the only stained-glass window in all of St. Peter's Basilica.

Similar to *The Ecstasy of St. Teresa* of Ávila (1644–1652), another work by Bernini, the chair of St. Peter can be defined, without a doubt, as a masterpiece of the Baroque in its blending together of architecture, sculpture, and details giving rise to a work of global art through theatrical representation of a fantastic vision. This sculpture undergoes spectacular natural lighting effects, especially in the afternoon when the sun goes down behind the basilica's apse.

SCRIPTURE MEDITATION

EZEKIEL 10:1–4

Then I looked and there above the firmament over the heads of the cherubim was something like a sapphire, something that looked like a throne. And he said to the man dressed in linen: Go within the wheelwork under the cherubim; fill both your hands with burning coals from the place among the cherubim, then scatter them over the city. As I watched, he entered. Now the cherubim were standing to the south of the temple when the man went in and a cloud filled the inner court. The glory of the LORD had moved off the cherubim to the threshold of the temple; the temple was filled with the cloud, the whole court brilliant with the glory of the LORD.

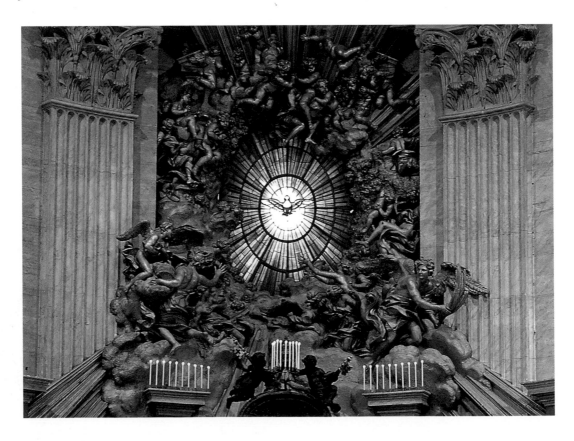

Our first meditation invites us to begin at the beginning, when the angels were in heaven attending the heavenly court. Praying and meditating over spiritual themes, like angels, can be a difficult task. It's OK if you have difficulty grasping exactly who these angels are or what they have to teach us. Angels are pure spirits. We are not. They are in God's court and see him face to face. We do not...yet. None of us has experienced angels, or at least not frequently, and so we need images of earthly experiences that help us understand their role.

One way to understand angels is to compare them to servants in a king's court. Scripture, in fact, uses this image often to refer to angels. Around the throne of the king would be those servants who carried out his bidding. They would summon people to him, carry his messages, and attend to the needs of the court. These were his most trusted collaborators and were there to hear and learn from his wisdom, to understand his plan, carry it out faithfully, and eventually—even in his absence—carry out their duties according to his principles.

Ezekiel chapter 10 reveals that angels are powerful and awesome creatures who are near God for a reason: They can handle it. One of their main duties is to adorn his throne and support his presence, not out of any need God has for emotional or practical support, but rather as an expression of his munificence. Angels burn with his power and glory because they are so close to it, like coals in a fire that burn red-hot for having been in the center of the flame.

The throne of St. Peter and the glory of angels that surround it unite to express the reality of being close to God's throne in a convincing and powerful way. The Godhead is symbolized by the Holy Spirit, who is sent by the Father and the Son to sanctify. He is sent from the Father and the Son and in a sense is the ultimate example of what an angel should be: an expression of the love of God sent into the world.

The Holy Spirit window is surrounded by multitudes of angels who billow out from the center like clouds of witnesses to his glory. They dance in the light and reflect its glory. The assembly above the chair of Peter looks like an explosion of glorious light, like a sunflower or fireworks. From the intense center explodes beauty and glory. And it is this glory that penetrates the temple of St. Peter and fills it with *God's* glory.

In your moments of prayer and meditation, invite the glory of the Lord to also burst into the room where you pray and into the depths of your heart. He wants to share his glory with you, and angels are just one expression. He sends them because he wants to share something with us.

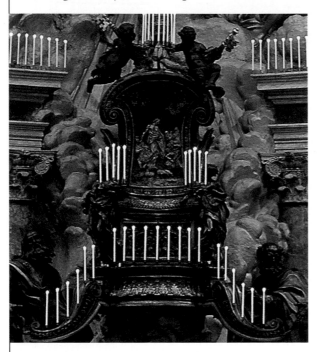

Below this heavenly power sits the symbol of earthly authority—the chair. Bernini uses the chair to highlight the temporal authority that God bestows on the vicar of Christ. God's glory is not only heavenly but also spills out into the earthly realm through the Incarnation and later in the Church founded by the Son. Angels are the principal testimony to this divine choice and thus are carved into every facet of this sculpture. If you look closely at the handrests, you will see two supporting angels. Angels gaze from all around the throne! Their spiritual presence helps us see that this temporal authority flows from and is anchored by the heavenly.

This same truth is confirmed again by the fact that four saintly bishops hold up the throne: two saints from the west and two from the east. The authority given by God to man is above all an authority to testify to the truth by our saintly lives. God shares his authority through the holy men and woman who use that authority to serve, to love, to reconcile, and to lead back to the Father. This is what the popes, bishops, and saints from all walks of life have sought to do for centuries.

Angels are also sent from heaven, from the very throne of God, in order to lead us back to that throne. They are ministers of God the Father, Son, and Holy Spirit and revel in helping us come back to the Father.

PRAYER AND REFLECTION

O Lord, permit us here to raise our voice and bring before your throne our feeble praise, and thank you for those angels whom you have sent to us to direct our ways in our weaknesses and free us from our enemies who look to spoil the beauty of your cherished work. Amen.

—Adapted from *My Prayer Book: Happiness in Goodness* by Rev. F. Lasance (1908)

⊰ In what ways can angels be examples for our own spiritual life?

⊰ How can we work with angels to glorify God and spread his love in the world?

⊰ How do you see the angels in your life trying to lead you closer to the throne of God?

⤠ *Spiritual Exercise* ⤠

⊰ Take this moment of prayer to just be in God's presence. Adore and enjoy his glory as the angels do. Soak up his presence and be set aflame by contact with him. Then let his presence penetrate your way of exercising authority. He has given you certain authority at work, in your family, and among your friends. Be sure to use it from a spiritual and heavenly perspective.

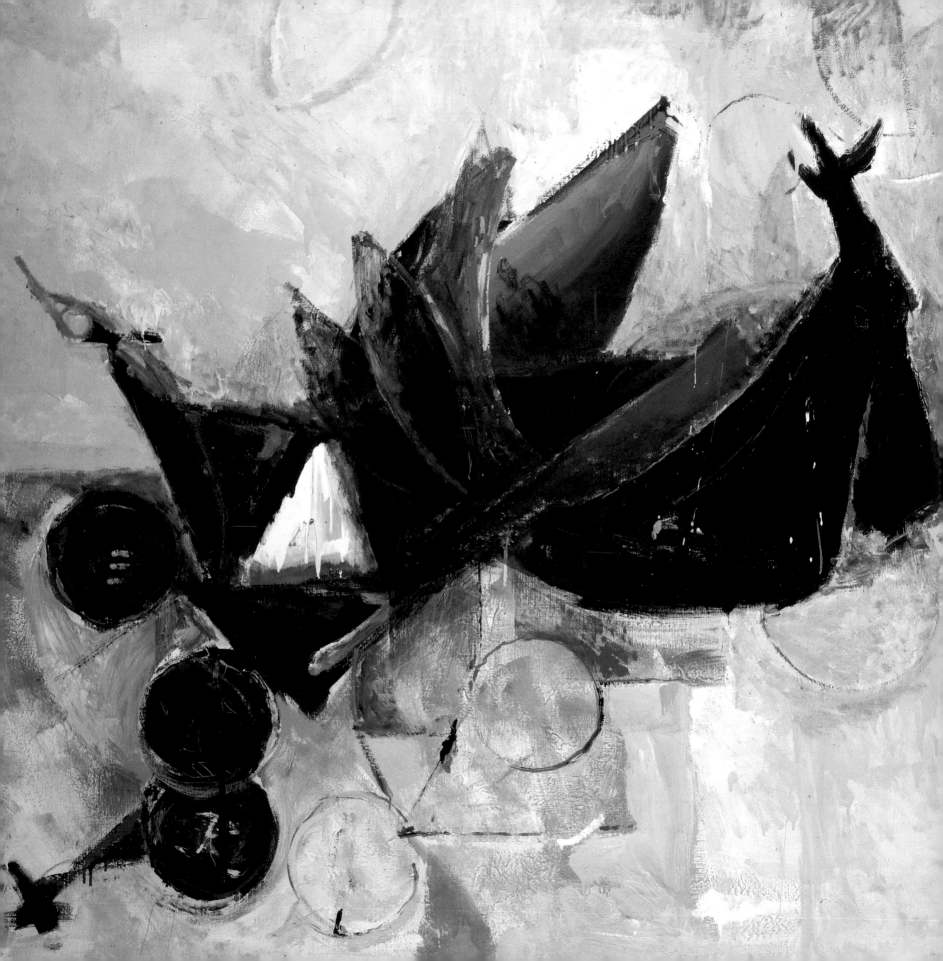

DAY 2

THE FALL OF THE ANGELS

Marino Marini
1963

THEME: The battle of the angels

FOCUS OF THIS MEDITATION: Angels remind us of our spiritual battles. They are called to fight for the king, defend his interests, and protect his people.

◄ The formal-technical experience of Marino Marini (1901–1960) was first characterized by his pictorial style. It was only at a later time that his plastic approach took over, giving him universal fame. Marini was deeply inspired by Piero della Francesca and Masaccio—austere mentors of simplicity and freshness—and he was avidly curious about the new artistic movements of the late nineteenth century.

Even if the subsequent choice of the artist was primarily sculptural, these pictorial experiences are a crucial success of his artistic career. A palette of cool and well-calibrated colors gives the painting a lyricism that is able to convey, with great intensity, the feeling of tragic drama unleashed by this work of art.

This painting, one of the most poetic and twisted versions of the angelic theme and closer to abstraction than to cubism, portrays a compositional autonomy emancipated from the sculptural production for which the artist was more properly known.

SCRIPTURE MEDITATION

REVELATION 12:7–12

Then war broke out in heaven; Michael and his angels battled against the dragon. The dragon and its angels fought back, but they did not prevail and there was no longer any place for them in heaven. The huge dragon, the ancient serpent, who is called the Devil and Satan, who deceived the whole world, was thrown down to earth, and its angels were thrown down with it. Then I heard a loud voice in heaven say:

> *"Now have salvation and power come,*
>
> *and the kingdom of our God*
>
> *and the authority of his Anointed.*
>
> *For the accuser of our brothers is cast out,*
>
> *who accuses them before our God day and night.*
>
> *They conquered him by the blood of the Lamb*
>
> *and by the word of their testimony;*
>
> *love for life did not deter them from death.*
>
> *Therefore, rejoice, you heavens,*
>
> *and you who dwell in them.*
>
> *But woe to you, earth and sea,*
>
> *for the Devil has come down to you in great fury,*
>
> *for he knows he has but a short time."*

*T*he heart of our relationship with Jesus is found in the use of our free will. What choice will we make—believe or not believe, love or not love, trust or not trust.

The angels are no different. As persons with intelligence and free will, they also had that same question to answer. Jeremiah 2:20 tells us how they responded: "Long ago you broke your yoke, you tore off your bonds. You said, 'I will not serve.'" And the *Catechism of the Catholic Church* tells us, "Scripture speaks of a sin of these angels" (*CCC* 392). Their "fall" was in the free choice of these created spirits to radically and irrevocably *reject* God and his reign.

Our relationship with God always implies service, accepting his kingship or fatherhood. We live in a culture that doesn't like service, which sees it as degrading or humiliating. "How dare you ask me to serve or obey?" is the temptation to rebellion that often sneaks into our hearts. So many of our struggles within relationships, within our families, or within ourselves come down to this: Will we be humble and serve Christ and our neighbor or will we rebel against that service?

The passage on Michael and Satan in their celestial battle is played out in the heart of each of us on a daily basis. We need to claim St. Michael's victory for ourselves by opting to pierce through our egoism and allow God's humble plan to be set free in our lives. Real freedom is found in the heavenly world of the spirit, while frustration and death are found in the world of rebellion.

It wasn't enough for the angels to fall themselves. They want us to fall with them. We are caught in a spiritual battle, and we are the terrain. We experience the death, the temptation, the battle. That is why Marini's painting is so

fantastic. Being abstract, totally devoid of realistic details, it focuses on the essential truth—struggle, violence, falling, confusion. It forgets all the details and cuts straight to the heart of the matter. The fall of the angels was about a struggle between wills, intertwined, often difficult to distinguish.

The context of this struggle is a heavenly background. The angels had it all: heavenly bliss, union with God, amazing privileges, full knowledge. Yet they also had a choice. Tradition tells us that upon knowing God's plan for mankind, Lucifer stood up and rejected that plan with those horrific, enslaving words, *"Non serviam,"* I will not serve. Envy got the best of him. "For God formed [man] to be imperishable; the image of his own nature he made us. But by the envy of the devil, death entered the world, and they who are allied with him experience it" (Wisdom 2:23–24).

You would think by affirming his independence and rejecting service to God, Lucifer would have found freedom. Rather, by narrowly adhering to his own will and closing himself off from divine wisdom and truth, he embraced his own demise. The interior confusion, rebellion, and rejection of God creates nothing short of a total mess, a moral disaster. Marini's work epitomizes just that. The composition reveals the drama of the fall of the angels and mirrors our own moral drama. Just look at the painting and notice the falling into chaos, the order being lost, confusion being created by recognizable elements whose unity is fragmented.

The battle of Michael and Satan is played out in our hearts on a daily basis.

PRAYER AND REFLECTION

O glorious prince St. Michael, chief and commander of the heavenly hosts, guardian of souls, vanquisher of rebel spirits, servant in the house of the Divine King and our admirable conductor, you who shine with excellence and superhuman virtue, deliver us from all evil...and enable us by your gracious protection to serve God more and more faithfully every day. Amen.

—Adapted from *Prayer to St. Michael the Archangel* by Pope Leo XIII (1886)

- How do you see the tempter in your everyday life?

- What are some ways in which you can prepare yourself to do battle with these fallen spirits and the temptations they bring to you?

- How are you called to serve God? In your family, work, or volunteer roles, do you ever find yourself struggling to participate fully in this service or do you find yourself begrudging God this duty?

 Spiritual Exercise

- As you meditate on this painting, allow our Lord to speak to you about the way this battle goes in your own soul. Do this not to be saddened by the times you fail but to unveil the influence of the tempter and choose to reject his work. Uncover some of the occasions that lead you to fall and list the ways you can avoid them.

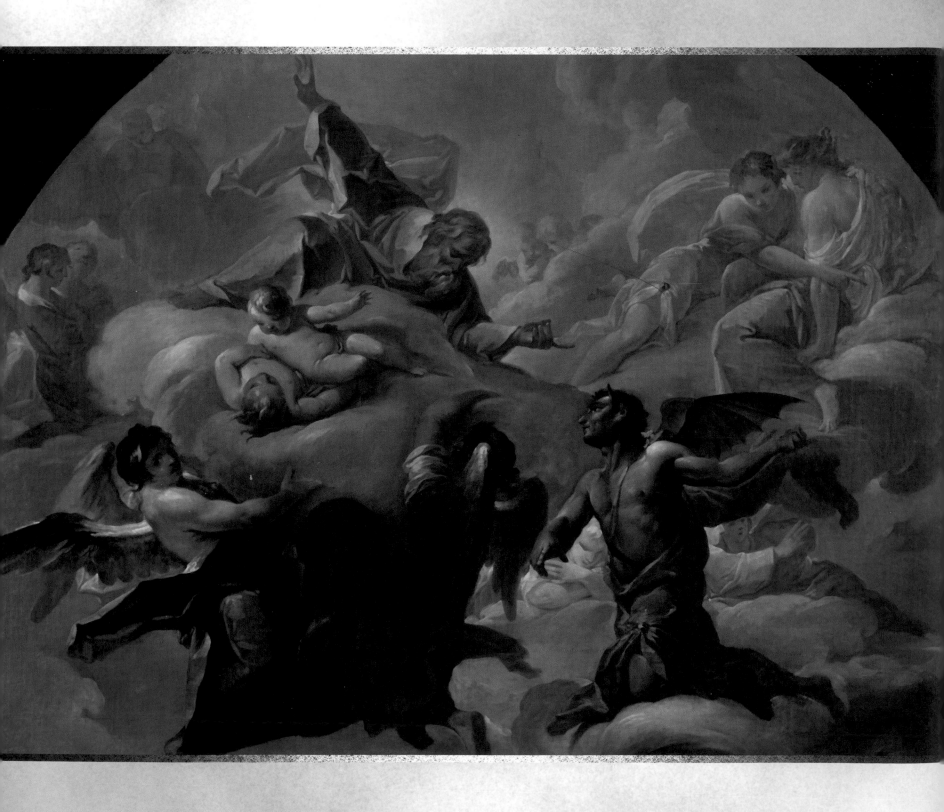

SATAN BEFORE THE LORD

The Circle of Corrado Giaquinto
Mid-eighteenth century

THEME: The work of evil angels

FOCUS OF THIS MEDITATION: God permits evil angels to test his servants.
Just as he does not take away or limit our freedom, he permits the actions of evil spirits
in the world because even that evil can be the occasion for good by the grace of God.

◀ In *Satan Before the Lord,* God is depicted addressing the devil, indicated by his pointing downward. The figure of the fallen angel has been characterized by the usual iconographic attributes: pointed ears, bat's wings, and dark coloring.

Although the scene is difficult to interpret, it is possible to identify its correlation with the passage from the Book of Job (1:6–12) in which Satan receives permission from God to torment the rich man Job. Only after a hard and long spiritual exercise does God intervene to strengthen and nurture the virtue of patient Job, who through his faith was able to fight and reject his enemy.

This painting has a pendant that represents what happens next: A young man and a woman with a child are in the act of sacrificing a ram. This is Job, sacrificing the animal to God to ask for a blessing on his son.

SCRIPTURE MEDITATION

JOB 1:6–12

One day, when the sons of God came to present themselves before the LORD, Satan also came among them. And the LORD said to Satan, "Whence do you come?" Then Satan answered the LORD and said, "From roaming the earth and patrolling it." And the LORD said to Satan, "Have you noticed my servant Job, and that there is no one on earth like him, blameless and upright, fearing God and avoiding evil?" But Satan answered the LORD and said, "Is it for nothing that Job is God-fearing? Have you not surrounded him and his family and all that he has with your protection? You have blessed the work of his hands, and his livestock are spread over the land. But now put forth your hand and touch anything that he has, and surely he will blaspheme you to your face." And the LORD said to Satan, "Behold, all that he has is in your power; only do not lay a hand upon his person." So Satan went forth from the presence of the LORD.

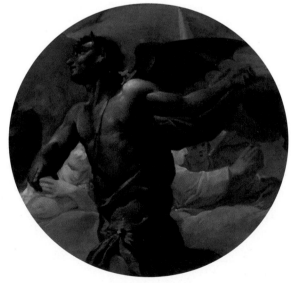

2 CORINTHIANS 11:14

...Even Satan masquerades as an angel of light.

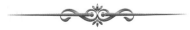

Some years back, a friend of mine organized two conferences in Rome. The first was on the Holy Spirit, and although almost 100 people participated it received very little public attention. The next week, he organized a one-day conference on exorcism and while only eight people came it was covered in major newspapers! Evil has a sinister attraction. It comes in shiny packaging. Why else would we choose something that does us so much harm?

But the person most interested in evil is going unnoticed. The devil himself. One of his best tactics is to make us think he doesn't exist. He would rather Christians not talk about him than be informed of his power and dealings on earth. If anyone speaks about these beliefs, they are "old school" or pre-Vatican II. Modern psychology and science have come to explain many things formerly attributed to the devil and his minions, but this doesn't mean the devil has ceased to be a real presence in our modern world.

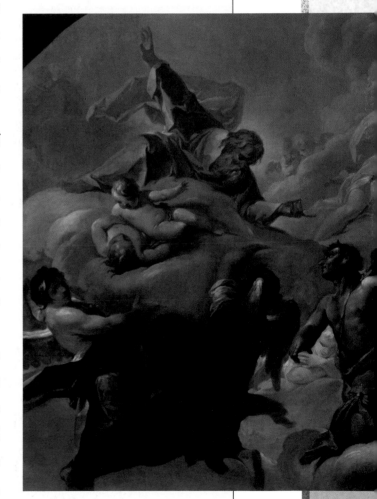

Popular culture has no problem focusing on the existence of these forces, fascinated as it is with evil, the occult, and the like. The truth Scripture reveals speaks to this. From Genesis to Revelation, the Bible is full of references to the devil and the evil spirits who serve him. God's truth and our own experience confirm that "our struggle is not with flesh and blood but with the principalities, with the powers, with the world rulers of this present darkness, with the evil spirits in the heavens" (Ephesians 6:12).

Today's painting and Scripture passages typify Satan's existence and exemplify how he works. God authoritatively rests upon his celestial throne, surrounded by attending angels. A golden hue radiates around him as angels converse to his right and left. God is in the center dynamically engaging Satan, who appears in the painting's lower right. The two frolicking *putti* at Satan's left seem to have no fear of the horned Satan just a short distance away.

Satan is engaged in dialogue with God, who asks if he has seen his servant Job. Satan admits to Job's virtue but attributes it merely to God's protective goodness. Surely Job would curse God if he was poor, suffering, and alone.

As if to prove the authenticity of Job's love, God permits Satan to touch his goods but not his person. Satan then sets about exterminating all his livestock, destroying his homes, his fields, and his family.

The devil's work to tempt each of us may not be so blatant, but we can be sure he is at work with his evil angels to lead us away from God. His work is easy to uncover once we look with honesty into our hearts and lives. He comes to sow discontent, division, envy, anxiety, and hardness of heart. He knows each of our hearts and tries to find just the right strategy to draw us to him and away from God.

When admitting the existence of the evil one, we need to avoid two extremes. On the one hand, we should not be overly concerned or focused on him so that we live in fear of his presence and influence. At the same time, we should not live in denial of the existence of this spiritual battle that rages around us. We must be calmly aware and walk with confidence, for we are on the winning side.

We must be calmly aware and walk with confidence, for we are on the winning side.

PRAYER AND REFLECTION

St. Michael the Archangel, defend us in battle. Be our protection against the wickedness and snares of the Devil. May God rebuke him, we humbly pray, and do you, O Prince of the heavenly host, by the power of God, thrust into hell Satan and all the evil Spirits who prowl about the world seeking the ruin of souls. Amen.

—Adapted from *Prayer to St. Michael the Archangel* by Pope Leo XIII (1886)

* Take some time to see how the tempter works in your own life. Has he attacked some of your possessions, your health, your family, your relationship with God?

* Let us not be like the spoiled children of a rich parent, showering him with love and affection as long as the credit card still works. Of course we want God's blessings, but above all, we want him, the source of those blessings. Where do you see God's blessings? Where do you see his grace helping you over obstacles?

* When God does permit certain temptations to assail us or the effect of evil to touch our lives, we should respond humbly, just as Job did. "The LORD gave and the LORD has taken away; blessed be the name of the LORD!" (Job 1:21). How can you work to cultivate that attitude in your life?

◡ Spiritual Exercise ◡

* Saint Paul had good advice for early Christians that still applies to our lives today. "Put on the armor of God so that you may be able to stand firm against the tactics of the devil" (Ephesians 6:11). Remember to put on the spiritual armor of God this morning, through acts of faith and trust, making this a part of your routine before you start your day.

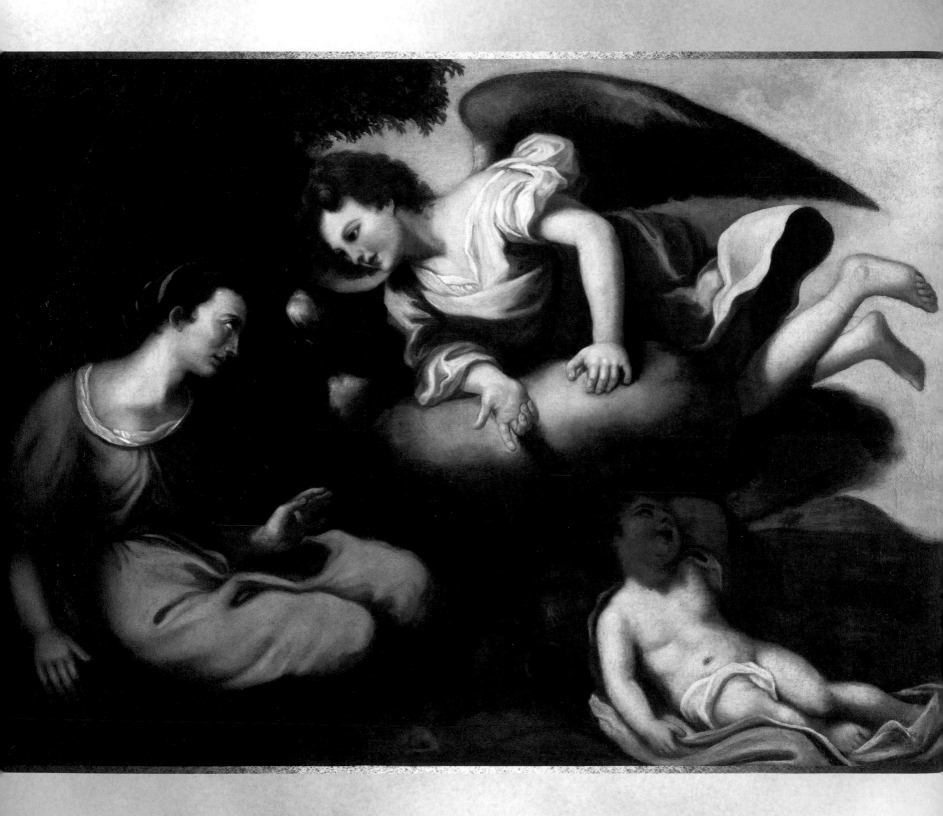

DAY 4

HAGAR AND ISHMAEL

Unknown
Circa sixteenth–seventeenth centuries

THEME: The angel comes to care for Hagar and Ishmael.

FOCUS OF THIS MEDITATION: God has mercy on the poor and sends his angels to sustain them in their grief. Just as God was faithful to Abraham and his descendants, so will God use his angels to keep his promises to us.

◄ This beautiful work of art most likely dates between the end of the sixteenth and the early seventeenth century and was completed by an anonymous artist. We can see a hint of the Baroque movement emerging in the pattern of the drapery.

It was during the sixteenth century that scenes depicting the expulsion of Hagar and Ishmael by Abraham or Hagar and Ishmael in the desert began to appear. This is unlike the artwork of the Middle Ages, which depicted the story of Hagar almost exclusively in connection with the cycles of Abraham. This painting focuses exclusively on Hagar, her son, and their angelic helper.

The painting depicts the scene of God's messenger angel coming to Hagar in the desert (Genesis 21:17). On the left side of the painting, the slave Hagar is listening to the angel on the cloud before her, telling her to not be afraid because God has heard her son's cry. The child Ishmael sleeps on a red cloth with his head resting on the now-empty bottle of water.

The composition is dominated by these three figures, leaving little space for the landscape and sky.

SCRIPTURE MEDITATION

GENESIS 21:14–19

Early the next morning Abraham got some bread and a skin of water and gave them to Hagar. Then, placing the child on her back, he sent her away. As she roamed aimlessly in the wilderness of Beer-sheba, the water in the skin was used up. So she put the child down under one of the bushes, and then went and sat down opposite him, about a bowshot away; for she said to herself, "I cannot watch the child die." As she sat opposite him, she wept aloud. God heard the boy's voice, and God's angel called to Hagar from heaven: "What is the matter, Hagar? Do not fear; God has heard the boy's voice in this plight of his. Get up, lift up the boy and hold him by the hand; for I will make of him a great nation." Then God opened her eyes, and she saw a well of water. She went and filled the skin with water, and then let the boy drink.

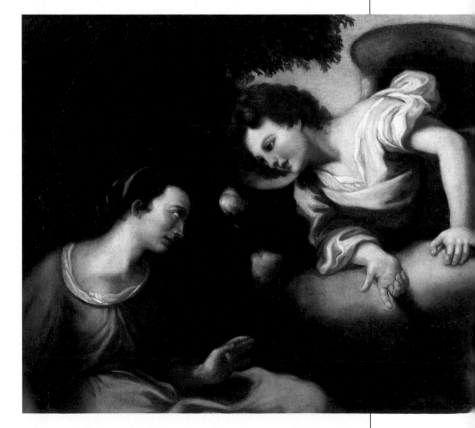

God sends his messenger to assure Hagar that he has heard the cries of her son.

The best way to understand the role angels play in our own lives is to look at what they did in the lives of those who came before us. The Old Testament is a great place to start, and there is no shortage of passages where we can find angels at work. Time and time again, angels are key players in the major events of our salvation history.

As discussed in the introduction, angels are named after their role as God's envoys or messengers. Throughout the Old Testament, God communicates to his servants through the message of an angel.

God promised Abraham descendants as numerous as the stars in the sky, but as yet, his wife, Sara, was unable to conceive. Sara induced Abraham to lie with her slave girl, Hagar, and indeed a son was born to them, Ishmael. When Sara finally did conceive and give birth to her own son, Isaac, she began to treat Hagar and Ishmael so poorly that Hagar ran away with her son. An angel of God visited Hagar in the desert and had consoling and challenging words for her. The angel insisted she return but also promised that Abraham's son through her would be great and enjoy God's blessing.

Once Hagar returned, things did not improve with Sara, and once again she must flee to a barren place. It is here that our unknown artist takes up the story. The painting has a circular pattern, and the three figures all lead the eye of the observer 'round and 'round the painting without a point of rest. The angel, wings unfurled above, curves over Hagar, who is languishing against a rock waiting for the hour when dehydration will claim her life and that of her child. She has placed the child under the shade of a bush resting on the empty water skin given to them by Abraham. There is no hope. All that is left to do is turn her eyes from the boy, cry, and drift into death. As we struggle with suffering in our lives, we can certainly relate to Hagar's despair.

The dark tones depict the desperateness of the situation. The starved cries of the child and the painful moaning of the helpless mother reach the ears of God. He responds by sending his messenger to assure them they have found pity. "What is the matter, Hagar? Don't be afraid; God has heard the boy's cry in this plight of his."

God hears our every cry. It may seem that he does not, that everyone is against us, that he will never fulfill his promises, yet God hears, sees, and responds.

The following are words he could be saying to you today. "Arise, lift up the boy and hold him by the hand; for I will make of him a great nation." God promises us great things if we listen to him and accept his call to not give in to despair. He invites us to get up, lift those who are counting on us, and lead them to a place of confidence in God. If we give up, God cannot work his miracles. Yet if we stand up and grab on to his promises, he can begin his great work in us.

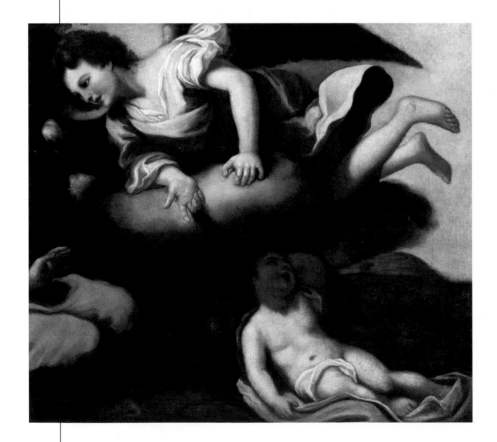

God promises us great things if we listen to him and accept his call to work his miracles.

PRAYER AND REFLECTION

Lord, some days, when I am at my most desperate—like Hagar in the desert—I feel my cries fall on deaf ears. I feel as lost and forsaken as your servant, Hagar. Give me the grace to know that even when the journey is difficult and long, you and your angels are accompanying me. Help me to claim in faith, hope, and love that you are faithful to your promises! Amen.

- What is the "barren land" you find yourself stranded in when you are desperate and afraid? Reflect on this place and how God's messengers find you there.

- Are there obstacles that prevent you from seeing the greatness God will work in you? Spend time in prayer asking God to open your eyes.

- Reflect on these messenger angels and how they may be at work in your own life and the lives of those around you.

Spiritual Exercise

- "Then God opened her eyes, and she saw a well of water" (Genesis 21:19). Hagar sees what she could not see before—a way out, a source from which to draw strength. The angel of God gave her this message of encouragement and allowed her to see the solution. The angels in our lives will do the same for us. Look for these messengers God sends, open your eyes to their presence and the strength they bring.

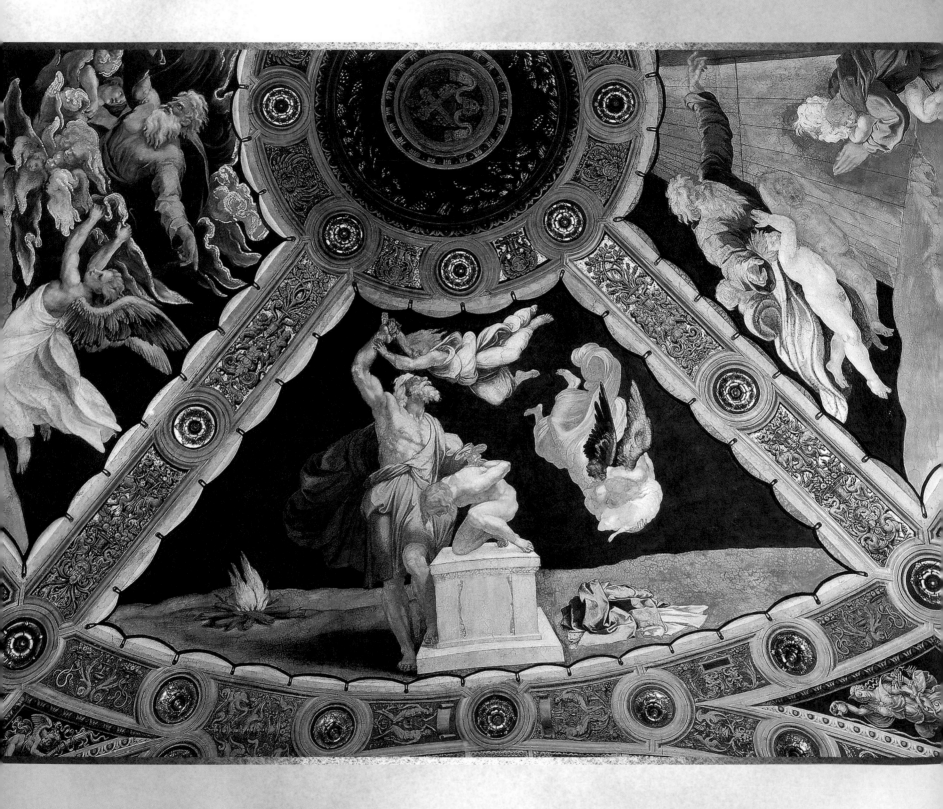

THE SACRIFICE OF ISAAC

From Ceiling, *Stanza di Eliodoro*
Raphael Sanzio
1511

THEME: Angels prevent Abraham from sacrificing his son, Isaac.

FOCUS OF THIS MEDITATION: God sends angels as messengers of his mercy and consolation. Abraham generously responds to God's call, and God sends his angels to save Abraham and Isaac from the supreme sacrifice.

◀ *The Sacrifice of Isaac*, a fresco by Raphael Sanzio (better known as Raphael) dates to 1511. It is part of a larger piece that decorates the ceiling in the Room of Heliodorus. The entire piece includes four episodes, all dating to the second half of 1511. Giorgio Vasari attributes all four episodes to Raphael (1483–1520), and this remains the most common attribution. However, Giovanni Cavalcaselle credits the labor to Baldassarre Peruzzi. Adolfo Venturi and William of Marcillat credit Gianfrancesco Penni. Unfortunately, due to the poor state of preservation, it is difficult to draw firm conclusions.

In the center of the vault is a medallion with the arms of Julius II, surrounded by arabesques in monochrome on a golden background. The composition develops figuratively around a ring, divided diagonally into four compartments, each showing a scene of divine intervention from the Old Testament. Fake gold studs and rings are interspersed throughout to give the impression of hung tapestries.

The Sacrifice of Isaac is located above *the Mass at Bolsena*. This particular comparison presents a relationship opposition: While *the Mass at Bolsena* shows the doubt of transubstantiation, today's painting shows Abraham demonstrating unwavering trust in God during a moment of sacrifice. This painting—stemming from Genesis 22:2–13—is set on a deep blue background before which Abraham is going to sacrifice his son. The arm with the sword is blocked by one angel while a second rushes from the sky, perhaps to pick up the clothes of Isaac to cover him. To the viewer's left is fire, a typical element of sacrificial scenes.

SCRIPTURE MEDITATION

GENESIS 22:1–12

Some time afterward, God put Abraham to the test and said to him: Abraham! "Here I am!" he replied. Then God said: Take your son Isaac, your only one, whom you love, and go to the land of Moriah. There offer him up as a burnt offering on one of the heights that I will point out to you. Early the next morning Abraham saddled his donkey, took with him two of his servants and his son Isaac, and after cutting the wood for the burnt offering, set out for the place of which God had told him. On the third day Abraham caught sight of the place from a distance. Abraham said to his servants: "Stay here with the donkey, while the boy and I go on over there. We will worship and then come back to you." So Abraham took the wood for the burnt offering and laid it on his son Isaac, while he himself carried the fire and the knife. As the two walked on together, Isaac spoke to his father Abraham. "Father!" he said. "Here I am," he replied. Isaac continued, "Here are the fire and the wood, but where is the sheep for the burnt offering?" "My son," Abraham answered, "God will provide the sheep for the burnt offering." Then the two walked on together. When they came to the place of which God had told him, Abraham built an altar there and arranged the wood on it. Next he bound his son Isaac, and put him on top of the wood on the altar. Then Abraham reached out and took the knife to slaughter his son. But the angel of the LORD called to him from heaven, "Abraham, Abraham!" "Here I am," he answered. "Do not lay your hand on the boy," said the angel. "Do not do the least thing to him. For now I know that you fear God, since you did not withhold from me your son, your only one."

Once again we meditate upon an angelic intervention in the life of Abraham. After Hagar and Ishmael are banished by Sara, God calls upon his servant, Abraham, and tells him to take Isaac to the land of Moriah and a place God will reveal. There, he is to sacrifice his beloved and only son. His answer is, "Ready!" This reply itself could be more than enough to lead us into deep meditation. Abraham's immediate response is one of active abandonment. There is no hint of defensiveness or suspicion toward God. He calls and Abraham answers immediately, instinctively. Ready! And I? How do I respond to God calling me? What interior attitudes hinder or help this response?

From three days off, Abraham sees the place where he is to sacrifice his son and leaves behind his servants to go alone. What a terribly painful three-day journey it must have been with Isaac. With what love must the father have spoken to the son, believing these would be his last words, their last conversation. What storm must have raged in Abraham's heart; yet he could not allow his son to know anything was amiss, could not share the interior darkness and torment between his faith and his nature as a loving father. God asked this, and Abraham knew he must trust, must believe. Throughout this travail, Abraham knew he must smile, must not let on. As a parent, how often do you live this drama of love for God and your children, expressed in silence and a simple smile, regardless of what is wrong?

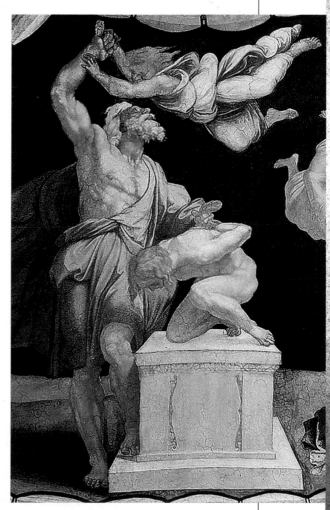

Raphael depicts the utterly personal nature of obedience to God's call by placing Abraham and Isaac alone in the scene. It is just the two of them, and above all just Abraham, set against the divine blue that envelops his figure, just as God surrounds and embraces our most intimate and costly decisions to love and follow him.

Abraham's strong, sculpted figure impresses us as heroic. He is majestic, his muscular torso and biceps flexing in the moment just before bringing down the blade on his son. He is fully committed to going through with the act, and there will be no stopping him, unless God himself sends down an angel of mercy. There is no hesitation or uncertainty. Abraham's faith is shared by his son. Isaac is no helpless toddler. He is young, yes, but strong enough to resist. Yet the sacrifice is not imposed on him. Rather, he accepts it. His strength is even more evident as he exposes his neck to the knife, becoming vulnerable and totally trusting of his father and God the Father.

Abraham and Isaac are not totally alone for this dramatic event. Raphael places an angel in the scene as God's representative and messenger. This angel calls out for Abraham to stop in the midst of his action, with Abraham still listening. Even in his suffering, he does not close his ears or heart to God's voice.

In that last instant, when Abraham and Isaac's hearts are fully set on God's will, the mighty missionary of God's love swoops in to forcefully stay the father's hand. God will not let anything happen to his beloved! It can be hard to hear God's voice, but if we are willing to listen and step out in faith—even if that means abandoning something we hold dear—God will make himself heard.

"Do not lay your hand on the boy." The angel states what Abraham wants to hear so badly. "Do not do the least thing to him." Relief must have flooded into his heart along with an immense love for God, who spared him the ultimate sacrifice. Gratitude must have enveloped him: His son, the greatest gift of God, is still alive.

Then God's messenger speaks words of consolation: "I know that you fear God, since you did not withhold from me your son, your only one."

Love is revealed in not holding anything back, in giving God your all, even those things most dear to you, trusting he will return them to you in abundance.

PRAYER AND REFLECTION

Take, Lord, receive all my heart, my memory, understanding, and will.

Take, Lord, receive all I have. Everything comes from you, now I return it.

Take, Lord, receive, all is yours now. My woundedness, my sins, all my good and my bad.

Give me only your love and your grace. That's enough for me.

Amen.

- Of the four images in the fresco, *The Sacrifice of Isaac* is the most uncluttered, asking us to take in the act and little else. How do you think Abraham struggled all alone, ready to sacrifice his son? How would you deal with this struggle? Would your faith be strong enough to do as God asked?

- Are there things in your life God has asked you to offer up for his sake? Were you able to give them up or did you cling onto them even tighter? If you weren't able to make that sacrifice yet, think about why, try to understand what it is you're really trying to hold on to.

- We know in the New Testament it is God who sacrifices his only Son, and he does so for us. What can we learn from this sacrifice and Abraham's willingness to do the same? Does knowing God sacrificed his only Son for us make it easier for you to trust God when he asks something of you?

～ Spiritual Exercise ～

- Spend time in silence, listening for God's voice. Be prepared to respond, "Ready!" to whatever he asks of you.

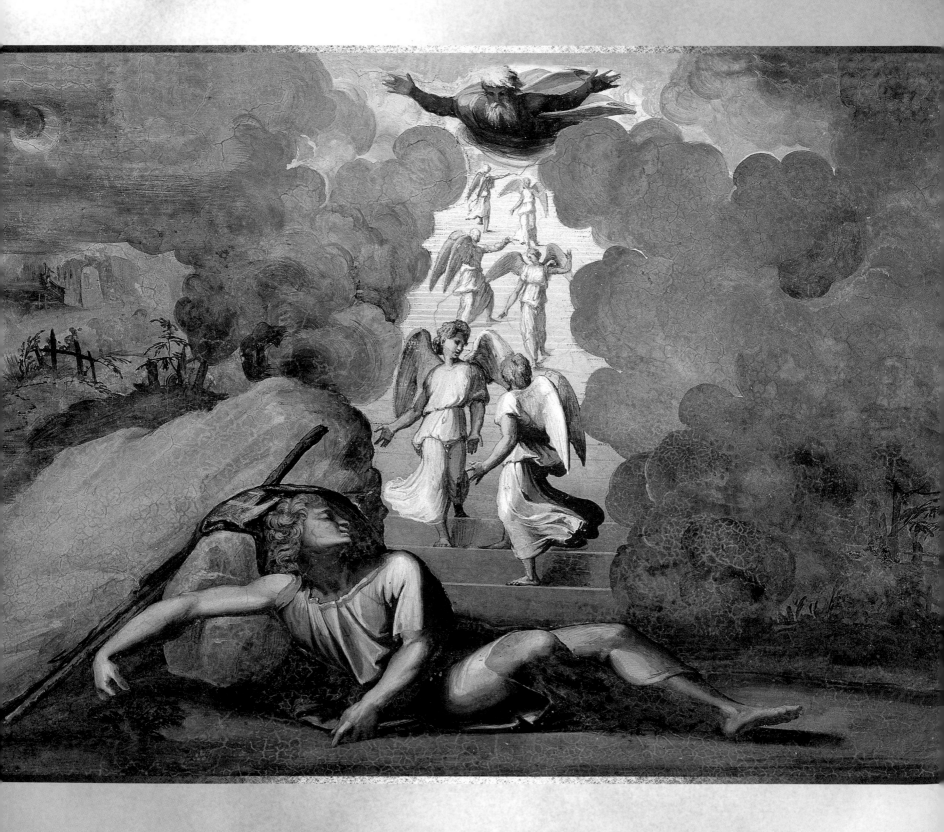

THE DREAM OF JACOB

From *The Loggia of Raphael*
Raphael Sanzio
1517–1518

THEME: Jacob's ladder

FOCUS OF THIS MEDITATION: Angels establish a link between heaven and earth, and they will rise and descend on the Son of Man.

◀ *The Loggia of Raphael* is part of a series of frescoes depicting biblical stories dating to the end of 1517 through 1519. This cycle of frescoes is located on the ceiling vault of the second floor of the Apostolic Palace, adjacent to the Raphael Rooms.

Under each vault are four fresco programs surrounded by stucco frames of various shapes (hexagonal, rectangular, or arched). The first twelve vaults have stories of the Old Testament, and the last one depicts scenes of the New Testament. These frescoes are often called "Raphael's Bible" due to the richness and complexity of the scenes and the number of biblical stories they capture.

The sixth of the twelve vaults is devoted to stories of Jacob. The paintings, rectangular in shape, represent Jacob's dream, the meeting with Rachel, the covenant with Laban, and the way to Canaan. *The Dream of Jacob,* appropriately, overlooks *The Deliverance of St. Peter,* as God appears in a dream to Jacob and frees St. Peter through a dream.

SCRIPTURE MEDITATION

GENESIS 28:11–16

When he came upon a certain place, he stopped there for the night, since the sun had already set. Taking one of the stones at the place, he put it under his head and lay down in that place. Then he had a dream: a stairway rested on the ground, with its top reaching to the heavens; and God's angels were going up and down on it. And there was the LORD standing beside him and saying: I am the LORD, the God of Abraham your father and the God of Isaac; the land on which you are lying I will give to you and your descendants. Your descendants will be like the dust of the earth, and through them you will spread to the west and the east, to the north and the south. In you and your descendants all the families of the earth will find blessing. I am with you and will protect you wherever you go, and bring you back to this land. I will never leave you until I have done what I promised you. When Jacob awoke from his sleep, he said, "Truly, the LORD is in this place and I did not know it!"

The story of Jacob's ladder has received widespread commentary by Jewish, Muslim, and early Christian theologians. In all these interpretations there is one common thread: There is a constant connection between heaven and earth, and it is angels who travel this space most frequently. Angels can travel between God and men easily, and they do so consistently.

This scene of Jacob's ladder is the first time angels appear to Jacob. Having taken a stone from the altar of remembrance at this holy site, he lays his head on the sacred rock to rest. This could very well be a reference to how Jacob rested with the Lord, resting in a holy way, leaning on God even in his sleep. This blessed rest brought him divine illumination. He saw a ladder built by God that started on earth and rose into heaven, providing an angelic pathway. Raphael depicts this rock as so large that Jacob's whole body rests against it, similar to the pose of Adam before the divine touch of God as depicted in Michelangelo's creation of man.

Recall the story of the tower of Babel, where people try to build a towering structure to reach up to God. God frustrates their efforts, for they are building on their own strength and for their own selfish ends without resting their efforts on God. Yet here, God himself reaches down and sets up a connection with man through his patriarchs and his descendants. We can meditate on the fact that God wants to be part of our life and personal history. He stretches out the connection through grace, the sacraments, and the Church. He wants there to be constant connection between you and him. Are you aware of God's longing to be a part of your life? Do you cultivate an open-door policy for this divine guest?

What God says when Jacob sees the ladder is significant. He renews the covenant he made with Jacob's grandfather, Abraham, with his father Isaac, and now with Jacob, who will become Israel, father of the twelve sons who will become the twelve tribes of Israel. God promises him prosperity and a land for his offspring. God is faithful to his promises, and even while Jacob is sleeping, God is revealing and realizing this plan. When Jacob awakens from this vision, he is awestruck and exclaims that God is no doubt in this spot, even if at first he was unaware.

God's plan comes to its fullness when the final and definitive bridge is extended between

heaven and earth in the person of Jesus Christ. Jacob names the place of his vision Bethel, which will become Bethlehem, the city where God's Son through Jacob's line will descend upon the earth to lead his Chosen People to their ultimate Promised Land. Jesus is the way to the Father. Even when Jesus explains himself to Nicodemus, he refers to himself as similar to a ladder. "Amen, amen, I say to you, you will see the sky opened and the angels of God ascending and descending on the Son of Man" (John 1:51).

It is certainly true that God is all around us and that his angels are present to us as well, guiding us down God's path. They come and go, bring us his message, inspire us, protect us, reveal his plan to us and remind us heaven is only a few rungs away if we just turn and climb upward.

Just as Jacob discovered this connection to heaven in a concrete place and in a moment of peace, so must we take this moment of prayer to open our hearts up to this mystical ladder which is Jesus Christ. He comes to us daily and most especially on the altar in the Eucharist. He descends so that through communing with him we might ascend and be united with the Father. Bethlehem, the place of Jacob's vision, the place of Jesus' birth, is translated as *House of Bread*. No doubt that bread is the same that comes down from heaven to our churches, our local houses of bread, and is the best place to find this ladder and climb toward God.

PRAYER AND REFLECTION

Lord, I am not worthy of your presence in my life, but you come to me anyway. Thank you for sending your Son, my bridge into heaven, and help me to embrace the upward path that leads me to union with you. Help me to embrace him in the word of Scripture that comes down to me in the Bible as well as in the Bread of Life that comes down from heaven. Amen.

※ Think about Jacob's words, "Truly, the Lord is in this spot, although I did not know it!" When has the Lord surprised you with his presence?

※ While God is always with us, we can't always feel his presence. When is it most difficult for you to feel the presence of God and his angels? When is it easiest?

※ It can be easy to overlook God's messengers among us, so spend time today paying attention to the people around you. Look at every encounter as an opportunity to see God.

~ *Spiritual Exercise* ~

※ Take time to reflect on God's desire to be a part of your life. The next time you receive Communion, make an effort to prepare a room in your heart for God to dwell, and keep that space open as you go back to your day-to-day tasks.

ANGELS AND CHRIST

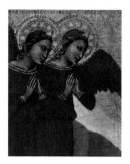

THE ROLE OF ANGELS in the New Testament begins with the presence of angels in the life of Christ.

The first thing to notice is that the angelic world held a place in the heart and thoughts of Jesus. The evangelists talk of his intimate dealings with angels (Matthew 4:11 and Luke 22:43). Jesus himself speaks of them as real and active beings, affirming that while they watch over humanity they are also seeing the face of the Father (Matthew 18:10). The angels even rejoice with him at the salvation of sinners (Luke 15:10). They are not subject to our earthly conditions (Matthew 22:30), however, there are limits to their knowledge, for Jesus tells us that they do not know the day of the Last Judgment, even though they will execute his decisions on that day (Matthew 13:39, 49; 24:31). While angels may know more of God's divine plan than us, there are still some things only known to God.

Jesus says the angels will accompany the Son of Man on his Second Coming (Matthew 25:31) and rise and descend upon him (John 1:51) just like they did on Jacob's ladder (Genesis 28:10). The angels will do his bidding as they do God the Father's bidding in the Old Testament, for he will send them out to gather the elect (Matthew 24:31) and reject the damned from the kingdom (Matthew 13:41). During the passion they are at his service (Luke 22:43) even when he does not call on them (Matthew 26:53).

The New Testament makes quite clear that angels are subordinate to Christ (1 Timothy 3:16 and Ephesians 1:20) and acknowledge his dominion over them (Revelation 5:11). In his Incarnation, Jesus humbles himself below them (Hebrews 2:7), but he is still divine, the Son of God, so they adore him (Hebrews 1:6) for they have been created by him, in him, and for him (Colossians 1:16). They serve him, and it only stands to reason that, seeing his infinite love for humanity as shown on the cross, angels will be quick to love and serve what he loved and saved: each one of us.

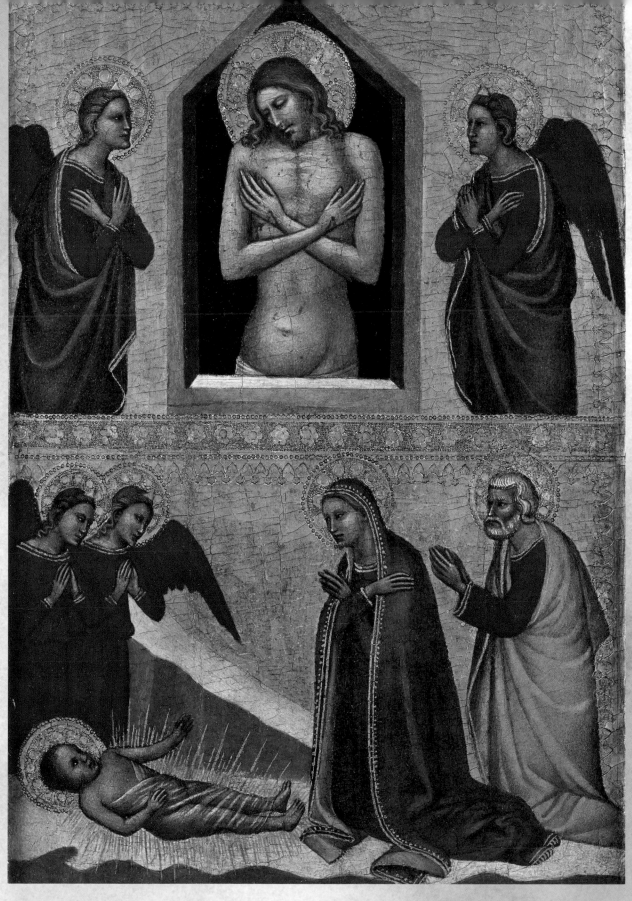

The Dead Christ and the Adoration of the Infant Jesus
by Francescuccio Ghissi

Section II: Angels and Christ

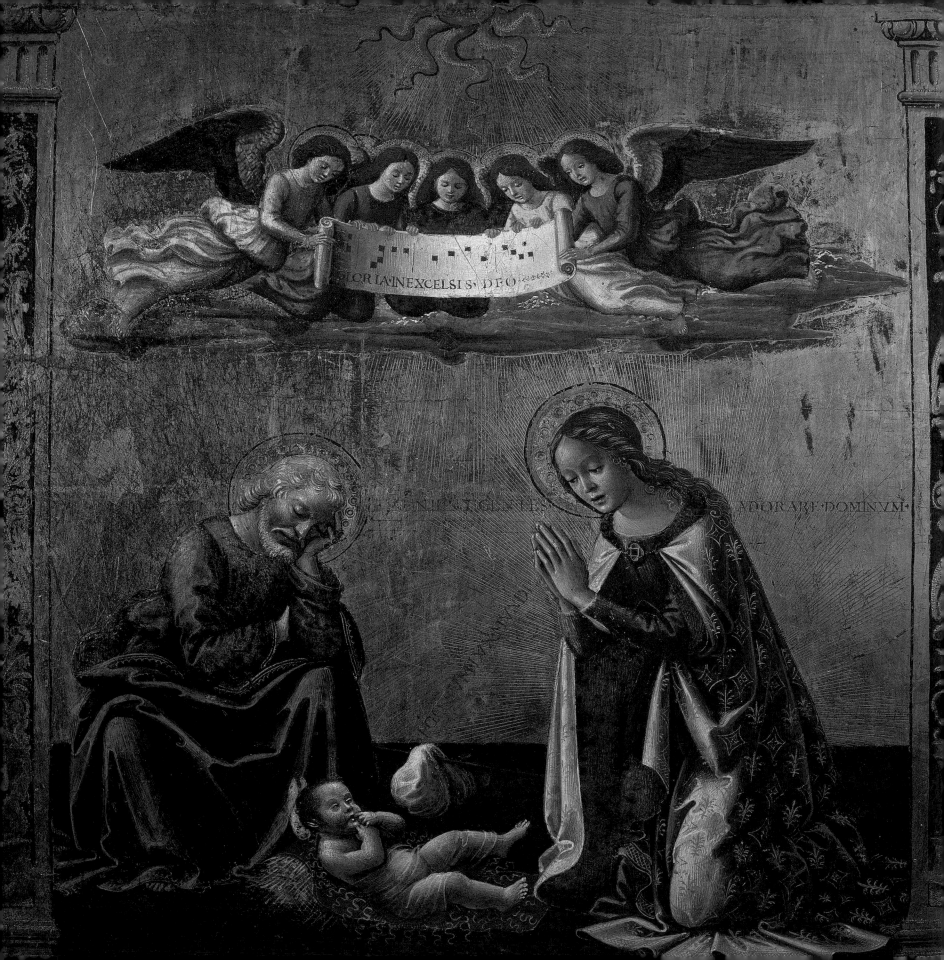

THE NATIVITY

Domenico Bigordi (called Ghirlandaio)
1492

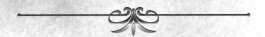

THEME: Angels join us in glorifying the Lord.

FOCUS OF THIS MEDITATION: Angels in the New Testament
lead us to Jesus and proclaim his glory.

◄ Domenico Bigordi (1449–1494), better known as
Ghirlandaio, was a painter of the Florentine Renaissance.
His workshop was known for producing many quality
paintings from many talented artists but is perhaps best
known for one particular apprentice, Michelangelo.

Ghirlandaio's style was famous for its portrayal of contem-
porary people within religious narratives, which can be seen
in his figures of Mary and Joseph in this story. Mary is active-
ly in prayer while watching over her newborn Son, a contrast

to Joseph, who is in a restful pose on the other side.

The plain gold background works to make this piece
timeless as it causes the viewer to focus on the figures of
Mary, Joseph, and Jesus. We find no stable, fire, manger,
or animals to distract us from our Savior's birth. This scene
could be taking place in any time under any setting. It is the
Holy Family that is important. The angels overhead watch
as this great mystery of God unfolds, and they call us all to
worship this holy Child.

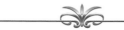

SCRIPTURE MEDITATION
LUKE 2:10–14

The angel said to them, "Do not be afraid; for behold, I proclaim to you good news of great joy that will be for all the people. For today in the city of David a savior has been born for you who is Messiah and Lord. And this will be a sign for you: you will find an infant wrapped in swaddling clothes and lying in a manger." And suddenly there was a multitude of the heavenly host with the angel, praising God and saying: "Glory to God in the highest and on earth peace to those on whom his favor rests."

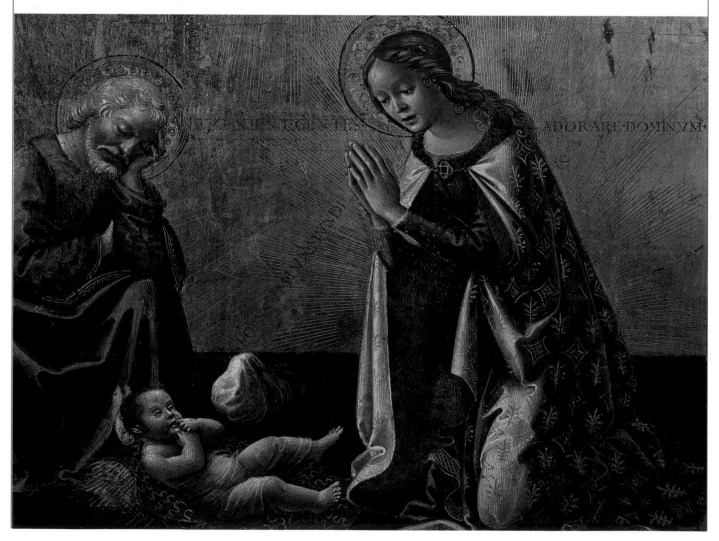

The golden background of *The Nativity* focuses our attention on the mystical and timeless theological meaning of the birth of Christ rather than on the particular details of its historical setting. We find no stable, no grass, no cattle. The cave is gone, fire is removed, and there is nothing else that would link it to a time, place, or circumstance. Christ's birth is a universal event, valid for all times and places, for all people.

This more reserved decorative motif allows *Il Ghirlandaio* to focus our attention on the essentials of this moment. Joseph, the man who has a humble and silent heart, is shown sleeping peacefully, meditatively, because he is the just man capable of hearing God's voice while at rest. Angels told him in a dream not to fear to take Mary as his wife (Matthew 1:20). Later, angels came to him in a dream to tell him to flee to Egypt to avoid Herod's vengeful henchmen (Matthew 2:13). Like Mary, Joseph reflects on things profoundly as he grapples with God's will and the amazing vocation he has been given. His prayer leads him to "man up" to his call rather than take the easier path of becoming an absentee father. Following God will mean pilgrimage as the symbols near him indicate—his walking stick, water jug, and knapsack. He assumes his role as leader and protector, an example for the Holy Family. He is not dozing lazily. Rather, he is silently attentive. Later, he displays his commitment to get busy and follow the angel's voice.

Mary's figure has a heightened descriptive charm highlighted by her youthful appearance, flowing hair, and the ornate mantle that fans out from under her knee toward the viewer. She leans forward in active prayer and as a protective presence over her Child. Her knee is bent prominently in the foreground, adding depth to the painting. Her posture is at once eager, adoring, and active.

Our adoration of Jesus and our willingness to follow him should have these same characteristics: the silent meditation of Joseph and the active attentiveness of Mary. While Joseph and Mary are there for Jesus in different ways, both are very much present to him. It is that sense of being present to God, whatever we're doing, that can be the hardest to master. We must keep ourselves from being distracted by the things around us so we can focus on the only thing that matters.

As our focus moves from Mary and Joseph to Jesus, we see he is propped on a roll of wheat while playfully sucking his fingers and looking at his loving Mother. This seemingly innocent gesture could focus our meditation on John's theological reading of the Incarnation as the Word spoken by the Father. Or it can remind us of Jesus' prophetic mission as the preacher of truth and the one who will convoke his followers and form his Church with his instruction and revelation. Just as the Child Jesus responds to his Mother's loving gaze, so will our Lord respond to us when we go to him in prayer or gaze at him lovingly during adoration of the Blessed Sacrament.

In the line of sight between Mary and Jesus are *"EGO SUM LUX MUNDI!"* (I am the Light of the World!). Jesus' spiritually rich statement enables us to interpret the painting and the event of the Incarnation in one phrase. He is the light coming into the world that will enlighten the hearts of all people and cast out the darkness of doubt, fear, and confusion.

The angels in heaven watch over and are involved with the mystery playing out below them. This is indicated by the arrangement of the angels in heaven, all looking down upon Jesus and holding the heavenly choir sheet. Their roles are to praise God and lead us to adore Jesus with them. Turn your attention to the Latin phrase stenciled in red that runs horizontally through the center of the painting: *Venientes Gentes Adorare Dominum*, the "People Shall Come to Worship the Lord."

Angels make themselves present in all the key moments of our redemption.

That is what the angels in heaven lead the shepherds to do. While out in the field with their flock, the pastors are interrupted by the angel of the Lord, who says in our Scripture passage, "Do not be afraid; for behold, I proclaim to you good news of great joy that will be for all the people."

The angel comforts them by inviting them not to be afraid and then proclaims the good news. The shepherds' response is to go in an adoring procession to see Jesus: "Let us go, then, to Bethlehem to see this thing that has taken place, which the Lord has made known to us."

Angels are all around Jesus' life and—as we will see—they make themselves present in all the key moments of our redemption. They accompany Jesus and are at his service while also reaching out to us. Keep your eyes open today to see how angels are reaching out to lead you to Jesus!

PRAYER AND REFLECTION

Glory to God in the highest, and peace to his people on earth! Lord God, heavenly king, Almighty God and Father: We worship you, we give you thanks, we praise you for your glory. Amen.

🙞 How often do you get distracted by your surroundings when you should be focusing on God? Like Ghirlandaio, try to ease out distractions so only God attracts your attention.

🙞 Angels come to lead us to Jesus so we can worship him together. How have angels been at work in your life?

🙞 We need both the silent meditation of Joseph and the active attentiveness of Mary. Which style is easiest for you? Which is the most difficult? How can you adjust your prayer life so both ways work for you?

～ *Spiritual Exercise* ～

🙞 The next time you find yourself in silent prayer, let Jesus take up all of your attention. Let the rest of the background fade away. Let Jesus take the foreground. Let his light enlighten you.

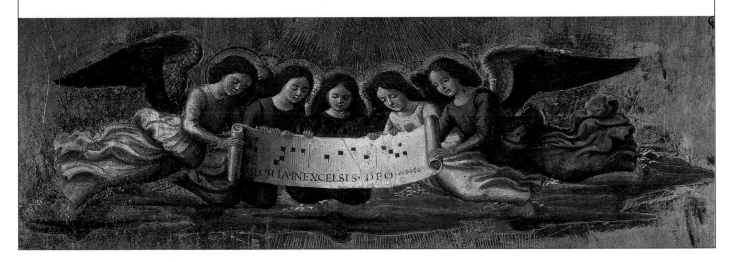

Bartolo di Fredi (circa 1330–1410) was a Sienese painter who studied under Ambrogio Lorenzetti. Bartolo is well-known for his two fresco cycles in the lovely Tuscan town of San Gimignano. One series deals with Old Testament subjects and can be found in the Collegiata (1356) and the other is in the church of San Agostino and depicts the birth and death of the Virgin (1366).

Bartolo was the most successful Sienese painter of the later fourteenth century. He shared a workshop with Andrea Vanni and produced a large number of altarpieces and frescoes. On some of his most important commissions he worked with his son, Andrea di Fredi. In addition to these, he also collaborated with other artists on mural and altarpieces and polychrome sculptures. Today's painting is taken from one of these collaborations.

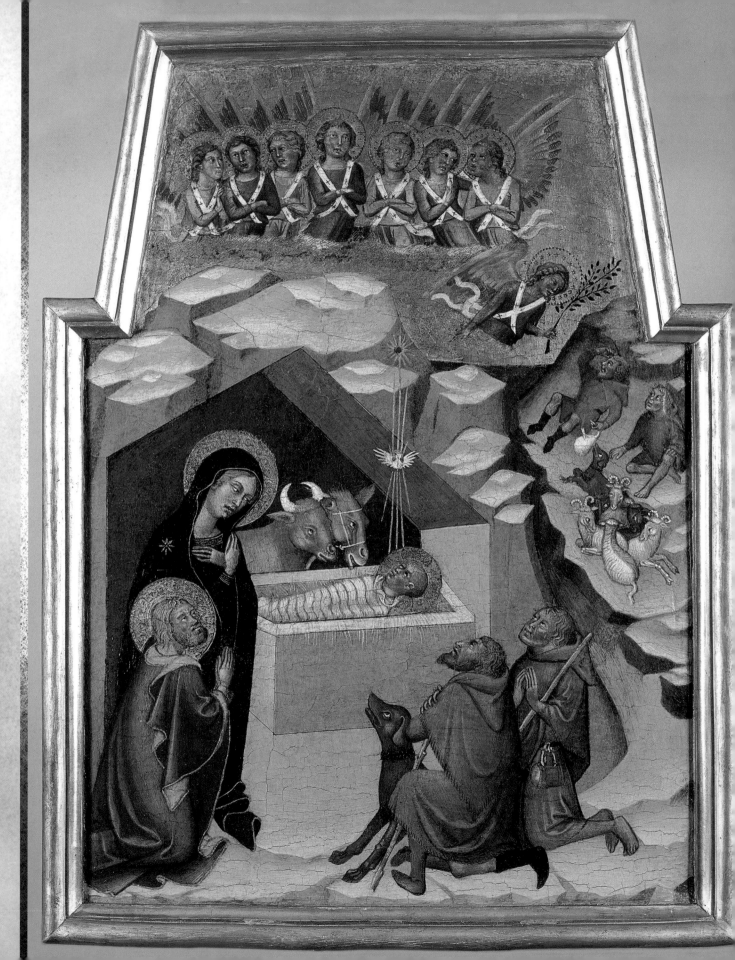

DAY 8

NATIVITY AND ADORATION
OF THE SHEPHERDS

Bartolo di Fredi
1383

THEME: Angels adore Jesus.

FOCUS OF THIS MEDITATION: Angels share in our celebration of Christ the Lord.

◄ Taking a careful look at this small panel, you can identify the most well-known iconographic composition of *Nativity and Adoration of the Shepherds*. The Virgin Mary and St. Joseph are depicted in a cave in front of the Child Jesus, who is swaddled and lying in a manger. A dove and a star appear above Jesus to enlighten him and to represent the Trinity.

The Virgin, upright and with her arms folded across her chest, is painted in a higher scale than the other characters to indicate the devotion that drives her to the Lord. St. Joseph kneels with clasped hands. Beside the Virgin, the ox and the donkey warm Jesus with their breath, as described in the apocryphal Gospel of Pseudo-Matthew, while the shepherds kneel in front of the manger. On the right side of the painting,

the scene of the annunciation by the angel to the shepherds is represented in a smaller scale. One of the pastors is portrayed covering his face with one hand, showing surprise and fright of the apparition, while holding a bagpipe with the other.

The angel who appears to these shepherds brings the news of the birth of our Lord and holds an olive branch, symbol of peace and celebration. A choir of angels, shown only from the waist up, is arranged in a semicircle and caught in the act of singing and emerging from clouds. This work therefore represents not only the Nativity and adoration of shepherds but also the scene of the annunciation of the birth of our Lord heralded by the angel to the shepherds, according to the Gospel of Luke 2:7–18.

SCRIPTURE MEDITATION

HEBREWS 1:1–4

In times past, God spoke in partial and various ways to our ancestors through the prophets; in these last days, he spoke to us through a son, whom he made heir of all things and through whom he created the universe, who is the refulgence of his glory, the very imprint of his being, and who sustains all things by his mighty word. When he had accomplished purification from sins, he took his seat at the right hand of the Majesty on high, as far superior to the angels as the name he has inherited is more excellent than theirs.

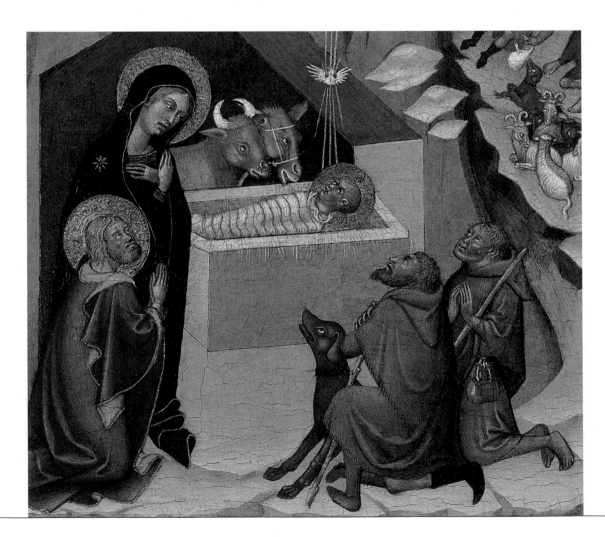

*I*n today's meditation, we turn to a theological interpretation of the Incarnation from the Book of Hebrews. The author is interested in proving the divinity of Christ and chooses to talk about angels to accomplish this. In the first chapter of Hebrews, the sacred writer insists that the Lord wasn't just another prophet or angel sent by God, but he was the very Son of God himself. For if angels adore him and are sent to announce his coming, then certainly he is superior to the angels.

Hebrews continues by saying that God has spoken through Jesus Christ, created the world through him, that Christ shares the very imprint of God's being, and sustains all of creation. There is little doubt about what the author of Hebrews believes about the divine nature of the Son of God. And the angels attest to it all. They are his fiery ministers and the winds that accompany him.

Angels in the New Testament serve Jesus, speak about him, direct others to him, and console him in his passion. In the Old Testament, angels principally spoke on behalf of God, yet right at Jesus' birth we notice an adjustment. They are sent to announce his arrival and lead everyone to the Son.

And who are the first to whom the angels speak? The poor and humble. Mary, Joseph, and now the shepherds.

We need to be poor in spirit, unattached to ourselves and fully attached to him and his will in order to hear the voices of the angels God sends us. Our hearts need to be like the cave in Bethlehem—just enough room for Jesus, Mary, Joseph, and a few friends focused on Jesus. If our hearts are simple spaces—without the distracting noises of all those gadgets, agendas, meetings, and worldly commitments—then the angels can arrive and speak to us, leading us to the crib. Don't be afraid to simplify your life and get rid of a few things that crowd your cave and keep the angels, and the Baby, away.

This particular painting comes from a polyptich on the life of Mary, and due to the form of the frame, it seems to be the painting that sat at the top of the group. Notice that angelic choirs sit at the top of the painting. It is beautiful to think that angels sit atop the story of your life as well.

There in heaven, they announce the blessings to come upon you and are there all throughout your story to lead you to Christ.

The humble shepherds to whom the angels sing appear in two scenes. The first is on the hill watching over their sheep. They are lying on the ground with their sheep when the angel arrives with palms of peace to proclaim the good news. They are getting up to hear this amazing tale while the dog keeps the sheep together in a group. Their simple hearts are open to the good news, and they easily take the road that leads to the manger.

Upon arrival, the shepherds assume a humble posture, kneeling before Jesus at the manger. One has his hands joined in prayer while the other crosses his arms. Try to imitate their attentive hearts as you enter into dialogue with Jesus now. They seem to look up toward the Holy Spirit floating above and to the divine star with the angels on high. The dove and star over Jesus direct our prayer to the Trinity and indicate his divine identity, to which the shepherds bend reverent knee. He is not just any child, but the Son of God and the one sent by the Father in the Spirit to redeem the world, just as the angels have told them.

The dog, man's best friend, is faithfully imitating his master's adoration of Jesus. He also looks up toward the Savior and rejoices at his coming. In the image of the happy shepherd dog, I like to see a little angel as well. The animals in our lives comfort us when we need company, show us affection when we're alone, and listen to us as we talk to them or ourselves. They also defend us. Countless people owe their canine friends for more than a few acts of protection.

The angels stand close to the side of Jesus in adoration and faithful service. They are messengers sent to keep us wandering sheep close to the Shepherd. They are by our side day and night, keeping watch over us for Jesus. They also fulfill a role of consolation and protection if we turn to them and allow them to guide us.

PRAYER AND REFLECTION

Joyfully, let us rise and join in the songs and adoration of the angels. Like the shepherds, let us humbly approach the Lord. Amen.

- If the angels of the Lord came to you today and asked you to drop everything and go see Jesus, would you be able to do it or would you need to get things in order first?

- The animals came to celebrate the birth of Jesus even though they could bring no material gifts. God has given us all gifts that we alone can give back to him. What can you bring the Baby Jesus that can't be bought in a store?

- It is the purpose of angels to be ministers of God's word. Who in your life needs to be reminded of that message? Say a prayer for God to send one of these angels into that person's life as a reminder of God's heavenly peace.

➤ Spiritual Exercise ➤

- Simplifying your life can be a demanding and intimidating task. You may rebel against the idea of even thinking about it! But you don't have to simplify every part of your life all at once. Pick an area you don't find too intimidating and clear out the clutter so Jesus has a place to rest.

In the early Church, the feast of the arrival of the *Magi* (Epiphany) and the Baptism of Christ were celebrated together. Jesus' revelation to the nations, symbolized by the wise men from the East, and his baptism which began his mission *ad gentes*, were united together. The principal symbol for both of these events was light, given that the light of the star led the wise men to Jesus, and he had come to lead all men to the light.

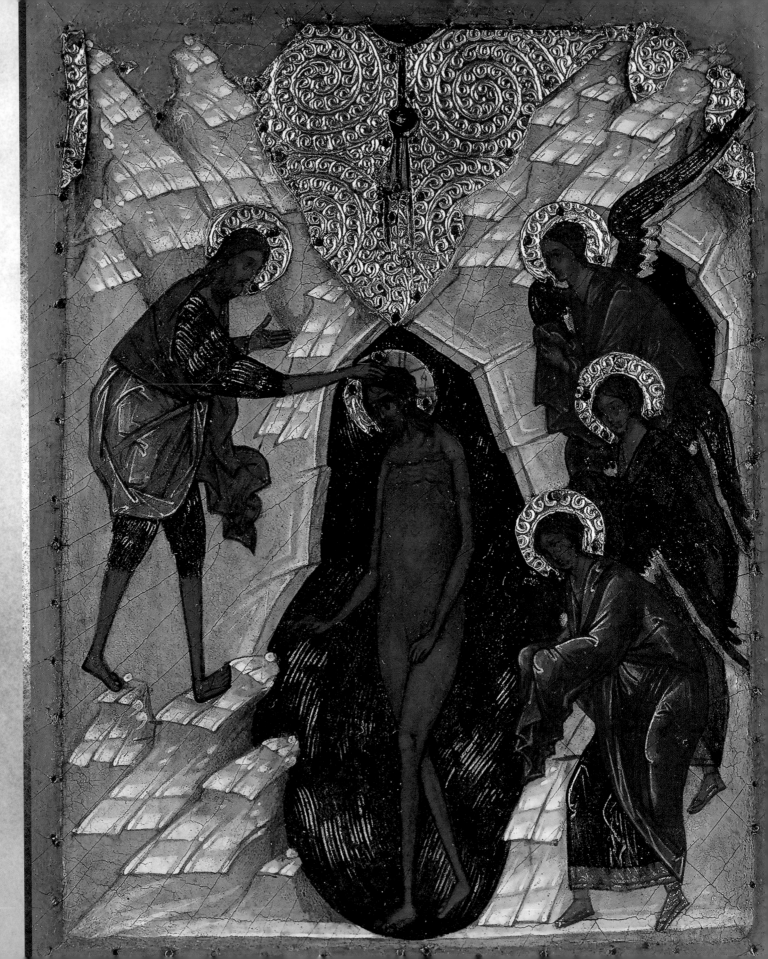

DAY 9

THE BAPTISM OF CHRIST

Russian Novgorod School
Early sixteenth century

THEME: The baptism of Jesus

FOCUS OF THIS MEDITATION: We receive new life and new creation in Jesus Christ through baptism. The angels accompany Christ in this glorious moment and his subsequent period of purification in the desert.

◄ An icon is a sacred representation painted on wood, typical of Byzantine and Slavic origin. In the Byzantine Church's tradition, the icon has a special meaning: specific traditions guided the creation of the painting, including the preparative work, materials used, symbolism, and the order and place in which the work would be displayed. Theological tradition holds that icons are works of God himself realized through the artist's hands. That is why this icon, as well as others, were never signed by their artists. It was considered inappropriate to place the name of a person, who was merely the instrument of God, on an icon as its creator.

This baptismal scene shows John the Baptist on the left and a trio of angels to the right. Traditionally in iconography, angels are depicted on the right side, and while they are not mentioned in the Gospel account, the artist has included them in keeping with the Eastern style. You may also notice the position of Jesus' feet, showing him taking a step forward. This can be found in other icons of the baptism around this time, and a similar position can be seen in icons of the ascension.

Icons were painted on wooden boards, usually made of linden, larch, or spruce. The surface was carved down a bit (this area is called a chest or ark) in order to leave a raised frame around the edges. The frame, in addition to protecting the painting, represented the separation between the earthly and the divine in the plan of the icon's representation. The frame and the ground of this work, colored using ocher pigment, were intended to be covered by an ornamental sheathing in order to show only the central scene.

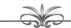

SCRIPTURE MEDITATION

MARK 1:9–13

It happened in those days that Jesus came from Nazareth of Galilee and was baptized in the Jordan by John. On coming up out of the water he saw the heavens being torn open and the Spirit, like a dove, descending upon him. And a voice came from the heavens, "You are my beloved Son; with you I am well pleased." At once the Spirit drove him out into the desert, and he remained in the desert for forty days, tempted by Satan. He was among wild beasts, and the angels ministered to him.

Are you like the angels in the painting, constantly adoring God and spreading the message of his love?

The rocky landscape of this icon has four mountain peaks, which seem to stylistically fill the void of the upper section of the icon and, at the same time, are distinguishable only at their highest point, while the rest of the conformation of their bases is unitary. All the characters of the icon rest upon this level, at the foot of the mountains. The four peaks represent the evangelists. Upon their testimony "rest" the principal mysteries of the Christian faith, which, in turn, form the basis and foundation of their writings.

On the right side of the baptism icon, three angels appear with veiled hands as a sign of adoration and veneration. Their presence indicates that angelic creatures recognize man and God in Christ, their Lord and master. These angels have their hands concealed by the sleeves of their mantles, adopting a sign of reverence used in the Oriental Imperial Court and the Byzantine liturgy. This tradition of reverence and respect survives in our Roman liturgy when the priest uses the humeral veil to cover his hands when giving the Eucharist benediction. It is a wonderful reminder for us who often get too used to God's presence in our lives.

Christ is at the center of the iconographic representation. He is naked and surrounded in a womblike space; his nakedness is not the result of a stylistic choice of realism. It works to convey the idea that this moment is a renewal or rebirth. Christ is the new man who is born again by God. Christ seems to spring from the created elements as naked as Adam was when he sprung from God's creative word. He, in truth, is here as Adam; he is the new Adam. And all who pass through the death and immersion and the new life of baptismal resurrection are new creatures in him.

It is important to note Christ's right hand: He gives a gesture of blessing of the waters even as they are blessing him. This is the same gesture that occurs in many icons representing creation. God is shown in the figure of the Son, for only the Son has taken on flesh and can be seen. He blesses the first waters that covered the earth in Genesis. The regenerative waters that were blessed by the creative word of God and brought life to the first man are capable, with God's blessing, of bringing life to all men in Jesus Christ.

Generally in baptism icons, Jesus is fully immersed. We have already said how these waters can appear as a life-giving womb, but they are also meant to recall a sepulcher. They form a dark cave and appear as a hell: After his death, Christ went down to the underworld to recover those

created in his divine image among the dead. First among them was Adam himself. And upon emerging from his own tomb victorious, Christ vanquished death and removed its sting. We are invited to let Christ swallow up the areas of death in our lives in order to resurrect to the new life he wins for us.

In the waters of the Jordan, which are depicted as a vortex of greenish waves around the figure of Christ, are marine animals—specifically fish. These sea creatures actually represent the "evil" creatures that lurk in the deadly depths of water. The Byzantine Church practices baptism by immersion, which faithfully represents the same itinerary of Christ's death and resurrection. John Chrysostom says, "Going down into the water and emerging again are the images of the descent into hell and the resurrection."

In this icon, John the Baptist raises his hand to the sky, signifying his attempt to avoid the task he has been given: to baptize Jesus Christ, the Son of God, when he is not even worthy of untying his sandals. John is clothed in camel skins, wearing a leather belt and wrapped in a cloak: He is the figure of the old man in need of regeneration. The old man, the first Adam, is now saved by the new man, the new Adam, Jesus Christ.

When in your life have you raised your hand to God, trying to forgo a task that seemed too difficult or intimidating for you? Did God take this task away or ask you to go through with it anyway? We can learn a lot from John the Baptist here. Even when we are not worthy, God can say the words to make us so. God may not take away the uncomfortable tasks, but he will give us the grace necessary to complete them.

We, too, must be humble enough to recognize this humble man, the Son of God. Like the angels, we must look on in adoration and bowing respect. And we must die with him so we can also rise with him. This passage of new life begins in baptism but continues into the desert where the angels wait on him. Think back to your own baptism, the beginning of your personal faith journey. How have you upheld those vows in your life? Are you like the angels in the painting, constantly adoring God and spreading the message of his love, or do you need to be reminded of the greatness of God?

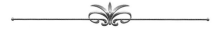

PRAYER AND REFLECTION

Dear God, thank you for the gift of your grace I received at baptism. Help me to remember and recall that grace when I come to the deserts of my own life, send your angels to help me when I stumble, and keep me on the path that leads to you. Amen.

❧ Where could you use some light in your life? Take time in silent prayer to ask Jesus to illuminate the right path for you.

❧ We are not worthy to untie Jesus' sandals, yet he died for us! When was the last time you reflected on this mercy? When has Jesus asked you to be greater than what you think you are?

❧ Reflect on your own baptism. How does the Holy Spirit move in your life now?

Spiritual Exercise

❧ Meditate on this mystery of Christ's baptism, death, and resurrection. Think about an area in your life where you need to be refreshed and use that change as a chance to renew and strengthen your faith.

The reasons for the resounding success of Sebastiano Conca (1680–1764) can be drawn from his affiliation with great painters and his ability to mediate the different stylistic components of his time. His ability in depicting scenery, grandiloquent and grandiose, was learned over years of apprenticeship and collaboration with Solimena, and his mastery of composition was influenced by the reformed classicism of Carlo Maratta, whom he was able to access more directly once he moved to Rome.

This painting and its pendant entered into the Vatican Picture Gallery in December 1913, along with a group of paintings donated to Pope Pius X by the Sacred Congregation for the Propagation of the Faith.

The artist's signature, "Eq. Seb. Conca/fec. Rom. 1746," inscribed on the lower right rock, was discovered during the last restoration of the painting.

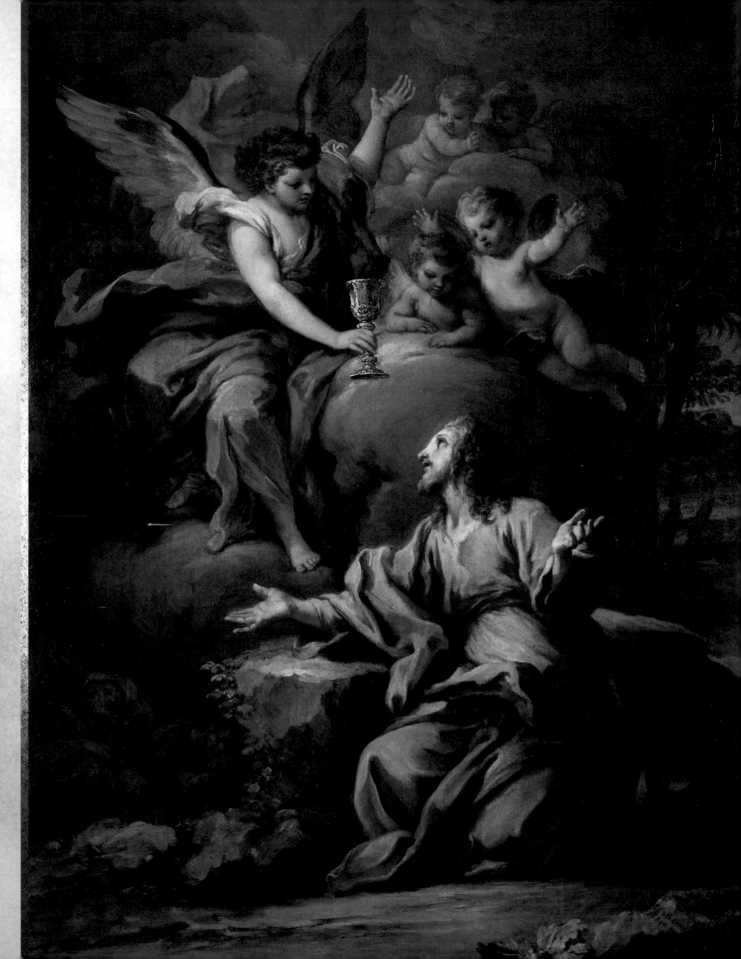

CHRIST IN THE GARDEN OF GETHSEMANE

Sebastiano Conca
1746

THEME: Angels in the Garden of Gethsemane

FOCUS OF THIS MEDITATION: Even in our darkest times, the angels of the Lord provide light and hope.

◀ In this painting, which is a pendant to *Deposition From the Cross*, Sebastiano Conca successfully blends this Baroque wealth of activity with a symmetrical, classicizing composition centered on the spiritual devotion between Christ and the angel. Despite the painting's expansive scale, his brilliant handling lends a devotional sweetness that points toward the Rococo style. Conca's style, characterized by its concreteness, becomes—particularly in connection with the varying conceptions of light—soft, warm, and spiritual. Jesus is transfigured into a mystic key by the elegance of color, the peculiar brightness of dawn, and the softness of the brush strokes.

Jesus is depicted praying in the barren, rocky landscape of Gethsemane. On his knees, the Savior leans with one arm to a raised spur, which looks like an altar. Light surrounds and mitigates the naturalism present in every element of the representation: the clouds, extraordinarily delicate and aerial, appear iridescent and are made pearly by the glow of the sunrise and the angelic glow, evoked by the prayers of Christ, offering the grail to Jesus. Christ's face beatifically reflects the heavenly light emanating from the angel, who holds a goblet and shades his eyes in the foreground. The angel has characteristics of the ethereal but at the same time is also a material apparition.

In the left corner, the apostles sleep, while on the other side, in the distance, one can observe a glimpse of the exotic and lush landscape. Christ is dressed in bright colors that isolate him from the darkly robed apostles sleeping among the rocks, camouflaged in the shadows—a prefiguration of the inevitable events about to unfold. The dark, twilight atmosphere of the setting advances the drama of the event through color contrast.

SCRIPTURE MEDITATION

LUKE 22:39–46

Then going out he went, as was his custom, to the Mount of Olives, and the disciples followed him. When he arrived at the place he said to them, "Pray that you may not undergo the test." After withdrawing about a stone's throw from them and kneeling, he prayed, saying, "Father, if you are willing, take this cup away from me; still, not my will but yours be done." And to strengthen him an angel from heaven appeared to him. He was in such agony and he prayed so fervently that his sweat became like drops of blood falling on the ground. When he rose from prayer and returned to his disciples, he found them sleeping from grief. He said to them, "Why are you sleeping? Get up and pray that you may not undergo the test."

*F*ocus in on the center of this painting and you will see that you are drawn to the gaze between Jesus and the chalice the angel is offering him. Sabastiano understands that the essence of the agony in the Garden is Jesus before the bitter cup the Father extends to him through the hands of the angel.

It is a single moment in his life, a mere few hours after the Last Supper. Jesus is now presented with the reality of his betrayal, judgment, passion, and death, just a few minutes away. This is the moment of truth, the moment of acceptance and his last chance to prepare for all that awaits him. It's these dramatic moments of suffering that bring life sharply into focus. What would you do if you knew you were in your final hours? How would that realization affect the choices you make between now and then?

The angels in heaven are embraced in the golden hue that runs throughout the painting. There is a strong unity of palette broken only by the rose and blue of the vestments of Christ. The hand gesture of the angel, arm upraised, seems to indicate that the cup being offered comes from above, that it is God's divine will. The angel is merely offering the chalice to Jesus for him to accept. The choice to take it is still up to him. In these gestures, especially in his acceptance, we can see the deepest meaning of Jesus' passion.

When we think of Christ's passion, we think of all the suffering Jesus embraced, but it's more a sense of passivity. Jesus accepts his passion—he allows it to come to him—and he doesn't run from it. In our own path of holiness, we are also asked to endure a type of passion—those sufferings we don't choose but that God allows us to suffer and invites us to embrace. We allow him to form us and shape us by not resisting or running from those passions.

In Jesus' passivity, he gives his suffering and death for us. This is unlike his ministry up until the agony in the Garden, during which he gives his life for us. We often lump these acts together and miss the distinction. Christ gave his life and his death for us. We give our lives for each other in our activity; we embrace the little deaths by passive acceptance.

Jesus' attitude toward receiving this passion is evident in his open arms. Just like the posture he will assume when he is nailed to the cross, Jesus' arms are outstretched in humble embrace, acceptance, and abandonment even in the Garden. His acceptance has some characteristics that are

important to meditate on. He suffers without resentment. He is not constantly recriminating Judas or Peter or John during his trial or flagellation. After the resurrection, it's all about forgiveness. He never challenged anybody with, "Where were you when I needed you?" Can you give your life over in love without resentment and bitterness?

Jesus' passion was also a great humiliation that he accepted without running. How many wounds do we have that do not heal? Oftentimes, humility is needed to accept those wounds and the humiliation they imply. If we are able to enter into those wounds, accept them as part of the chalice, we can learn from them and gain the spiritual depth and peace we need.

Suffering and weakness, done right, give us moral intelligence. We learn it from our own humiliations. Think of the things that have made you grow in your life. In virtually every case, do you know what brought that depth into your life? Some humiliation you wouldn't want to talk about. Some powerlessness, whether it was before the death of a loved one, a sickness, a lack of acceptance or love, betrayal, or abuse. These sufferings, accepted and assimilated, have made you deep. We see the same in the lives of many of our saints who suffered similar things. They, like Jesus before them, allowed suffering to bring them to compassion, not to bitterness. That's the test.

The setting for Jesus' test, the agony of Jesus, is the Garden. Gardens don't appear very often in Scripture, but they're important. There is the Garden of God's creative love and the Garden of man's original sin. Gardens are a place in Scripture where lovers go and where love is tested. Where does Mary Magdalene, who was the great lover in Scripture, find Jesus on Easter Sunday? The Song of Songs is set in a garden. That's very important in getting to the drama of the agony in the Garden. This is a drama inside of love.

Love requires sacrifice, laying down one's life. It requires purification. Sweating blood in the Garden is about the drama inside of love—the drama that's deepest inside of your loneliness. What's happening in the Garden is a test of love. Jesus knows all this and goes into the Garden to do what Adam failed to do in the first Garden. He goes to pay the price of love. He looks at the chalice, the price of our salvation, and with a heart full of generous, uncomplicated love, accepts the Father's invitation. "Not my will but yours be done."

PRAYER AND REFLECTION

"Father, if you are willing, take this cup away from me; still, not my will but yours be done."
Amen.

⚜ How would you respond if God asked you to give your life for someone you love?
Would you respond the same way if he asked you to do so for a stranger or even an enemy?
Think about these different responses and then think about Christ's response.

⚜ We often feel that putting up with small annoyances (getting cut off in traffic, working
with an annoying coworker, being last in a slow line at the store, etc.) is more than we can
take. How can you take these moments and use them as opportunities for accepting love?

⚜ Think about the apostles, hiding in the shadows of the painting and falling asleep as Jesus
prayed. What would you do in their situation? How do you respond when others come to
you for help and support?

➤ *Spiritual Exercise* ➤

⚜ Everything we do should be for love of
God, but suffering, sacrificing for God is
not an easy task. We can, however, actively
try to suffer with love. The next time you
find yourself frustrated or overburdened or
struggling to understand the obstacles in
your path, think back to Jesus' words and
make them your own. "Not my will but
yours be done."

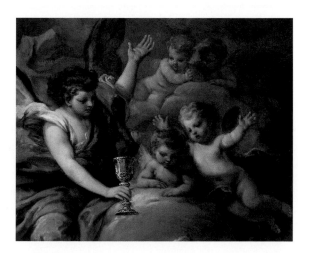

THE TRINITY WITH THE DEAD CHRIST

Ludovico Carracci
1590

THEME: Angels at Christ's death

FOCUS OF THIS MEDITATION: Angels will be his escorts on the last day!

◀ In this painting, Ludovico Carracci both articulates and explores the theological-iconological scan, which starts in choosing *The Trinity With the Dead Christ* as the emblematic point of departure. The subject of this painting reveals the iconographic influence typical of the Middle Ages—a profound difference from the style of the Counter-Reformation. Instead of employing the hierarchy of figures in representation—God between the Holy Spirit and Jesus Christ on the cross—Ludovico combines the theme of the Trinity with that of the deposition. Christ is welcomed by paternal arms instead of those of the Virgin and is surrounded by angels who support the symbols of the passion. The perspective from below, the accuracy with which characters are portrayed, the definition of chiaroscuro, and the intense fluidity of brush stroke create an atmosphere full of great humanity and strong spiritual intimacy.

Ludovico Carracci's so-called *Throne of Grace* (a name given to a work of art in which the dead Christ appears in the arms of his Father) is mesmerizing. In *The Trinity With the Dead Christ*, the old bearded father, a Catholic priam, holds his disarmed son on his knees, abandoned in a feverish tremor of limbs, while the contrite angels try to help him. The pictorial style of Ludovico was always lower than that of his younger cousins Agostino and Annibale, perhaps because of the mystical setting of his mind, which denied his figures a sense of worldliness.

While a firm naturalist in his figure drawing, Carracci (1555–1619) is inspired by Correggio and the Venetian painters, maintaining some of the Mannerist style that had dominated Italian painting for most of the sixteenth century. His style balances the mannerisms of his piety and the naturalism of the works of his cousins. This painting was annexed to the papal collection at the end of the seventeenth century.

SCRIPTURE MEDITATION

LUKE 23:44–47

It was now about noon and darkness came over the whole land until three in the afternoon because of an eclipse of the sun. Then the veil of the temple was torn down the middle. Jesus cried out in a loud voice, "Father, into your hands I commend my spirit"; and when he had said this he breathed his last. The centurion who witnessed what had happened glorified God and said, "This man was innocent beyond doubt."

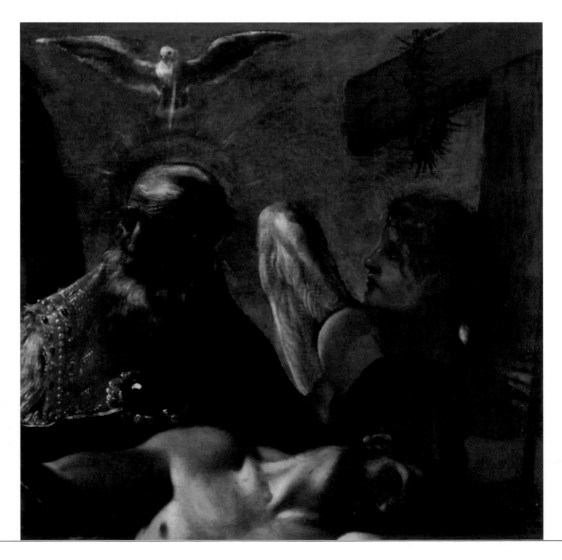

If angels are everywhere in Christ's life, then there is little doubt they are also near him at the hour of his death. They are at his annunciation, at his birth, and during his public ministry. Jesus refers to them often and even promised that they could come to defend him in the hour of his death (Matthew 26:53). They are at his resurrection, confused with gardeners. But they are not just with him in his earthly life. They are there in the moment when his soul leaves his body. This is consoling for us because we can be assured these angels we are meditating on will also be with us at the hour of our own passage from this life to the next.

In today's painting, we have a fantastic reflection on a moment no one has ever seen. Ludovico Carracci imagines that moment, not when Mary takes the corpse of her dead Son in her arms, but rather when the heavenly Father receives the vanquished spoils of his Son's battle for the salvation of humanity.

It is something we hardly ever meditate on—the suffering of the Father at losing his Son. That loving relationship between the Father and the Son seemed to be broken, even if only for a moment. Theology has often struggled with balancing the idea of a loving and caring God who no doubt suffers with us and at the same time protecting the divine nature that is totally other, totally full of being and unable to suffer in a way we can understand. Yet Carracci focuses on that popular intuition that the loving Father and Holy Spirit suffer the loss of the Son. In this dramatic painting of *The Trinity With the Dead Christ*, we can meditate on the suffering of the divine Godhead in achieving our salvation.

Our faith teaches us that God willed his only begotten Son should become man to suffer and die for the salvation of humanity. This divine decision manifests both the justice and the mercy of God. It manifests his justice because it shows that God has actually required satisfaction for the sins of men. Yet it manifests his mercy because no one but one fully God and fully man could have offered a suitable satisfaction for the debt incurred. Because he was God, Christ could offer God an infinite satisfaction for the infinite offense of our sin. Because he was man, Christ could offer a man's satisfaction for humanity's sin. The Trinity was in the very heart of the plan of redemption, and they paid the highest price for its achievement.

It is a terrible suffering for the parent any time a child passes away first. My own family lost my older brother at the end of his teenage years, and I remember how terrible it was to see my

parents grieve the death of their son. I was too young to fully appreciate it, but I distinctly recall their pain. Imagine the Father who willingly sends his Son to the cross, sacrificing one Son to gain life for all his other children. The Father's head turns away in grief almost fearing to touch the hands he pierced.

The angels are depicted once again as the celestial witnesses and accompaniment of God in this mystical moment. Each angel handles one of the instruments of Jesus' glorious passion. The angels do not save Christ from his passion but handle the trophies of his victory with extreme reverence. We saw in the life of Christ that the angels served him as they serve God. Their whole beings are focused on and devoted to the Trinity and to witness how the powers of evil came back to strike at the very Son they refused to serve. The angels had personally witnessed Lucifer and his evil spirits condemned into hell by the Father, yet strangely they were given some permission to wound the Son.

In faithful devotion to the obedient and suffering servant, one angel holds the pillar of the flagellation where Jesus subjected himself to the stripes that would make us whole. In the upper right, another winged witness holds the wooden cross like a standard with the crown of thorns hanging from it. These two symbols flank the upper portion of the painting and serve almost as the frame that surrounds the Father and the Holy Spirit. In the lower foreground, the angel closest to us holds up in clear view two of the nails as she turns toward us.

If we were to come up with an epitaph of this moment, perhaps no other words of Scripture would be more appropriate than those of St. Paul: "Rather, he emptied himself, taking the form of a slave, coming in human likeness; and found human in appearance, he humbled himself, becoming obedient to death, even death on a cross" (Philippians 2:7–8).

God the Father is robed in a cope, and some have seen in his face the portrait of Gregory XIII, a contemporary of the painter. The rich decorations of the royal trappings contrast with the nakedness of the Son who was stripped of his divine dignity. Jesus' body is bathed in a warm light coming down from the upper left. He is cradled in the womb of the Father and supported by the cherubs. His resting body shows no signs of his sufferings except the wound in his one hand that rests on the father's knee. This is the moment of rest after the battle.

PRAYER AND REFLECTION

Heavenly Father, you loved us so much you sacrificed your only Son. Let us not take that sacrifice for granted or forget how much it cost you. Hold us in your loving arms at the hour of our death as well, as we are also your children. Amen.

⚜ Our painting today offers a unique perspective of the Trinity. Does it help you understand the great love of God that was behind the death of the Son?

⚜ Accompany the Father and the Holy Spirit in their observing the fidelity of the Son. Give thanks with them. Rejoice with them at the salvation of humanity.

⚜ God is willing to undergo extreme suffering for us, and we are sometimes asked to suffer in our lives as well. How do you handle these sufferings when they come to you or those you love? Are you able to see God even in the unhappy times?

～ *Spiritual Exercise* ～

⚜ There is nothing so heartbreaking as a parent losing a child. Offer a prayer for all those who have lost a child and say a prayer of thanksgiving for the love of your parents and children, and ask God to have his angels watch over them.

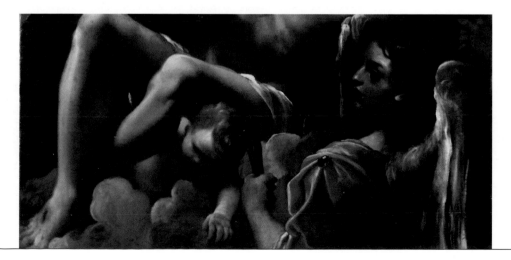

This painting by Domenico Cresti, also called Passignano (1559–1638), expresses the strong influence of the values of the Counter-Reformation on the artist and is characterized by his mature style. Cresti, who lived in Florence for years, attended the workshops of Giorgio Vasari and the Zuccari brothers. Passignano received numerous commissions from various popes, such as Gregory XIII, Sixtus V, and Clement VIII and was also active at St. Peter's Basilica under Urban VIII. This painting, owned by the Jesuit order, ultimately entered the Painting Gallery of Pope Pius VI at the Vatican.

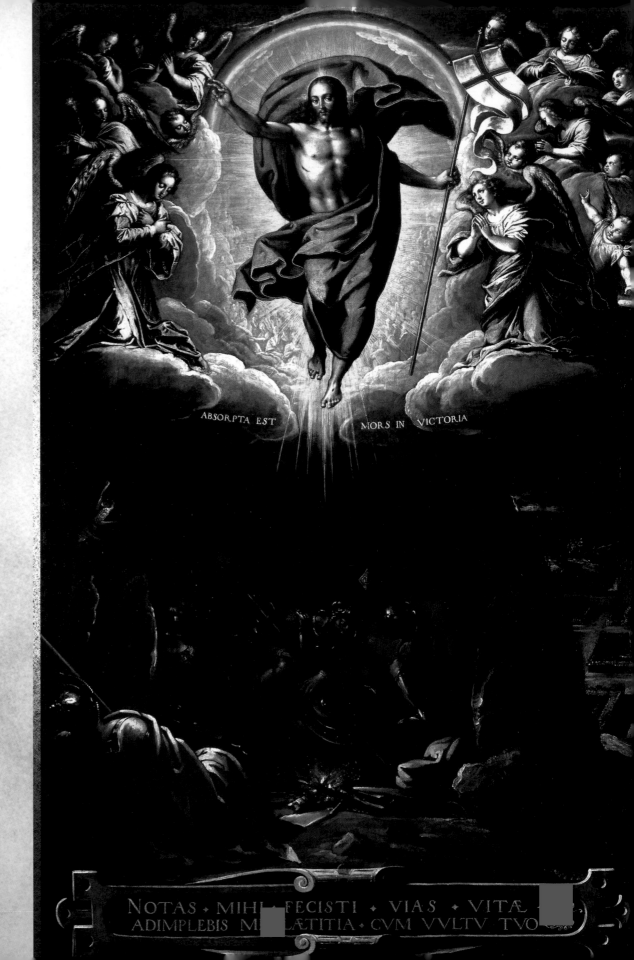

ABSORPTA EST MORS IN VICTORIA

NOTAS · MIHI · FECISTI · VIAS · VITÆ
ADIMPLEBIS M.. LÆTITIA · CVM VVLTV TVO

THE RESURRECTION

Domenico Cresti
Early seventeenth century

THEME: Angels at the resurrection

FOCUS OF THIS MEDITATION: Angels announce Jesus'
triumphant resurrection, bringing light to the darkness of our hearts.

◀ This work of art was created to explain theological concepts following the teachings of the Church. In fact, notably, two quotes from the Bible are written in the lower part of the painting—Psalm 15:11 and an excerpt from 1 Corinthians 15:54. Both passages refer to the episode of the resurrection of Christ, which represents the victory over death and the expression of the glory of eternal life.

In this painting, Cresti creates two distinct sections; the lower and darker one is pervaded by the darkness of the sepulcher. Some sleeping guards, resting upon the rocks, are illuminated by the faint light of a fire about to go out, while a landscape with manicured gardens is visible in the distance, to the right side of the canvas. In the upper section, a radiant Jesus Christ triumphs, surrounded by a host of praying angels and cherubs. It is interesting to note the sharp contrast between lightness and darkness, which is unusual for the structure of the iconographic theme of the resurrection. Here, the dichotomy between life and death is theologically and ideologically emphasized and summarized by the figure of the resurrected Jesus.

The presence of many adoring angels further emphasizes his victory over death, which is supported by further evidence, not only in the passage, *"ABSORPTA EAST VICTORIA MORSIN"* adapted from Paul (death is swallowed up in victory) but also from the words of the psalm.

SCRIPTURE MEDITATION

MATTHEW 28:1–7

After the sabbath, as the first day of the week was dawning, Mary Magdalene and the other Mary came to see the tomb. And behold, there was a great earthquake; for an angel of the Lord descended from heaven, approached, rolled back the stone, and sat upon it. His appearance was like lightning and his clothing was white as snow. The guards were shaken with fear of him and became like dead men. Then the angel said to the women in reply, "Do not be afraid! I know that you are seeking Jesus the crucified. He is not here, for he has been raised just as he said. Come and see the place where he lay. Then go quickly and tell his disciples, 'He has been raised from the dead, and he is going before you to Galilee; there you will see him.' Behold, I have told you."

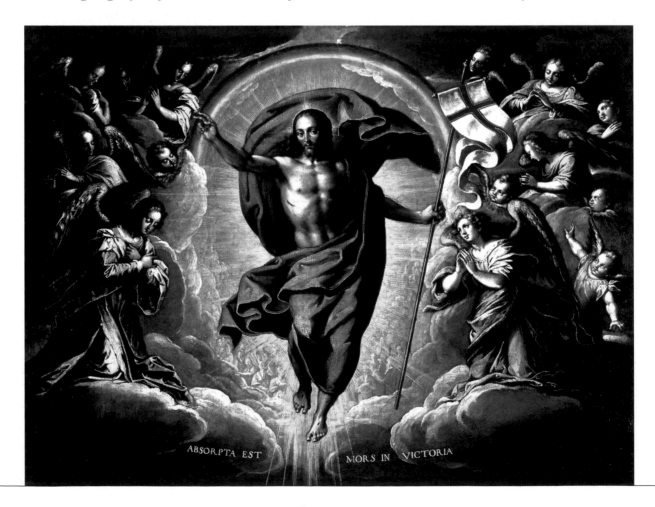

ABSORPTA EST MORS IN VICTORIA

This painting exemplifies a profound resurrection truth. No matter how dark it appears, no matter how bad, we can never give up hope, for God's power is stronger than even death!

Fr. Lorenzo Ricci, the last superior general of the Jesuits before their suppression in 1773, had this painting placed in the chapel of St. Ignatius in La Storta, a few miles outside Rome. The church marked the spot where Ignatius had a vision before arriving in Rome to seek permission to found the Jesuit order. Perhaps Lorenzo placed the resurrection here as a theological symbol of the founding of the order, an effort of Christ to conquer sin and death. Or perhaps he did so in the knowledge of the coming suppression. This very difficult period in the Jesuits' history saw Pope Clement XIV, for political reasons, suppress the activities of the order in the Portuguese and Spanish empires, Malta and Parma.

We all have dark moments of our personal histories when sin, our weakness, or the evil others choose, do us much harm. It seems death will swallow us up, that God has abandoned us, and that faith, hope, and love are impossible for us to achieve, or perhaps faith itself is a dream. The darkness in the lower half of the painting suggests just that—the world of darkness and despair without the light of Christ. The soldiers sleep, the city down below with its manicured but cold gardens is orderly but lifeless. The rotten trunk, gutted of all its strength, symbolizes this barren world where hate has conquered love, death has extinguished the light of life.

Yet even while the soldiers are asleep and unaware, God is working his victory. Indeed, precisely through that death and darkness, Christ was gathering his faithful followers in the underworld and marching them toward a glorious victory. Even in your despair or darkness, God is at work and preparing his victory. Do not let hope be vanquished. Hold on. A new day is dawning!

The beautiful Christ figure is surrounded by light, dressed in a fantastic rose-colored garment that sets him off from the golden sun shining behind. The angels and cherubs cheer and applaud his triumphant arrival upon the clouds of heaven. In his left hand, the Savior hoists the standard of victory, the bloody red cross of martyrdom, set upon the pure white of the resurrection. One barely notices the glorious throng of victors sweeping away under the feet of Christ. He, like a new Moses, is leading them into the promised land of eternal life. The angels who stand at the gate of heaven form almost two gates that swing open upon the entry of the king.

This is the reality in heaven, contrasted with the reality on earth. Yet the light of heaven is bursting through into the world and will overcome the darkness we see there now. Even in your darkest moments you can be sure that God's victory is coming soon. Fr. Ricci never saw the restoration of the Society of Jesus, yet it happened soon after his death, and the Jesuits were able to continue their work, contributing greatly to the extension of the kingdom of God.

The scene in our painting was going on while Peter, James, John, Mary Magdalene, and the other apostles were at home in fear and sadness. The next morning, they arrive at the tomb only to find it open and the body of their beloved Savior no longer in the grave. Victory was being won even as they slept. The same can be true for us. If we have faith, the Lord can bring healing and victory even as we sleep.

"Where, O death, is your victory? Where, O death, is your sting?"

The passage that appears in the clouds, resting on the border between the darkness and the light, is the theological message of the painting. Death is swallowed up in victory. The words that follow these in Scripture are also eloquent: "Where, O death, is your victory? Where, O death, is your sting? The sting of death is sin, and the power of sin is the law. But thanks be to God who gives us the victory through our Lord Jesus Christ. Therefore, my beloved brothers, be firm, steadfast, always fully devoted to the work of the Lord, knowing that in the Lord your labor is not in vain" (1 Corinthians 15:55–58).

The angels who watched over Christ accompanied him in his triumphal entry into heaven and announced his resurrection to the incredulous apostles will also watch over you and lead you every day into the victory that awaits those who believe in the power of Christ's resurrection.

NOTAS · MIHI · FECISTI · VIAS · VITÆ
ADIMPLEBIS ME · LÆTITIA · CVM VVLTV TVO

PRAYER AND REFLECTION

Angel of God, enlighten the darkness of my mind with the glorious light of the resurrected Christ whom you behold. Soften the hardness of my heart with the balm of his goodness and love. Encourage and motivate my will to persevere in my love, held up by the certainty that victory will belong to those who follow Jesus Christ. Amen.

- When was the last time your received Christ's light in the sacrament of reconciliation? Offering our sins up to God can be a truly freeing experience. Allow that presence to enter into your life.

- What is your reality on earth? What about the realities of your neighbors? Those in another country? It can be easy for our darkness to blind us to the darkness of others, but angels are not the only messengers of God. We can bring light to those around us, but only when we look past our own darkness.

- What do you think was going through the minds of Peter, James, John, Mary Magdalene, and the rest of Jesus' apostles in those dark nights before Jesus came back? Did they feel grief or anger? Did they long for someone to ease their pain?

- How do you think they felt on that Easter Sunday morning when Jesus returned to them?

➤ *Spiritual Exercise* ➤

- Even in darkness and despair, there is hope in Christ. Go out today and live in celebration because Christ has triumphed over death. Light is coming to dispel the darkness.

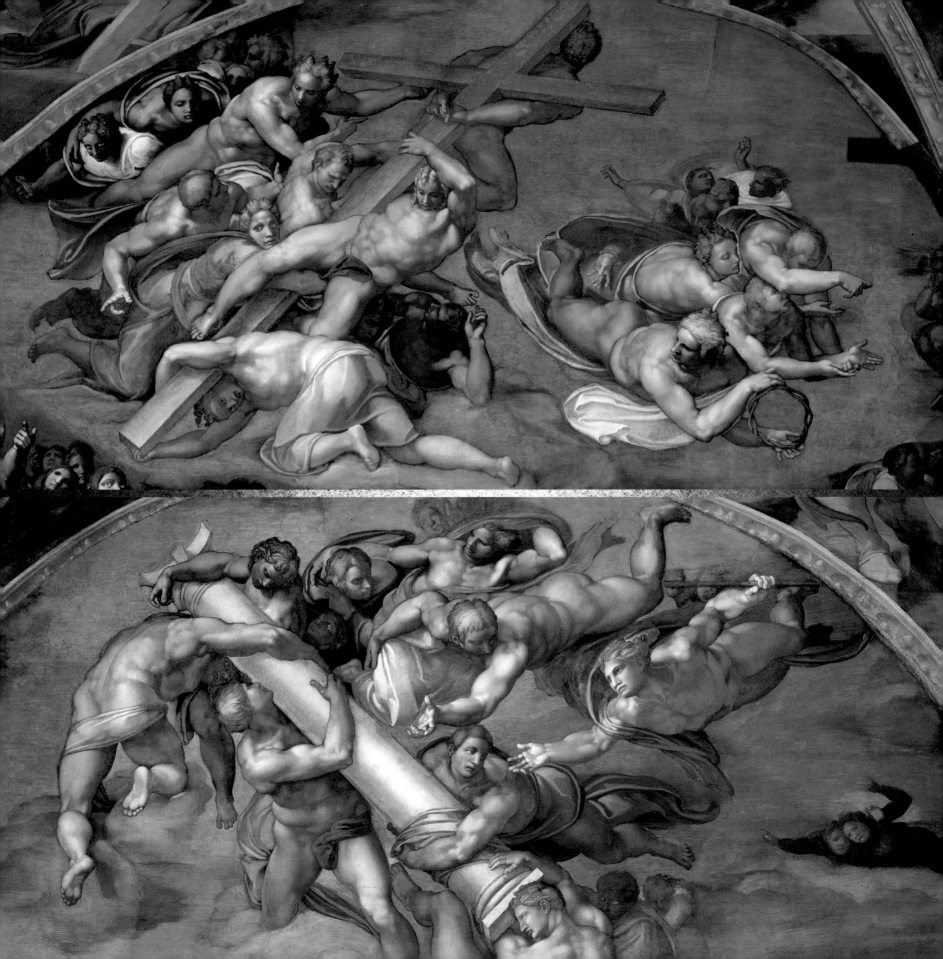

ANGELS WITH INSTRUMENTS OF THE PASSION

From *The Last Judgment* frescoes
Michelangelo Buonarroti
1537

THEME: Angels at the Last Judgment

FOCUS OF THIS MEDITATION: Angels accompany Christ and herald the Last Judgment.

◀ *The Last Judgment* by Michelangelo Buonarroti (1475–1564), painted between 1536 and 1541, is a fresco made to decorate the wall behind the altar of the Sistine Chapel. This monumental work is one of the greatest representations of the Parousia, the last coming of Christ at the end of time to usher in the kingdom of God. The centerpiece of the entire composition is the figure of Christ the Judge with the Virgin at his side, represented in a halo, surrounded by a crowd of apostles, prophets, patriarchs, sibyls, heroines of the Old Testament, martyrs, virgins, and saints who form a double crown of swirling bodies.

The two upper lunettes in today's image are occupied by four groups of angels bearing the symbols of the passion of Christ, symbolizing his sacrifice and the fulfillment of human redemption. They represent the starting point of the viewer's reading of the fresco and predict the feelings that dominate the entire composition. These wingless angels compose an extremely complex view, emerging in the foreground against the backdrop of a bright, ultramarine blue sky.

The views are very bold, and bright contrasts are very pronounced. The expressions of these angels—strained by their exerted effort, with eyes wide open as if in a moment of shocking revelation—reveal one of the new motives in Michelangelo's representation of the end of time: the blessed share in feelings of anxiety, trepidation, and overwhelming, inner loss of soul, all emotions which are so radically different from the spiritual tranquility and inner radiance of traditional exultation depictions.

SCRIPTURE MEDITATION

MATTHEW 24:30–31, 36

And then the sign of the Son of Man will appear in heaven, and all the tribes of the earth will mourn, and they will see the Son of Man coming upon the clouds of heaven with power and great glory. And he will send out his angels with a trumpet blast, and they will gather his elect from the four winds, from one end of the heavens to the other. […] But of that day and hour no one knows, neither the angels of heaven, nor the Son, but the Father alone.

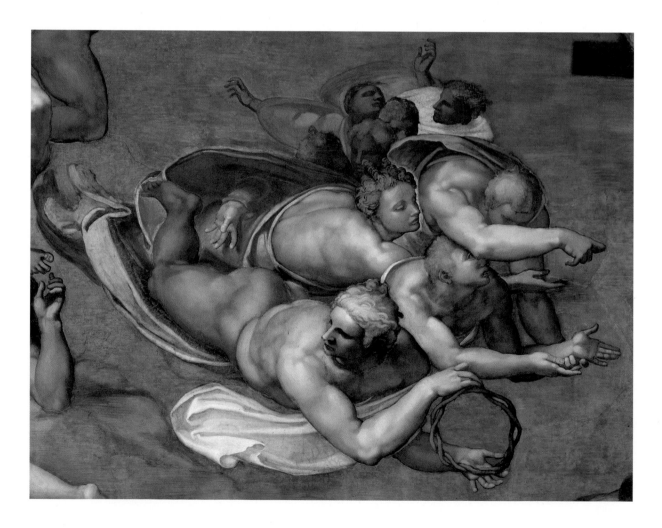

In the painting *The Last Judgment*, Michelangelo was largely inspired not only by *The Divine Comedy* and the hymn *Dies Irae* (Day of Wrath), but also, perhaps even more strongly, by the pages of Scripture, especially the Book of Revelation. From the first line to the last, Revelation is a constant barrage of awe-inspiring angelic superheroes declaring messages, passing out wrath, crushing the dragon, defending the elect, sounding trumpets of judgment, and celebrating the arrival of the Son of Man.

Angels With the Instruments of the Passion specifically shows us how Jesus won the right to judge and how we will also reign with him. Because he loved until the end, he laid down his life for us while we were yet sinners, Christ earned the right to judge all humanity. And we, if we are united with him in a death like his, will also share in a resurrection like his. The instruments of his passion are the reason for his victory and, in fact, are the reason for the victory of all those present in heaven.

In the right lunette, some angels hover in the sky, attempting to raise the column of flagellation, dynamically intertwined in a formation symmetrical with the opposite side of the bezel. This time, there are five main figures in the transport, in addition to some figures in the shade and other angels who are rushing in flight. At the top, a young man who appears to be seated holds the capital of the column. To the side, one holds the trunk on his shoulder, bending his back and showing, in the dim light, an upturned face with wide-open eyes. Behind them, a blond boy with a powerful physique embraces the column, and a figure to the right wraps the column in a cloth, while a naked boy, crouching just below, has the difficult task of holding its base.

Other angels flock to the right: Two of them have intense eyes and are wrapped in drapery, and two are naked, including a dazzling blonde angel holding the stick that was used to give Jesus the sponge with vinegar.

Further back, the scale used to depose Christ from the cross is visible. In total, there are ten well-defined figures in the foreground and at least seven out of focus in the background.

The bezel on the left shows the traditional image of the raised cross in the presence of Christ the Judge. A few figures rise among the angels holding the cross—the angel on his back at the top, the nude one placed crosswise in the foreground, and the one kneeling toward the viewer with his

head thrown back. Each one, like us, struggles to carry the part of the cross of Christ that he is privileged to touch. It is not easy to carry the cross, but one day it will be our cause of glory and our passport into heaven!

Another group of angelic figures whisks toward the center of the fresco carrying the crown of thorns. The king deserves a crown, said the soldiers who tortured him, as one wound some thorny bush branches into a band. Yet little did they know that they were fabricating the crown of glory that would symbolize his regal fidelity to the plan of the Father. Some other figures of the pictorial group stretch out their hands, probably holding the nails of the passion or the dies with which the robe of Christ was held.

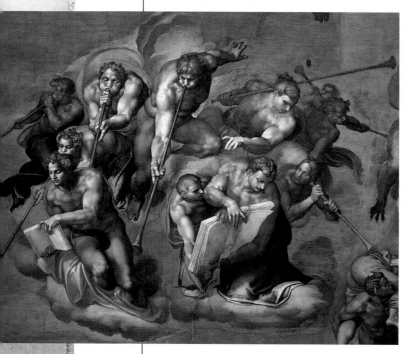

In the center of the fresco is a distinctly apocalyptic image of the seven angels sounding the seven trumpets found in Revelation chapters 6—9. With their successive horn blasts, the purifying wrath of God is set in motion while the Son, who has been given all authority in heaven and earth, arrives in the company of his angels to judge the living and the dead.

The *Catechism* teaches that "the resurrection of all the dead, 'of both the just and the unjust,' will precede the Last Judgment. This will be 'the hour when all who are in the tombs will hear [the Son of man's] voice and come forth, those who have done good, to the resurrection of life, and those who have done evil, to the resurrection of judgment.' Then Christ will come 'in his glory, and all the angels with him.[…] In the presence of Christ, who is Truth itself, the truth of each man's relationship with God will be laid bare. The Last Judgment will reveal even to its furthest consequences the good each person has done or failed to do during his earthly life" (*CCC* 1038–1039).

What a beautiful thought, that the Last Judgment will reveal all the good we did to its furthest consequences. We tend to focus on the evil, and in this last moment we will certainly be ashamed of it all, yet we will also glory in all the good we did!

PRAYER AND REFLECTION

May God's angels help me prepare for the final days and help me become worthy of eternal life with God. Amen.

- What do you feel about the Last Judgment? If the angels came for us today, would you be ready to go or do you still have work to finish?

- Since Christ is shown so often as a figure of sacrifice and mercy, it can be hard to see him as Christ the Judge. Why do you think it is God the Son who is given the role of the judge?

- Reflect on the list of your deeds, good and bad, to be reviewed on the last day. What have you done that would be worthy of praise? What might you need to ask forgiveness for?

- Look again at Michelangelo's angels with their trumpets. Do you find this image celebratory or frightening? Why?

Spiritual Exercise

- Take a moment to examine your relationship with God. If the end were coming today, would you recognize God as an old friend, one who knows your faults and loves you anyway, or would you tremble in fear of his judgment? If your relationship is not as strong as you'd like, take some time and set it aside for God, get to know him, and let him know you.

ANGELS AND MARY

IN THE NEW TESTAMENT, we see that the angels have a special relationship with Mary. She is the first person they go to when preparing for the Incarnation of the Son of God. Christian art, especially in the Renaissance, has paid particular attention to the wonderful spiritual resonance there is with Mary and the angels, the creatures who totally obey the word of the Lord.

When God decides to communicate his most amazing mystery, the Incarnation of the eternal Word, he sends an angel to prepare the way of his precursor. John's birth is announced by an angel to Zechariah (Luke 1:11). And when the fullness of time comes, none other than the angel Gabriel is sent from the throne of God with the mission of preparing the Incarnation. An angel is sent to our Lady to ask for her acceptance. Mary receives the celestial ambassador with humility and docility.

The angels also intervene in Mary's life through her spouse, St. Joseph. In dreams he is told not to fear taking her as his wife (Matthew 1:20). They tell the shepherds to visit the newborn king (Luke 2:9–14). What marvel must have filled Mary's heart when the poor shepherds or the traveling wise men explained how angels and stars told them to come! Later, the angels tell Joseph to flee with Mary to Egypt to avoid the vengeful Herod, who sought the Child's life (Matthew 2:13). If angels were so present in the first months of her motherhood and marriage, you can be sure Mary cultivated this angelic friendship throughout her life as she pondered all these events in her heart.

When her earthly life reached its most painful moments, there must have been angels to console her, just as Jesus had angels to console him in the Garden. The angel had promised Jesus would receive the throne of his father David (Luke 1:32). Would the angel not be there with the Mother of the Savior when he was lifted up on that throne and drew all men to himself (John 19:25)?

Angels were at the site of Jesus' resurrection (Matthew 28:5) to point the searching women toward Galilee and the upper room, where they found the Jesus whom they sought. No doubt Mary was there united with them in prayer and enjoyed the powerful confirmation of her faith by seeing her resurrected Son!

Let's accompany her through all the stages of her walk in faith, hope, and love. Enjoy the angelic presence that was a constant in her life from before the Incarnation, through her Son's passion, death, and resurrection. The angels were at Jesus' ascension and Mary's assumption and coronation in heaven and will be present in heaven for eternity.

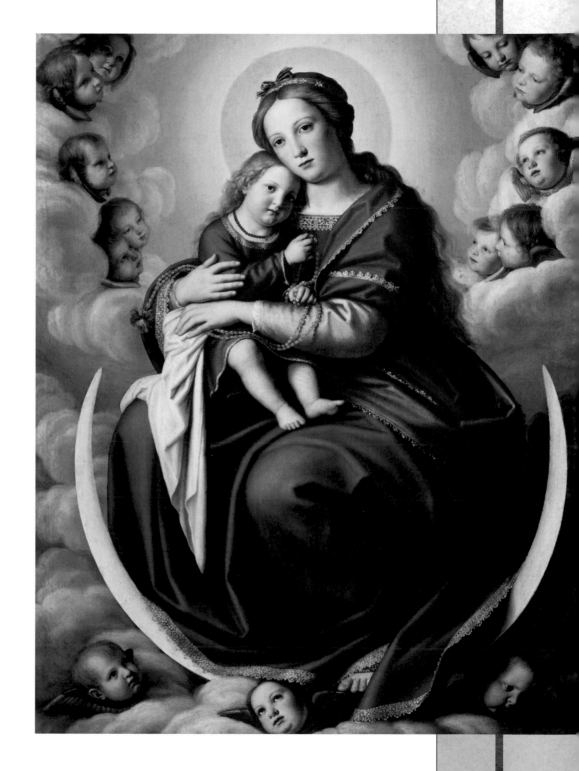

Madonna and Child by Giovanni Battista Salvi (called Sassoferrato) *Section III: Angels and Mary*

The art of Barocci (circa 1526–1612), a member of the Franciscan Third Order, was clearly influenced by his faith. His masterpieces could be considered a sort of *Biblia Pauperum*, or illustrated Bible, as Barocci firmly believed that art functioned to represent the holy Scriptures and illustrate the transcendent presence of God. Many artists, from Rubens to Bernini, found a source of inspiration in Barocci. His art has been significantly important in the development of modern European iconography by virtue of its realistic use of figures, light, and an original use of color. Well in advance of Caravaggio, Barocci made use of bright colors and contrasts of light and shadow to give more expressive power to figures, capturing their humanity with elegant vigor.

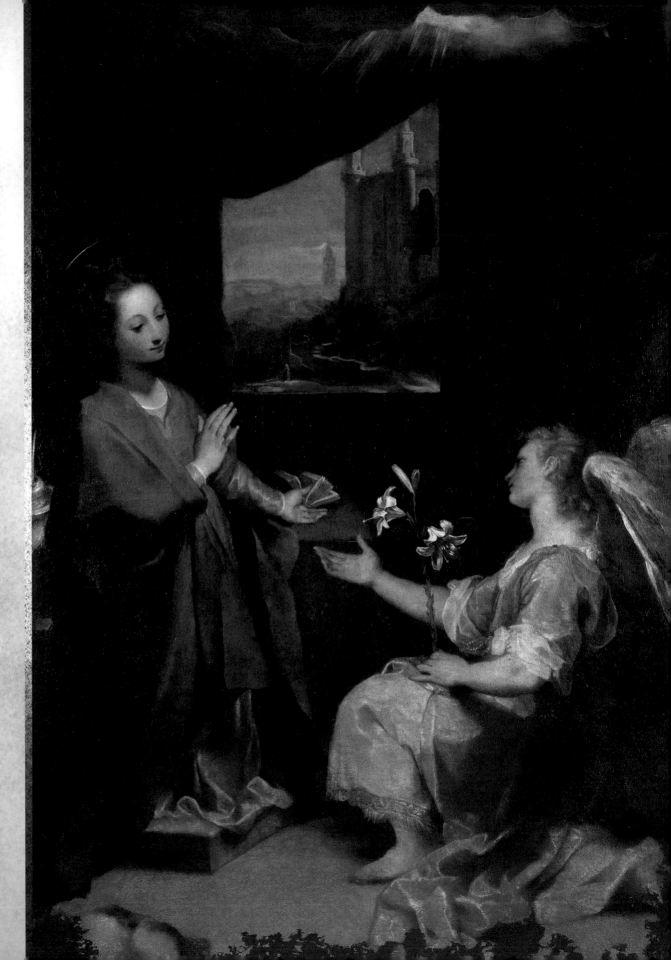

DAY 14

ANNUNCIATION

Federico Fiori (called Barocci),
1582–1584

THEME: Angels and the annunciation

FOCUS OF THIS MEDITATION: The event that changed all human history
and set Mary's life on a sacred course was announced by an angel.

◀ *Annunciation*, commissioned between 1582 and 1584 by Francesco Maria II della Rovere, duke of Urbino, for the Basilica of Loreto, is one of the most famous paintings by Barocci. This composition is characterized by a familiar tone, with the Archangel Gabriel breaking into the scene and distracting Mary from reading. The Virgin, laying the book on the table beside her, leans back a bit in surprise as she faces the angel before her. The refined way through which Federico Barocci outlines the two characters might suggest influences of Correggio. The artist may have known Correggio during a trip to Parma, perhaps accomplished before his second stay in Rome, around 1559. Barocci, religious artist par excellence, was one of the most important interpreters of Counter-Reformation painting as well as one of the most important Mannerist painters of the sixteenth century. His works are characterized by an extraordinary use of color and by atmospheres that

evoke motion and inspire intimate devotion. Each painting is accompanied by numerous sketches and preparatory studies that help scholars follow the laborious artistic process behind each of Barocci's masterpieces, revealing the contrast between the spontaneity, the lightness of the stroke in the finished work, and the meticulous and painstaking preparation and thought invested by the artist.

The painter was, perhaps, a victim of poisoning by jealous colleagues during his stay in Rome. This episode resulted not only in his failing health but in his inability to work long hours in front of commissioned altarpieces. To compensate for this, he minimized his painting time with detailed preparation. For the eighty paintings Barocci produced, he had 2,000 drawings and sketches. Barocci did not put anything on canvas without having first studied it for a long time with careful and meticulous planning.

SCRIPTURE MEDITATION

LUKE 1:28–38

And coming to her, he said, "Hail, favored one! The Lord is with you." But she was greatly troubled at what was said and pondered what sort of greeting this might be. Then the angel said to her, "Do not be afraid, Mary, for you have found favor with God. Behold, you will conceive in your womb and bear a son, and you shall name him Jesus. He will be great and will be called Son of the Most High, and the Lord God will give him the throne of David his father, and he will rule over the house of Jacob forever, and of his kingdom there will be no end." But Mary said to the angel, "How can this be, since I have no relations with a man?" And the angel said to her in

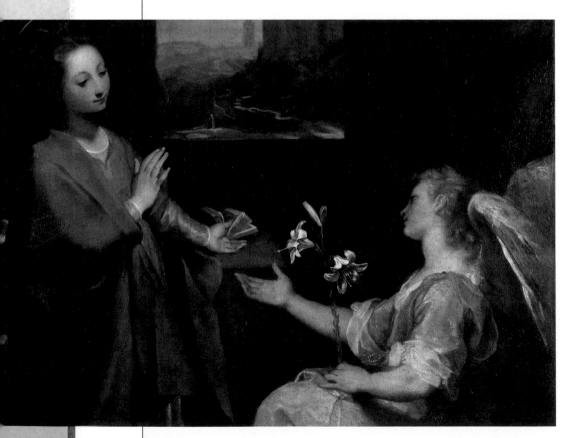

reply, "The holy Spirit will come upon you, and the power of the Most High will overshadow you. Therefore the child to be born will be called holy, the Son of God. And behold, Elizabeth, your relative, has also conceived a son in her old age, and this is the sixth month for her who was called barren; for nothing will be impossible for God." Mary said, "Behold, I am the hand-maid of the Lord. May it be done to me according to your word." Then the angel departed from her.

As you focus your mind and heart on today's meditation, forget about all other things you have to do today. You are now totally present to God, who wants to be with you for this time of prayer. What might be concerning you now? That, right there, is what you need to put aside to focus on God.

The deep perspective of the painting makes us feel part of the work itself, a guest at the house of the Virgin. Through the window the towers of the ducal palace of Urbino are visible; this view of the city was the same seen by Barocci from his studio. Our meditation is even more rich when we allow our imagination to enter into the biblical scene, so use the details of the painting to help you imagine the little room of our Lady and what she might have been doing when the angel arrived. Was she at work? Praying? Sleeping? No matter what, she was certainly not expecting an angelic visitor. God often erupts into the intimacy of our lives when we least expect him. Angels are not on our list of appointments each day. But we need to be open to God's arrival and the graces he sends, just like our Blessed Mother was open and willing. Think about recent graces or inspirations you have received and how you responded to them.

Another delicate detail, which symbolizes a great intimacy, is the cat asleep in the sewing basket, positioned by the artist in the lower left corner. The cat is barely visible in the Vatican's painting, although the version the artist did that resides in Santa Maria dei Angeli in Assisi is much clearer. Barocci used these familiar images to make the scene accessible to us, the observer, and bring us from our daily life into that of the Gospel.

Barocci imagines the Incarnation happening while the Virgin is alone, in the act of contemplating the Scriptures and, when the angel arrives, she abandons her reading and puts the book on a table. Barocci uses these details to emphasize Mary's attitude toward the annunciation. She was a woman of deep interior life, with a heart of silence and reflection that awaited the visitation of the Lord. From an iconographic point of view, the book of Scripture makes us recall the words of the Old Testament prophesying this moment: "The young woman, pregnant and about to bear a son, shall name him Emmanuel" (Isaiah 7:14). Her setting aside what she was doing in order to receive her divine visitor indicates an availability to drop what she was doing to listen.

There is no doubt God is also knocking at the door of your heart and doing so daily. How quickly do you set aside your plans to embrace the plans of the Lord?

To prove that Mary is "blessed among women, and full of grace," Barocci portrays her in the guise of a noblewoman of the time, renowned for her beauty. Her hair is delicately pulled back and neatly braided and affixed. In fact, Mary has a charming and serene look, neither embarrassed nor defensive. She is composed and in control in her surrender. Her red and blue clothes—symbolizing her divine motherhood—give a great light to the whole painting.

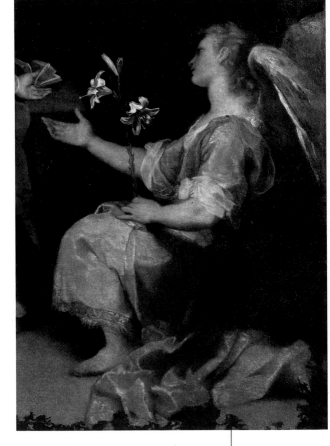

The Archangel Gabriel approaches the Virgin with a humble posture, kneeling and extending his advance. God's invitations to our soul may be unexpected and even violent in their arrival, but they are always respectful and patient in eliciting a response. The passage begins and ends with the movements of Gabriel. His arrival signifies the beginning of the great theophany, and his departure ends the dramatic event. Angels announce big moments. The good spirit brings peace and leaves us free while the bad spirit comes with pressure and guilt.

Gabriel is on his knees because Mary Immaculate is the only one to be full of grace and full of God, and he is caught in the act of greeting Mary with an expression that St. Thomas calls "the greeting of the Angel": "Hail, favored one!" (Luke 1:28). In his hand is a lily, the symbol of the perpetual virginity of Mary. At the top of the artwork it is possible to admire the celestial sphere. God looks down waiting for Mary's response to his request. The salvation of mankind lies in the acquiescence of Mary.

Mary, full of life, indulges with filial confidence to the plans of the Lord. She pronounces her "yes" with the understanding that the Lord has big plans for her. Barocci's compositional skills are even more evident in the scenes that represent this deep essence of life. His creative process is much like our own lives and much like the annunciation. We need to silently and attentively await the inspiration of the Lord to set us in the right direction. Prayer is just that, humbly waiting for the hour of God. Spend time in silent contemplation of this scene and allow Jesus to speak to your soul in any way he wishes.

PRAYER AND REFLECTION

Hail Mary, full of grace, the Lord is with you; blessed are you among women, and blessed is the fruit of your womb, Jesus. Holy Mary, Mother of God, pray for us sinners now and at the hour of our death. Amen.

- How often do you say "yes" to extra work, tasks, chores, favors, and events? How often do you say "yes" to the work God asks of you? Sometimes we have to say "no" to be free to give our wholehearted "yes" to greater things.

- What are you afraid of? Like Mary, sometimes we are asked to go into the unknown, to face those things we don't feel prepared for. Ask God for the grace you need to keep going.

- The secret of our own peace lies in balancing the tensions of our fallen human nature with our new life in Christ. What are some ways we can work toward this new life within our day-to-day tasks?

- Sometimes the people around us need help saying "yes" to what God asks. What are some ways you can help the people in your life say "yes?"

 Spiritual Exercise

- Mary didn't say, "Yes, but I need some details first," or, "I'm really busy, but I'll fit it in some time next year." She said "yes" with total trust and surrender, no caveats attached. Make time in your life to build your personal relationship with God, whether that's through the sacraments, prayer, or just returning to Mass after a lapse. Make surrendering to Mary your goal. Don't be afraid if that feels a long way off.

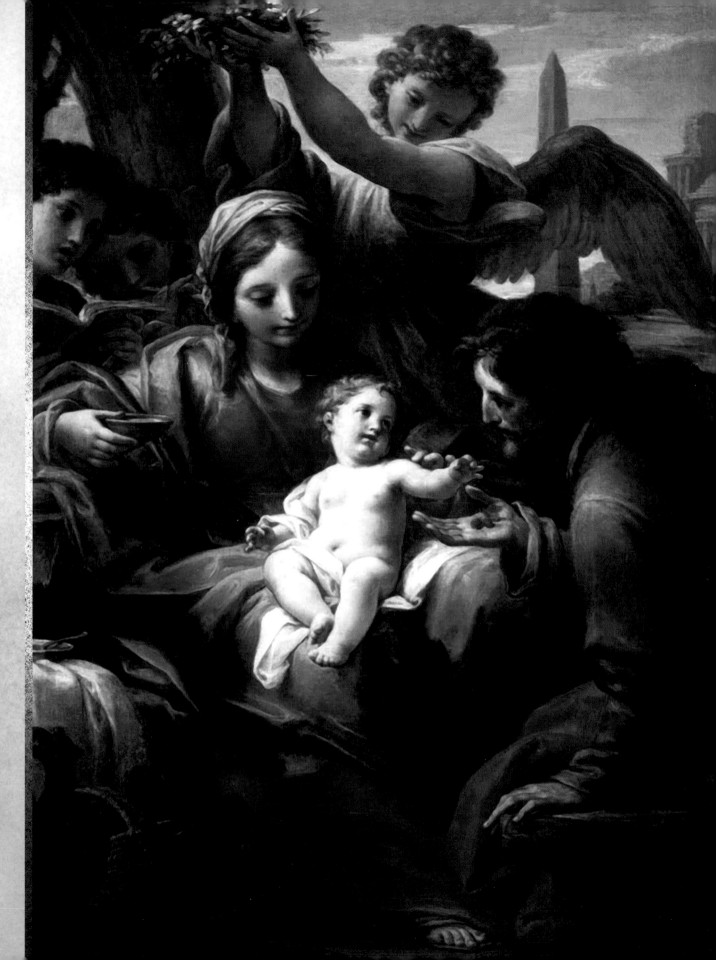

Francesco Mancini (1672–1737), born near Urbino, the hometown of Raphael, was trained under the supervision of Carlo Cignani, who had been working since 1686 in Forlì on the decoration of the cupola of the chapel of the Cathedral of Our Lady of Fire. After stints in Ravello and Foligno, he moved to Rome, where he came into contact with his fellow countryman, Carlo Maratta. That became a turning point in his career because the friends he met there led to multiple commissions from all over the papal states. His creative genius and quick execution had him working on frescoes in Macerata, Rimini, Forlì, Sant'Angelo in Vado, and Ravenna.

REST DURING THE FLIGHT INTO EGYPT

Francesco Mancini
Early eighteenth century

THEME: Angels and the Holy Family on the flight to Egypt

FOCUS OF THIS MEDITATION: Find in the angels an encouraging presence in all times.

◄ Mancini was esteemed by his contemporaries as one of the best painters of his time, highly appreciated for his clear and bright tones. Mancini carried forward the template of mixing the classical and the Baroque traditions as laid down by Maratta and his master, Cignani. He also exhibited a highly refined style with muted colors and a smoothness of execution, which anticipate the neoclassicism adopted by his pupils toward the end of the eighteenth century.

The main characteristics of Mancini's work are delicacy, grace, and elegance. This Vatican painting, enriched by the presence of three angelic figures of supreme grace, expresses an optical and chromatic freshness of the figures of the Holy Family. The painter visibly enhanced tones and values, surrounding the figures with an enveloping ambience; the rustic landscape of

a classical Egypt. Thanks to this pictorial solution, *Rest During the Flight Into Egypt* is enriched by a modern, almost formal conception immersed in a fresh light.

The obelisk, seen in the background, was a worldly symbol of the greatness of the Egyptian people, whose engineering and wealth made such amazing monoliths possible. The Romans, when they conquered the northern African territories, would triumphantly bring these obelisks back to decorate the city of Rome. One still sits in St. Peter's Square. Yet in Mancini's painting, this proud symbol shrinks in the distance. The light that emerges from the Baby Jesus is a pure, incandescent illumination, contrasted by the distant, hazy world behind. The true light was coming into the world, but would the world receive him?

SCRIPTURE MEDITATION

MATTHEW 2:13–15, 19–21

When they had departed, behold, the angel of the Lord appeared to Joseph in a dream and said, "Rise, take the child and his mother, flee to Egypt, and stay there until I tell you. Herod is going to search for the child to destroy him." Joseph rose and took the child and his mother by night and departed for Egypt. He stayed there until the death of Herod, that what the Lord had said through the prophet might be fulfilled, "Out of Egypt I called my son." […]When Herod had died, behold, the angel of the Lord appeared in a dream to Joseph in Egypt and said, "Rise, take the child and his mother and go to the land of Israel, for those who sought the child's life are dead." He rose, took the child and his mother, and went to the land of Israel.

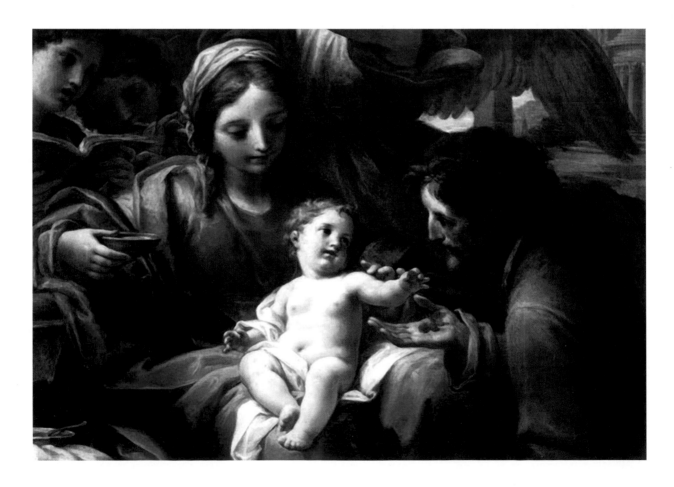

*T*oday's meditation offers us a work of art that allows us to easily use our imagination to enter into the scene. Place yourself on a rock and sit with the Holy Family under the shade as Mary perches the Baby Jesus on her lap and leans back, resting against the bench. Feel the breeze of the early morning, hear the joyful noises Jesus makes as he coos and gurgles at Joseph.

Realistic and human details characterize the paintings of Mancini. They make the moment depicted as ordinary as any other family sitting in a park and playing with their child. Mary has a bowl of water in her hand, perhaps ready to offer a drink to Jesus after he tastes the strawberry or to clean his stained little fingers. Baby food sits in a silver bowl on a white baby blanket. Perhaps it was just placed there by Joseph, for Jesus has finished his vegetables, and now Dad offers him dessert! A traveling basket sits by a water jug. These instruments show that the Holy Family is a pilgrim family, and the Egyptian obelisk in the background indicates their destination.

The circumstances of their flight are precarious, yet they are joyful and even playful in following God's path. No doubt these are trying times for the family as they walk by faith and not by sight toward a very uncertain future. Yet their focus is on the amazing gift of Jesus, and all their attention rests on him, his needs, and what makes him happy. This is a fantastic image for what our interior life should be like. Amidst the difficulties of our earthly journey, we should joyfully focus on Jesus and worry more about what he wants and less about what it might cost us.

There is a contrast between the bright colors around the intimate context of the Holy Family and the colder, more formal city in the background. The delicate angels in the background mediate between these two worlds. They are depicted, very naturally, as part of the event yet in a slightly different palette, as if to say they are there but not there. Do you notice how Mary and the Baby Jesus "pop" out of the picture because their colors are so much brighter? They are of another palette than the ethereal angels and the natural focal point of the scene. The angels, in more subdued tones, are as they belong, in the background, assisting and protecting the Holy Family.

A beautiful detail is the coming together of the hands of the family. Mary's delicate hand steadies Jesus' arm as he reaches out to Joseph, who offers the strawberries. Strawberries are a symbol of Christ's Incarnation and humanity. These three movements are food for so much meditation—

Mary who accompanies, Jesus who reaches out toward Joseph. What is Jesus reaching for and what are you offering him?

Mary offers her Son to you. He is reaching out and asking you to take your place on the bench next to Joseph and offer him your own humble gift. What will your gift be to him today?

Angels spoke to Joseph in a dream and sent them on this journey. There is no doubt angels accompanied them along the way. One angel hovers over the Holy Family almost like a canopy and awards Mary a laurel crown. His curly hair and pink garment depicts a peaceful context and a protective shield from the cold world beyond. Two other angels peer from behind making music, one singing from a choir book and the other playing the flute. This angelic duet offers divine background music for the resting couple.

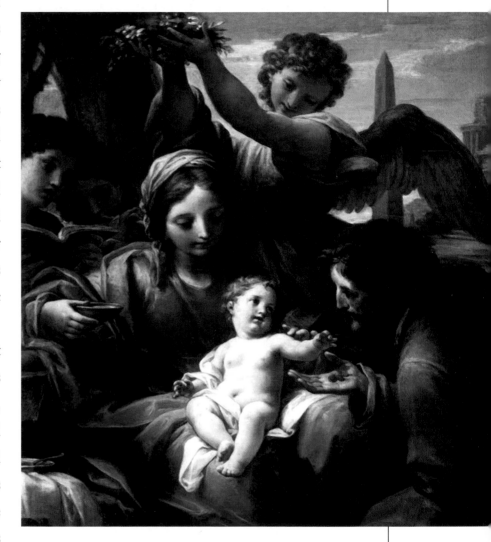

While these angels work to protect and honor the Holy Family and stand as mediators between God and the world, they cannot make Mary and Joseph good and holy; only the choices of Mary and Joseph can do that. Angels do not make us holy. Our good actions do. Angels can be instruments of God's grace and mediators of his gifts. What we do with those graces and gifts is where our holiness lies. They can console, motivate, and inspire. They can protect, defend, and promote us and the good. But a million angels cannot a saint make.

PRAYER AND REFLECTION

O God, who by the light of the Holy Spirit instructed the hearts of your faithful, give us through the Holy Spirit a love and desire to do what is right and just and a constant enjoyment of your comforts. Amen.

—Adapted from *The Angel of Prayer* (1861)

- If you had the opportunity to present the Baby Jesus with something, what would it be?

- How would this gift help Jesus on his journey to our salvation? How does having it or sharing it help you get to heaven?

- Look at Mary and Joseph. Even though he is an infant, they are willing to give up everything and follow Jesus to protect him, and they do so joyfully! Are you as joyful in his service?

- It's not always easy to use the graces and skills God gives us in the way he meant us to. How do the "angels" in your life keep you on the right track?

Spiritual Exercise

- Today, whatever you're asked to do, carry it all out with joy and offer it all up to the Baby Jesus. When you aren't sure you can make it on your own, ask the angels to help and intercede for you.

In *Deposition*, Conca achieves a high atmospheric fluidity, arriving at a more subdued, almost rarefied sensibility of brush strokes. Through a circular movement of figures that fluidly blend one with another—a testimony to his knowledge of contemporary French composition and style—Conca creates extraordinary and enchanting visions where the religious character of the subject and the dramatic tone of the narration are dissolved in pure lyricism.

In Conca's work, it is easy to see the creative evolution of the painter who focuses on a rich and enveloping structural cromatism with touches of color and light, which make throbbing forms. There is an emphasis on the shapes that is not only organic but emotional and dynamic.

Conca departs from artworks of the same subject in which the focus of the deposition tends to be the Virgin Mary fainting at the foot of the cross, with the other figures in the painting casting themselves upon her to share her grief. This approach was common in the fifteenth-century tradition.

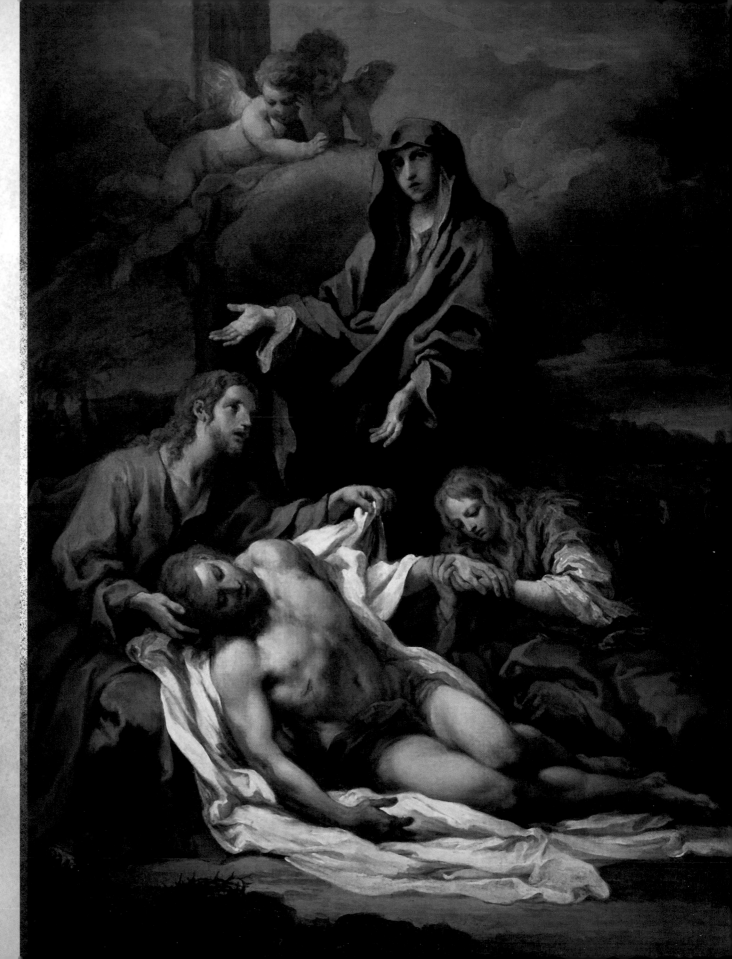

DAY 16

DEPOSITION

Sebastiano Conca
Circa 1700s

THEME: Christ being taken down from the cross

FOCUS OF THIS MEDITATION: Angels support Jesus' Mother in her most agonizing moment and receive her Son at his death.

◀ Sebastiano Conca studied in Naples under Francesco Solimena. In 1706, he moved to Rome, where he worked with Carlo Maratta. There he had success as a fresco and altar painter through the 1750s. Conca's exuberant artistic style was partially moderated by the direction of Maratta. Pietro Cardinal Ottoboni was his patron and introduced him to Pope Clement XI. Following this meeting, Conca painted the fresco of Jeremiah in the basilica of St. John Lateran, for which he was rewarded a papal knighthood and a diamond cross by the cardinal. In 1710, he opened his academy, the Accademia del Nudo, which specialized in the study of classical form and techniques. His approach attracted many students, such as Pompeo Batoni, the Sicilians Olivio Sozzi and Giuseppe Tresca, and served to spread his style throughout the continent.

In August 1731, the painter was called to Siena to paint the apse of the Church of the Santissima Annunziata. One of these works, the *Pool of Siloam,* earned him the widespread admiration of his contemporaries. He was later at the court of Savoy and worked in the Oratory of St. Philip and the Church of Santa Teresa in Turin. In 1739, he wrote a book titled *Ammonimenti* (Admonitions), containing moral and artistic precepts, and dedicated it to all the young people who wanted to become painters. After his return to Naples in 1752, Conca passed from these experiences of classical inspiration to the most grandiose canons of the late Baroque and Rococo, mainly inspired by the works of Luca Giordano. In this period, Conca painted dazzling and "illusionist" frescoes and paintings.

SCRIPTURE MEDITATION

JOHN 19:25–30

*Standing by the cross of Jesus were his mother
and his mother's sister, Mary the wife of
Clopas, and Mary of Magdala. When Jesus
saw his mother and the disciple there whom
he loved, he said to his mother, "Woman,
behold, your son." Then he said to the disciple,
"Behold, your mother." And from that hour
the disciple took her into his home. After this,
aware that everything was now finished, in
order that the Scripture might be fulfilled,
Jesus said, "I thirst." There was a vessel filled
with common wine. So they put a sponge
soaked in wine on a sprig of hyssop and put it
up to his mouth. When Jesus had taken the
wine, he said, "It is finished." And bowing his
head, he handed over the spirit.*

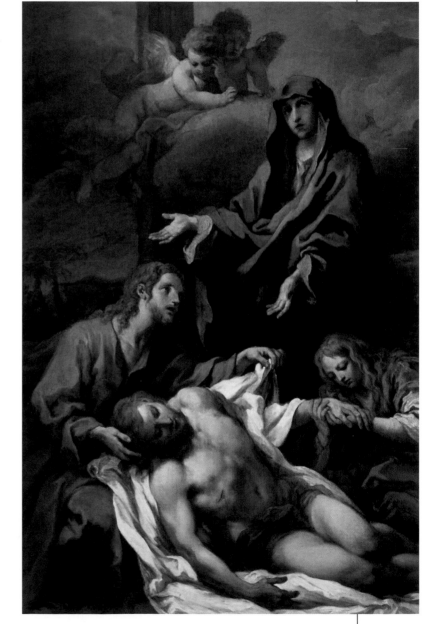

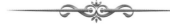

As we continue to meditate on the main events in the life of Mary, we see that they coincide entirely with the main events in the life of her Son. At each of these moments, artists cannot help but place angels in the pictorial meditation as heavenly onlookers and symbols of the other world observing the drama playing out on earth. Angels accompanied Jesus in his time in the desert and in the agony in the Garden, so there is no doubt they would continue to be present at the moment of his death until he comes again in glory. They are most certainly with you now as you meditate on this grievous moment in the life of Jesus and Mary.

Recently a group of fellow priests and I were discussing accompanying people at the hour of their death. I personally have not been present in this most profound of moments. Perhaps you have. I am told it is an amazingly spiritual time when you can feel the afterlife almost touching our sphere below. The passage of the soul from this life to eternity is mysterious but amazingly real for those present. You immediately know the life has ceased. The look on the dying person's face often communicates that he is seeing something quite real and beautiful, or in some cases, I am told, quite terrible. Then comes death, silent and peaceful.

When reading the Gospel of John, allow the narrative to invite you into the scene of Jesus' death as if you had never heard the story before. Each detail, each image should help you paint your own picture of the scene. See the soldiers; what are they discussing? Where are Mary, Mary Magdalene, and John? Are they speaking to each other or standing in silent prayer and grief? I would imagine them quiet and fully focused on Jesus, listening to his words and crossing paths with his line of sight to better accompany him in his last instant.

Then Jesus directs his dying wish to his Mother and to his beloved disciple. He entrusts them to one another as a last caring gesture of a Son whose father has died and who has no one to care for his Mother. Woman is entrusted to man and man to woman. We are indeed our sister's and brother's keeper. But something more is happening here. Jesus' words are spoken to you, to each of us! He says to you to take Mary into your own home, your own heart. She is to be your Mother, your protectress, your consolation. She is a gift to all—not just Catholics or Christians—but everyone. Just as Jesus is the Savior of all, his Mother is the Mother of all he has saved.

Once Jesus has passed from this life, after his side has been pierced and his body removed from the cross, our artist enters onto the scene to put in paint what no photographer was there to capture. His painting is his meditation on our passage.

Conca's composition pushes all the characters to the foreground in a kind of pyramid, and that leaves a part of the bare cross slightly shifted to the left. Next to it, two small winged angels observe the scene from above, backlit by a glow with warm tones that illuminate the clouds in the background. The crowd at the crucifixion is sparse, and only the people closest to Jesus attend his detachment from the cross. On the right, Mary Magdalene reverences the hand of Jesus, wounded by the stigmata, to kiss it, kneeling on the ground and forming a solid and compact figure with a red cape.

The realism created in the body of Jesus, heavy and disjointed from torture, lying on the ground, is painted using defined lines. John, on the left side, sustains the head of Christ and tries to cover his nakedness with a white cloth. The Virgin Mary's eyes look toward the observer, and with the large gesture of open arms as a sign of acceptance of God's will, she resigns from the scene.

It is Mary, wrapped in a blue cloak, who represents the pinnacle of a triangle formed by figures full of pathos. Her pain and suffering is not focused in on herself but directed out at the viewer. She offers, with her open arms, an invitation to contemplate the pierced one, her Son. She offers him to us as a gift but also as an invitation to consider our sins and what we have done to her Son. She is loving, and she is honest.

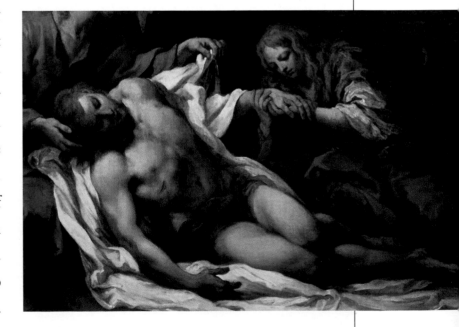

Allow her image and the sweet concern of the angels behind her to lead you in your own contemplation of her Son's total self-giving. Accept this gift and renew your own desire to take her into your home and him into your heart.

PRAYER AND REFLECTION

Holy Virgin, Mother of God, defend me from my enemies in my last hour and present me to your divine Son. Glorious St. Michael, prince of the heavenly host, my angel guardian and blessed patron, intercede for me and assist me in my final passage. Amen.

—Adapted from *The Angel of Prayer* (1861)

- If you were to create an image of Christ's deposition from the cross, what would it look like? What characters would be present? What elements would you emphasize?

- Christ died for our sins. Does the meaning of that phrase change for you as you look upon this painting?

- Mary is not portrayed here as a grieving mother but as one inviting us into her pain and sorrow. Why do you think Conca chose to depict her in this way?

 Spiritual Exercise

- Spend time in silence today. Contemplate the image and the death of our Savior. Give him thanks for his love.

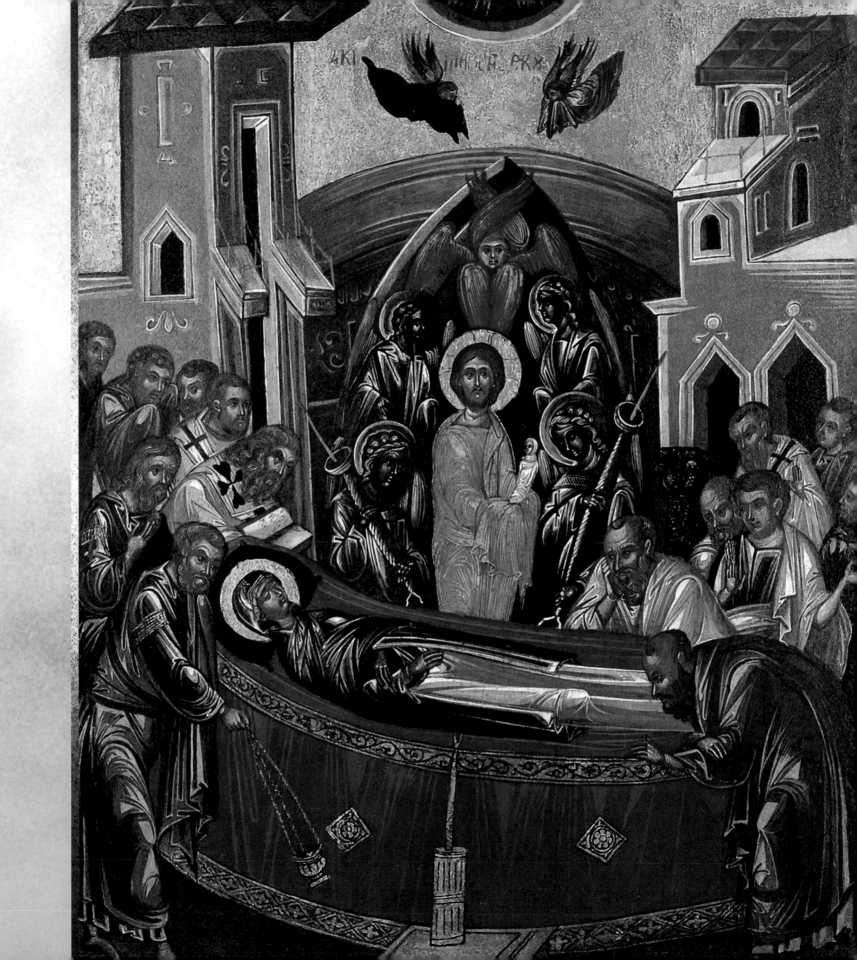

THE DORMITION
OF THE MOTHER OF GOD

The Cretan School
Late sixteenth century

THEME: Mary's faithful obedience and love

FOCUS OF THIS MEDITATION: Because Mary seeks the Lord and his will, no matter the cost, she rests in peace and is raised up to the Father.

◀ Mary is at the center of the icon on a pier that represents a Christian altar. Apostles stand around her with others. Those figures closest to the pier are the most visible and most important. It is in that position we find Peter and Paul, indicating the presence of the whole Church. In the midst of a semicircle and surrounded by angels holding candles in procession, Christ gently holds the soul of his Mother in his hands and carries her to heaven. The fiery seraphim, whose wings form the apex, relate this icon to the icons of the ascension of Christ. Two angels hover in heaven—one black and one pink.

The bed where she rests, which is also the altar of Mary, represents the area where the liturgy takes place: The apostles celebrate the liturgy while Christ, who is at the center behind the altar in the apse, presides over it. Peter spreads incense around the altar, as it would be occurring in the liturgy. These actions mimic the mystery participated in by the believer. Mary, being consumed in sleep, is going up from the altar to heaven. Finally, Mary is gloriously assumed into heaven and becomes the one who intercedes with her Son in favor of the whole Church that celebrates her.

The architecture, which laterally encloses the composition, represents the Church, designed with the usual inverse perspective, demonstrating that the scene takes place within the life of the Church. Lighted candles handled by angels indicate the liturgical procession into the heavenly liturgy.

SCRIPTURE MEDITATION

REVELATION 12:13–14

When the dragon saw that it had been thrown down to the earth, it pursued the woman who had given birth to the male child. But the woman was given the two wings of the great eagle, so that she could fly to her place in the desert, where, far from the serpent, she was taken care of for a year, two years, and a half-year.

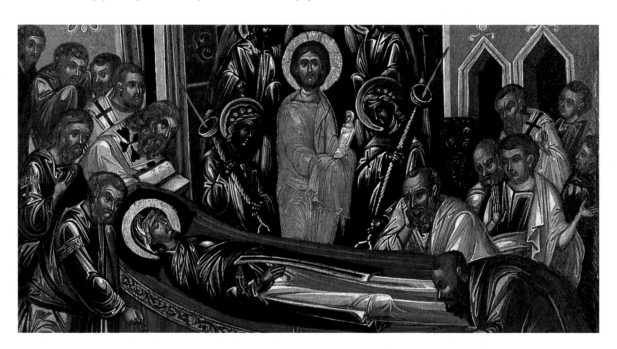

The Cretan School was one of icon painting that produced works from the fifteenth through the seventeenth centuries. The style of icon produced, also called Post-Byzantine Art, was greatly influenced by the artistic traditions of both the East and the West. This is fitting for this particular scene, as the dormition and assumption of Mary are events of great importance to both the Roman Catholic and Orthodox Churches.

The long tradition of icons is very much united to the liturgical and communal prayer of the Church. Iconographers fast and meditate for long periods before attempting to crystallize the essence of a particular mystery of faith into a painting. Each icon focuses on a particular liturgical feast day and is painted to visually accompany the prayers of that day. This icon from the Cretan School was produced for the feast of the Dormition of the Mother of God.

*I*n Christianity, the death of Mary, Mother of Jesus, is called the dormition, from the Latin *dormitio.* The use of the term dormition derives from the belief, supported by the Orthodox tradition, that Mary would not really have died but would have only fallen into a deep sleep before she was assumed into heaven.

The Dormition and Assumption of the Mother of God, events not narrated in holy Scripture, is the last great feast of the liturgical year. The Byzantine tradition has as its first great feast of the liturgical cycle the Nativity of the Mother of God on September 8 and ends with her dormition and transition into heaven on August 15 to emphasize that, for every Christian and the whole Church, the Virgin is the first to experience the saving mystery of Christ.

Resurrection and transfiguration are the two keys of Christianity, being the final works wrought by God for men. The *Theotokos*, then, translates into reality the end of the economy of salvation. The dormition teaches us that Mary has passed from death to life, participating in the joy of eternal life because the Mother of Life could not remain in corruption. We celebrate August 15 as a second Easter, the resurrection of Mary, who is already united to her Son Christ even before the final judgment, before the resurrection on the last day.

Both the Catholic and Orthodox Church affirm the doctrine of Mary's assumption into heaven. In Catholic Mariology, we see two theological hypotheses put into comparison: Death is the result of original sin, but because Mary was preserved from sin through her immaculate conception, she does not die. Mary was preserved from original sin through the merits of Christ (in other words, the fruits of redemption have been applied to Mary in advance), and she follows the Son, even in death. As was the case with the Son, her body is preserved from corruption. However, only the dogma of the assumption has been irrevocably proclaimed (*Munificentissimus Deus*, Pope Pius XII, 1950).

This icon is rooted in the relationship between the vertical figure of Christ, who stands out in the blue, and the horizontal body of the Virgin: union between heaven and earth. The shining robe of Christ intersects with the darkness of the earth, represented by the dark mantle of Mary. He has come down into the world through the womb of his Blessed Mother in order to bring light

into this world and in so doing takes her and us back up to the eternal Father. The dormition of the Mother of God is clearly linked to the salvific work of Christ himself; the apostles honor the mystery of Christ's redemption through the care of the body of the woman who was the privileged witness to the beginning, development, and culmination of that very salvation.

In memory of these events, two churches arise in Jerusalem today: that of the Dormition on Mount Zion, the place where the transition took place, and the Tomb of Mary, in the Kidron Valley, just a few steps from the Franciscan Basilica of the Agony in Gethsemane and in the same complex as the cave of betrayal, where the burial rite took place.

St. John Paul II, when reflecting on this moment in the times of Mary, said that more than focusing on whether or not she died, "It is more important to look for the Blessed Virgin's spiritual attitude at the moment of her departure from this world" (General Audience, June 25, 1997). It is beautiful to meditate upon this understanding that, in the moment of our own death, we will be surrounded by the same heavenly company who wish to lead us up to the Father. Jesus, our brother; Mary, our Mother, and the cloud of saints and angels will be there to cheer us on in our last moments. The love we have lived all our lives will become even more evident, for we will die as we have lived.

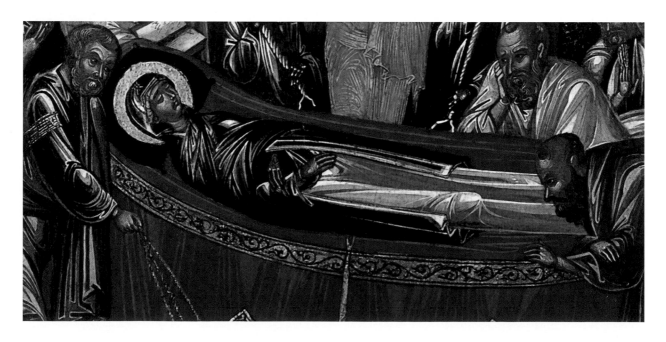

MEDITATIONS ON VATICAN ART: ANGELS

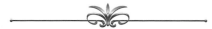

PRAYER AND REFLECTION

O Mary, my Mother,
I offer you my soul, my mind, and my heart.
Make of me God's instrument.
Give me a penetrating mind to discover,
firm to judge,
open to understand,
free to serve the truth;
an honest mind in telling what it sees rather than what it wants to see;
a tolerant mind which does not dictate to other people,
but which explains what it sees clearly;
a mind infused by the light and the truth of your Son Jesus,
patient in faith,
while waiting for the vision of eternal life.

—*Prayer to Mary for a Good Mind*, A. Hanrion, SJ, translated in 1958 by Chau T. Phan

⚜ Reflect on the known virtues of Mary.

⚜ Which of these virtues would you like to cultivate in your own life?

⚜ How does the life and example of Mary help us grow stronger in virtue and love for her Son?

⟿ *Spiritual Exercise* ⟿

⚜ Say a quiet prayer to Jesus through Mary and ask that she intercede on your behalf to her Son. Thank her for her holy example and pray that you may be as faithful as she was in your love for Jesus.

In 1348, when Silvestro dei Gherarducci was about nine years old, he entered the Camaldolese monastery of St. Mary of the Angels. In April 1398, he was elected prior of St. Mary of the Angels in Florence. He died October 5, 1399, in that same convent. An accomplished painter, he especially liked painting on wood, and a small corpus of works are scattered in museums around the world. *The Madonna del Latte,* now in the Uffizi, represents the first phase of the pictorial activity of the artist, influenced by a probable apprenticeship in the workshop of Andrea Orcagna. *Assumption of the Virgin*, in the Pinacoteca Vaticana, represents the maturation of his style.

The assumption is the moment in which the earthly life of the Blessed Virgin Mary ended and she is elevated soul and body into her heavenly glory. The feast day of August 15 has been the date of this celebration since the beginning of the ninth century. As we have already seen, the Orthodox tradition focuses the celebrations of this day on her dormition, or falling asleep.

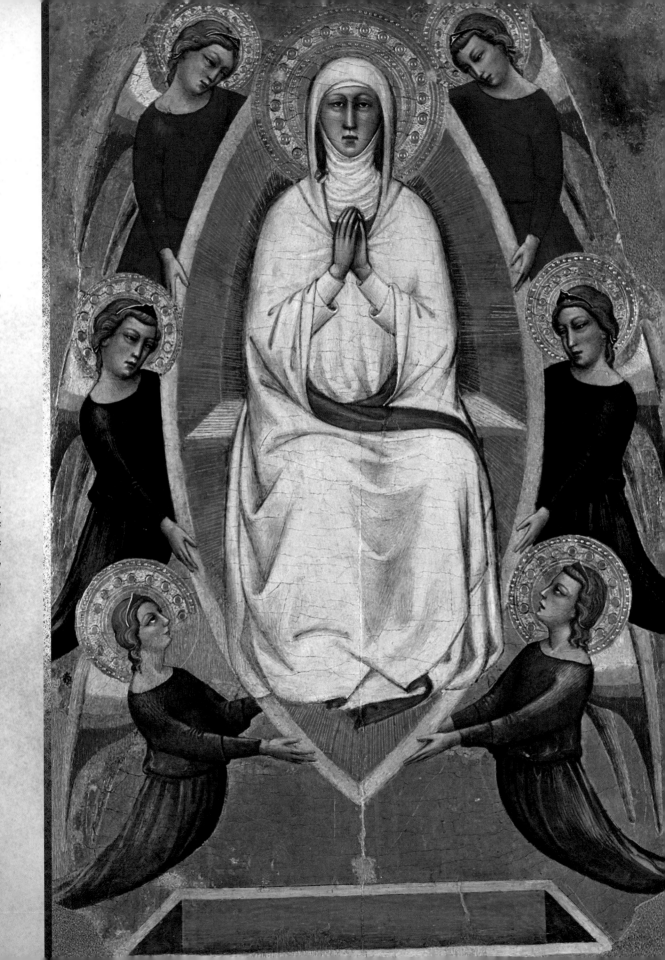

DAY 18

ASSUMPTION OF THE VIRGIN

Silvestro dei Gherarducci
Circa 1365

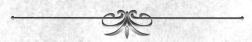

THEME: Mary's humble obedience to and love toward the commandments of God

FOCUS OF THIS MEDITATION: God raises up his beloved.

◀ The first depiction of the assumption appears on a brocade of the eighth century that is found in the treasury of the cathedral of Sens. Below the Virgin, a group of apostles carries crosses in procession, while the Virgin is accompanied by angels at her sides and feet. This image is probably inspired by the sixth-century pictorial tradition of the ascension of Christ, in which the praying Virgin is surrounded by the apostles, just below Christ.

The assumption began to be portrayed frequently following the iconography developed in Byzantine art. The Virgin is often shown lying on a couch, surrounded by the apostles, in the midst of which there is Christ, with the soul of the deceased Mary in his arms: Her soul is represented as a child in swaddling clothes. An important innovation is found in a

missal of the mid-eleventh century from Augusta where the illustration for the liturgy of the assumption shows the Virgin in prayer and placed in an oval-shaped background supported by angels, like the contemporary image of the ascension of Christ.

This formula, which uses the oval, is also found elsewhere; especially in the French Norman school in the second half of the eleventh century. In these instances, the Virgin wears a crown and holds a palm or a scepter. The elements of these early representations started gradually in a model type, leading to the establishment of an image in which the figure of the Virgin in glory is predominant, making it of secondary importance whether or not the iconography represents the assumption of the Virgin's body.

SCRIPTURE MEDITATION

PSALM 119:169–176

Let my cry come before you, LORD;

in keeping with your word, give me understanding.

Let my prayer come before you;

rescue me according to your promise.

May my lips pour forth your praise,

because you teach me your statutes.

May my tongue sing of your promise,

for all your commandments are righteous.

Keep your hand ready to help me,

for I have chosen your precepts.

I long for your salvation, LORD;

your law is my delight.

Let my soul live to praise you;

may your judgments give me help.

I have wandered like a lost sheep;

seek out your servant,

for I do not forget your commandments.

Yesterday's meditation and work of art focused on the moment of Mary's resting in the Spirit previous to her being assumed, body and soul, into heaven. Today's panel focuses on the moment just after. Once she rested peacefully in the arms of her Father because she was the first and most perfect follower of her Son, she was privileged to be taken up to be with him. There is no doubt that we can certainly apply these words of Jesus to his Mother: "Whoever serves me must follow me, and where I am, there also will my servant be. The Father will honor whoever serves me" (John 12:26).

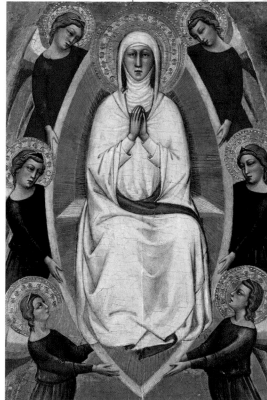

The composition of this small panel presents six angels holding the almond that encloses the Virgin. The meaning of the almond shape behind the Virgin has a rich tradition in icon painting. The *mandorla*, Italian for almond, is the way to represent the coming together of two realities, for indeed the almond shape is the area created by two intersecting spheres.

When Christ is in the center, it signifies his divinity and humanity. When Mary is placed in the center, it illustrates her humanity and special sanctity and holiness. In this moment of passing from this world to the heavenly world, her holiness and privilege are becoming patently evident.

The almond tree is also the first to flower in Greece, and so the almond became a symbol of new life and fruitfulness. Aaron's rod blossomed forth not only flowers but almonds, as stated in Numbers 17:8 in the *New Revised Standard Version Bible*: "When Moses went into the tent of the covenant on the next day, the staff of Aaron for the house of Levi had sprouted. It put forth buds, produced blossoms, and bore ripe almonds." The mandorla or almond is also meant to reveal a glory that cannot be seen. It is that cloud of glory that covers or shines behind Christ in his baptism, transfiguration, and ascension. In this sense we can also read in this moment of Mary's assumption into heaven that the mandorla is the glory of God around her as her fullness of grace radiates from her transfigured humanity.

Meditating on this glory that is the possession of all those in heaven should inspire us to seek the glory that is not passing: "Whoever speaks on his own seeks his own glory, but whoever seeks

the glory of the one who sent him is truthful, and there is no wrong in him" (John 7:18). What a challenge for us! To not seek our own glory but to receive the glory he wants to give us when he wants to give it to us! Our lives are a perpetual mix of the divine and the human, the oceans of God's goodness and our all-too-often murky, swampy humanity. This mix becomes glorious if we let God's greatness eclipse and shine through our weakness.

Accompanying the white-clad Mary and enveloped in heavenly gold are the angels who have experienced that glory from that first moment of their definitive choosing of God. The representation of the angels draws on the iconography of winged victories. The Louvre houses the most famous representation of the most famous pagan angel, the winged Nike, goddess of victory. She is the winged goddess, sister of Kratos (Strength), Bia (Force), and Zela (Zeal), who visited the battlefields of the Titan war, awarding victory to the Valiant. How much more are these winged angels true Nikes who award Mary, full of humble strength, virtuous force, and loving zeal with the laurel crown of victory.

Although the angels take part in the pictorial scene, they are seldom described in the Bible and the Apocrypha as being there. Their presence is, then, a passive one, even if shown "carrying" the Virgin to glory. Thus, the three tiers of angels look passively onto the Virgin, as if not expecting any response. This "blank" stare is to signify that they are not actually there since we have no scriptural or historical reference of their presence. They are there as servants, witnesses who accompany and observe but do not intervene, for Mary has already finished the race and won her crown. Angels are our champions, protectors, and helpers on earth. They can act powerfully on our behalf. But once the last trumpet sounds and we are beyond the judgment of God, they will simply be our covictors!

Turn to the passages of Psalm 119, which is traditionally sung by the monks on Holy Saturday, the day of Mary's victory of faith as she awaits the resurrection of her Son. Read and pray them as Mary would have prayed them. Conform your heart to their meaning and renew your desire to love and serve him with great generosity and purity. Just like Mary, just like the angels.

PRAYER AND REFLECTION

"No evil shall befall you, no affliction come near your tent. For he commands his angels...to guard you wherever you go" (Psalm 91:10–11).

✠ How do you proclaim the victory of Jesus over death? What more can you do to spread the joy of the resurrection?

✠ How does your life reflect the conquest of sin and death? Reflect on the commandments, most especially "that you shall love the Lord your God with all your heart, your soul and your mind." Do you keep these commandments in your thoughts, words, and actions?

✠ What is so special about the assumption of Mary that different churches hold it in such high regard? What do Mary, her life, and glorious assumption mean to you personally?

 Spiritual Exercise

✠ List five things you are thankful for and five ways you can better show the victory of Christ over sin in your life.

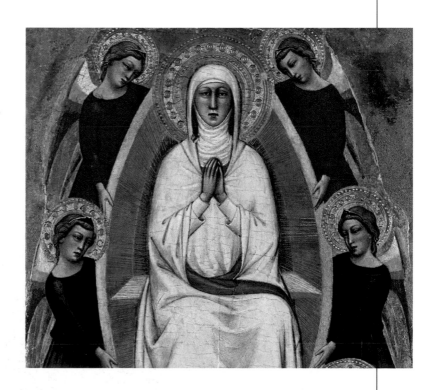

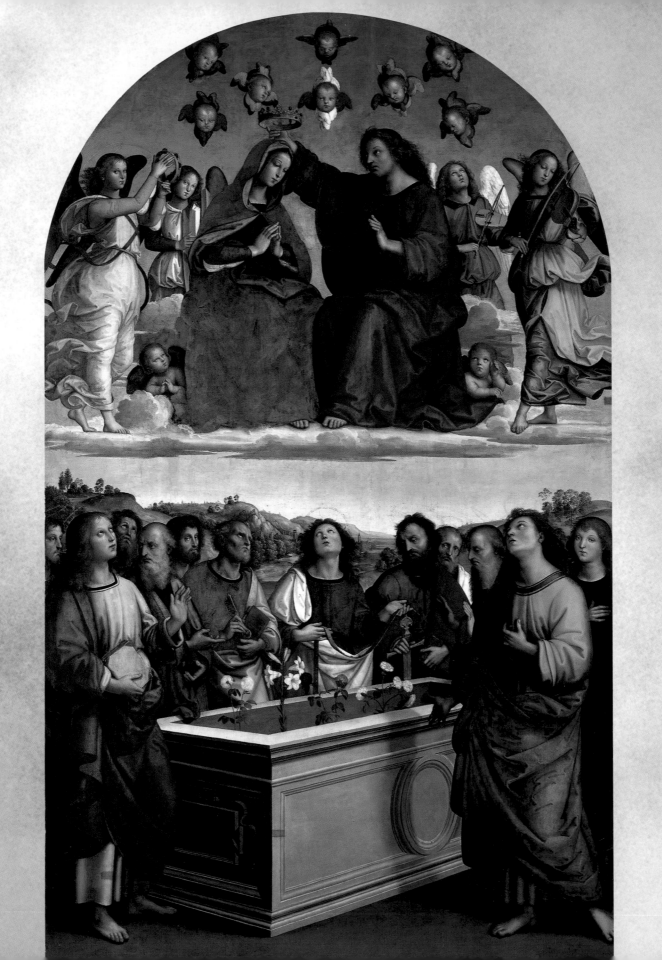

CORONATION
OF THE VIRGIN

Raphael Sanzio
1502–1503

THEME: Mary, the Queen Mother, is crowned by her Son, the King!

FOCUS OF THIS MEDITATION: Mary's moral and spiritual beauty, fruit
of her fidelity and love, are honored by her Son and Savior, Lord and Love.

◄ Raphael Sanzio was perhaps the most gifted artist of the
Renaissance and continues to be one of the most beloved.
The delicacy of his figures, the beauty of his colors, and the
virtuosity of his execution are unparalleled and still influence
artists today. Contemporary aficionados, like those of his
day, never tire of his effortless display of light, love, and
color. The Vatican Museums are blessed to have the rooms
painted by Raphael for Pope Julius II, his main patron. The
Vatican also has the tapestries he designed for the Sistine
Chapel, *The Transfiguration,* which he painted and hung
above his bed, and finally this amazing piece.

Coronation of the Virgin is an oil painting on panel, dated
to 1502–1503. It was commissioned as an altarpiece in 1502
by Maddalena degli Oddi for the church of San Francesco al
Prato in Perugia. In 1797, it was requisitioned by the French
and moved to Paris, where it was transferred to canvas.
In 1815, this altarpiece returned to Italy and, like many
recovered works, ended up in the Vatican, where it remained
at the disposal of Pope Pius VII, who decided to display it in
the Vatican Painting Gallery.

Several preparatory drawings for this work are known:
two of the musical angels (Oxford, Ashmolean Museum),
one of the apostle in the right foreground (London, British
Museum), and one of the apostle, St. Thomas, at center
(Lille, Musée des Beaux-Arts).

SCRIPTURE MEDITATION

PSALM 45:8

*You love justice and hate wrongdoing; therefore God, your God,
has anointed you with the oil of gladness above your fellow kings.*

SONG OF SONGS 4:7

You are beautiful in every way, my friend, there is no flaw in you!

ISAIAH 62:3

*You shall be a glorious crown in the hand of the LORD,
a royal diadem in the hand of your God.*

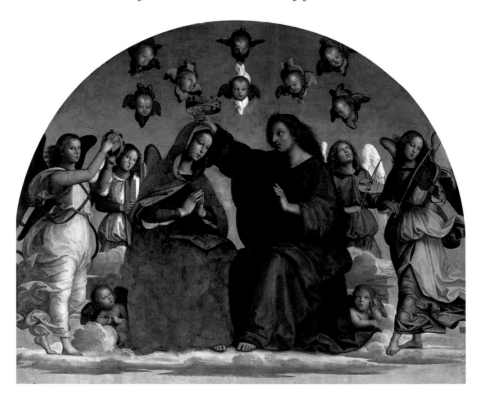

"The Angel of the Lord declared unto Mary" is the beginning of the dramatic and intimate collaboration of the Virgin with the plan of God for our salvation. This heavenly messenger swoops in on the Virgin and, in this last moment of her glory, a cloud of angelic hosts accompany her glorious coronation. Since kings and princes are a thing of the past in most countries, we may have a hard time appreciating the significance of this moment. But once a king was crowned, it was important that the queen was also honored. The king himself would confer a crown on the head of his beloved wife. And in the case of a young king who had no wife, his mother was given the honor of being the highest-ranked woman in the kingdom. This makes Mary the Queen of heaven since she is the Mother of the King and spouse of the Spirit!

The poetic words of the Song of Songs are a lyrical and divinely inspired poem of love that can be interpreted in many ways. One is attributing to Mary the role of the friend who captures the heart of the Father, choosing her to be the Mother of his Son. We can also read these words as God himself speaking to our own souls that attract his loving and redemptive gaze in Jesus Christ. Just reading that beautiful Scripture and looking at the image of Raphael could be enough for your meditation. Imagine the moment God's love crowns all your efforts to follow him! Or imagine the reward that awaits you for all your efforts on earth. Let that day inspire you to live this day with love!

Here we are, above all, focusing on the life of the Virgin and this final culmination of her faithful following of her Son. The coronation was a favorite theme in the chivalrous and regal fourteenth to seventeenth centuries. Some of the greatest painters of all time (Fra Angelico, Ghirlandaio, Botticelli, Filippo Lippi, Rubens, Velázquez, El Greco) have produced a coronation of Mary for the countless Mary chapels that populated the side altars of European cathedrals. Every house of God sought to have a place of honor for his Mother. We should also find a place in our day to honor and spend time with the Mother of our Lord.

Now let us meditate on our painting. This work of art portrays the coronation of the Virgin, divided into two registers, a typical execution of the school of Perugino. In the blue, upper half of the painting, the coronation takes place at the hand of Jesus and in the presence of four festive musical angels, a pair of winged *putti* among fluffy clouds, and a flock of cherubim and seraphim

in the air; in the terrestrial, lower ground of the painting, the twelve apostles stand in a semicircle around the uncovered tomb of Mary, marveling at the scene of heavenly ascension. Around the sarcophagus, flowers are placed as offerings to the Virgin, such as white lilies and roses.

Heaven is the home of angels, so it is no surprise that Raphael populates the sky around the crowned Virgin accompanied by the head of winged seraphs. They are like smiling punctuation marks that emphasize the glorious occasion. The choirs of angels play the four most common instruments of the time—the tambourine, harp, lute, and violin. This celestial concert is the final refrain of a song whose first words began years before: "My soul magnifies the Lord, and my spirit rejoices in God my Savior." What began in a humble home in Nazareth and continued amidst the company of the apostles and the formation of the early Church comes to a glorious conclusion in the heavenly courts.

Christ sits covered in the red of his passion while Mary's maternal blue humbly accepts the honor conferred on her by the Son. He has an expression of delicate respect and even nervousness as he places the crown on her head. Jesus will one day crown you and me as well, if we learn to be first by being last. "Blessed is the man who perseveres in temptation, for when he has been proved he will receive the crown of life that he promised to those who love him" (James 1:12), or, "And when the chief Shepherd is revealed, you will receive the unfading crown of glory" (1 Peter 5:4).

Mary's greatest glory is that she was the lowliest, so let us join her as we meditate and pray her own hymn of humility.

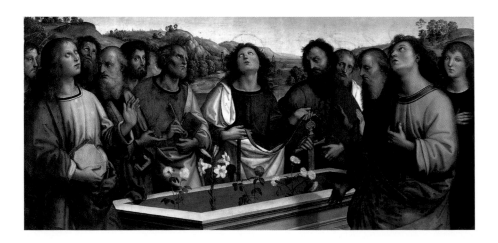

MEDITATIONS ON VATICAN ART: ANGELS

PRAYER AND REFLECTION

"My soul proclaims the greatness of the Lord; my spirit rejoices in God my savior. For he has looked upon his handmaid's lowliness; behold, from now on will all ages call me blessed. The Mighty One has done great things for me, and holy is his name. His mercy is from age to age to those who fear him. He has shown might with his arm, dispersed the arrogant of mind and heart. He has thrown down the rulers from their thrones but lifted up the lowly. The hungry he has filled with good things; the rich he has sent away empty. He has helped Israel his servant, remembering his mercy, according to his promise to our fathers, to Abraham and to his descendants forever" (Luke 1:46–55).

- Are we worthy to be crowned by Jesus as Mary is crowned? Do our actions deserve the praise that Jesus confers on Mary or are our deeds lacking for people of faith?

- When you die, what will people remember of you? What will your obituary say? Are you pleased with the legacy you will leave behind?

- Meditate on the mystery of Mary's coronation. Will you be humble enough to accept the crown Christ has prepared for you?

Spiritual Exercise

- Remember at least one good deed you have done in the past week that you would be happy to tell Jesus about. See if you can perform several more in the next few days. Pray for opportunities to carry these out.

In 1582, Annibale Carracci (1560–1609), his brother, Agostino, and his cousin, Ludovico, founded the Accademia degli Incamminati in Bologna. Teachers, staff, and students were involved in the creative process that departed from using natural models. Ludovico acted as director and organizer of the academy; Agostino was primarily responsible for teaching the design of perspective, architecture, and anatomy; and Annibale taught figure drawing. Before arriving in Rome, the Carracci men worked in Ferrara at the Palazzo dei Diamanti, where they created the decoration for a ceiling using the mythological themes associated with Venetian paintings, including those of Titian and Veronese.

DAY 20

AN ANGEL FREES THE SOULS OF PURGATORY

The Workshop of Annibale Carracci
1610

THEME: Mary is the intercessor of souls.

FOCUS OF THIS MEDITATION: Mary intercedes for the souls in purgatory, and she asks us to do the same on earth.

◀ The iconographic theme depicted in this painting represents a decisive moment, not only concerning the spread of praying for the poor souls in purgatory, but especially for new iconographic models. These models employed the macabre, intended as a *meditatio mortis,* in this case represented by the souls of purgatory. It marks a decisive shift of devotion's center of gravity toward the crowd of the poor in the afterlife and of all souls in purgatory deprived of any earthly help.

In great religious paintings, the theme of the souls in purgatory took the place of the theme of the Last Judgment, which had been typical in previous centuries. Similarly, the image of Mary, which previously had been used as an altarpiece of the main altars, began to be placed in chapels dedicated to the devotion of the souls of purgatory. This new image of the souls of purgatory emerged in treaties and in sermons of the seventeenth century as those in need of the living's help. The idea of a prompt return of thanks and favors in return for these intercessions became a common idea. Thus, representations of these souls of purgatory became common imagery in churches. Despite its growing popularity, this theme of purgatory was new to artists, but Mary was not. Considering how often her intercessory role is depicted in art, she was naturally linked to the plight of our brothers and sisters in purgatory.

SCRIPTURE MEDITATION

LAMENTATIONS 3:19–26

The thought of my wretched homelessness is wormwood and poison; Remembering it over and over, my soul is downcast. But this I will call to mind; therefore I will hope: The LORD's acts of mercy are not exhausted, his compassion is not spent; They are renewed each morning—great is your faithfulness! The LORD is my portion, I tell myself, therefore I will hope in him. The LORD is good to those who trust in him, to the one that seeks him; It is good to hope in silence for the LORD's deliverance.

Purgatory, from the Latin *purgare* (to make clean or to purify), has evolved in Catholic teaching over the centuries. However, as much as it has evolved, the foundation of this belief is the same as it was for Sts. Ambrose, Jerome, Augustine, Gregory, Thomas, and others of the early Church. This belief holds that many souls who depart this world in God's grace are not totally free of fault and are not yet ready to receive the fullness of the beatific vision. There is still purification to do. They are loved, forgiven, and accepted into God's eternity but need preparation before their final destination.

Some of these members of the early Church are pictured here with Mary in heaven, ready to intercede for and welcome into heaven the souls in purgatory. On the right side of the Virgin, one can identify the patron saint of Bologna, Proculus, who was a Roman officer martyred during the persecution of Christians under Diocletian. He is depicted with a cloak over his shoulder, carrying a spear. Next to him, the other patron saint of Bologna, San Petronius, a bishop who led the diocese of Bologna from 431 to 450, is represented. Petronius is depicted in his traditional manner, wearing episcopal robes with the insignia and the book. This depiction of the bishop shows his mature age with a white beard that makes him looks wise and fatherly.

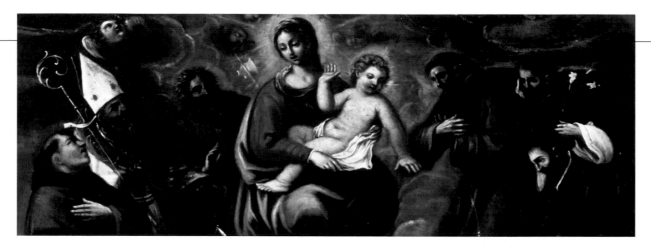

The next figure represented is St. Anthony of Padua, a teacher of theology once sent by St. Francis himself to halt the spread of the Catholic heresy in France and later transferred to Bologna and Padua. The iconography of St. Anthony includes a *summa* of symbols: the youth, the habits, the book, and the lily. These symbols hold both a memorial function in their expression of characteristics of his personality and a symbolic function in their representation of the gifts and qualities that were popularly attributed to him in devotion. Youth is connected with the ideal, pure, good character that welcomes everyone. The Franciscan habit (brown or black) recalls his belonging to the Franciscan order. The presence of the Child Jesus recalls the vision that Anthony would have at Camposampiero while expressing his devotion to the humanity of Christ and his intimate relationship with God. The lily represents his purity and his fight against the devil since childhood. Finally, the oldest symbol is that of the book, which represents his science, his doctrine, his preaching, and his teaching—always inspired by the book par excellence: the Bible.

To the Virgin's left, the artist represents St. Francis of Assisi, deacon and founder of the order that took his name. He is in a robe with hands folded to his chest, revealing stigmata wounds. According to the hagiographies, on September 14, 1224, two years before his death, while praying on the mountain of La Verna—the place where the namesake shrine was later built—Francis saw a crucified seraphim. Thus, after his death, traditional iconography always depicted Francis with the marks of the stigmata, a phenomenon that also earned Francis the name *alter Christus*.

Beside St. Francis are, from left, St. Dominic, founder of the Order of Dominican Preachers, who was proclaimed a saint in 1234, and St. Ignatius of Loyola, founder of the Jesuits and canonized in 1622.

It is not by accident that so much attention is paid to these holy people. We can ask for the intercession of these heavenly saints on our behalf and use their lives of exceptional holiness to inspire our own. It is for this reason we see beneath these saints and the Virgin Mary with the Infant, an angel descending to save a suffering soul. We believe that as a family of faith, our prayers for our departed brothers and sisters can bring them solace and help in this preparation process. Prayers, sacrifices, and acts of love offered for their sake can help them and us. We offer to take upon ourselves some of the purification they need and in this way we participate in their eternal growth and preparation.

Turning our attention to the lower half of the painting, our focus shifts to those in need of our intercession. Below, a series of naked men and women, depicted only from the waist up, invoke Mary while enveloped in flames. These figures are characterized by a solid monumentality and are voluminous. The artist's chosen palette emphasizes warm tones. The figures emerge with strength, while the clouds, lit from the top, contribute a large, lifting force to the whole scene, involving the Virgin juxtaposed with the figures of the souls in purgatory, relegated to the darkness. Stylistically speaking, the subjects differ from each other and are depicted with individual characteristics. Although the style of the painting appears harmonious as a whole, the representation of its figures are characterized by considerable stylistic differences, which is explained by the work's attribution to several artists.

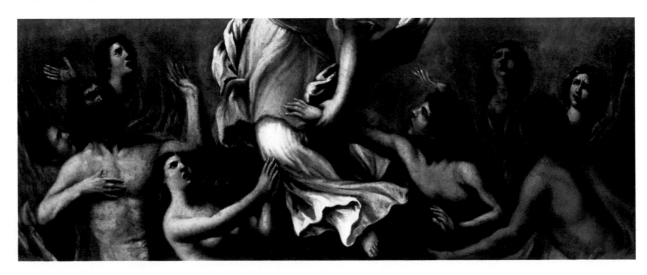

That there are personal consequences of sin, even after the sin itself has been forgiven by God, is supported by Scripture. God forgave man's first disobedience, but man must still suffer certain consequences. God forgave the lack of faith of Moses and Aaron, but they didn't enter the land of promise (Numbers 20:12). God pardoned the sin of David, but the life of the child wasn't spared (2 Samuel 12:13–14). And the New Testament teaches us that penitential acts are the real fruits of repentance (Matthew 3:8 and Luke 3:3). It is the Virgin Mary, directly above the angel, who is our chief intercessor to her Son. Here she is depicted wearing a red robe, a blue mantle, and a golden sash draped over her shoulders, sitting on the clouds. A series of rays, alternating with winged cherubs represented as childlike faces, seem to emanate from the Virgin, the only one of us worthy of assumption into heaven.

PRAYER AND REFLECTION

O my Jesus, forgive us our sins, save us from the fires of hell, and lead all souls to heaven, especially those in most need of your mercy. Amen.

- How do you view the time spent in purgatory?

- What are some events you must spend time preparing yourself to attend? Why is it so much more important to spend time preparing ourselves for heaven?

- What saints do you find particularly inspiring? Say a prayer that these saints will one day pray on your behalf when you are in purgatory.

Spiritual Exercise

- Say a rosary for all the souls in purgatory today.

ANGELS ALL AROUND US

ANGELS WERE POWERFUL PRESENCES in the life of the early Church. If God used his messengers in the Old Testament, in the life of his Son, and in the life of his Mother in the Gospels, then surely he would continue to send his messengers to the first believers of the New Testament!

These helpers guarantee the protection of the early Church (Acts 1:10 and Matthew 18:10). They accompany and protect Peter (Acts 12:7) and Paul (Acts 16:25) in the expansion of the early Church. Paul's letters show a doctrine of deep faith in the angels and how they work in the lives of Christ and his saints.

The angels help Mary Magdalene and the other women (Matthew 28:5) discover the power of the resurrection and go out as fervent apostles of the early Church. They accompany us in our worship as well as the celebration of a perpetual celestial liturgy (Revelation 12:1–9). The Scriptures invite the early Church to revere the angels (Revelation 22:8–9) with the respect due them but not to worship them, for they are fellow servants with us.

God knew the path of the first Christians would not be easy. They would face persecution and martyrdom as well as doubts and temptation. That is why God's angels were so important. They could provide the grace, comfort, and strength required to establish the Church.

But it was still up to those first members of the Church to accept that angelic help, just as it was up to Mary to say "yes."

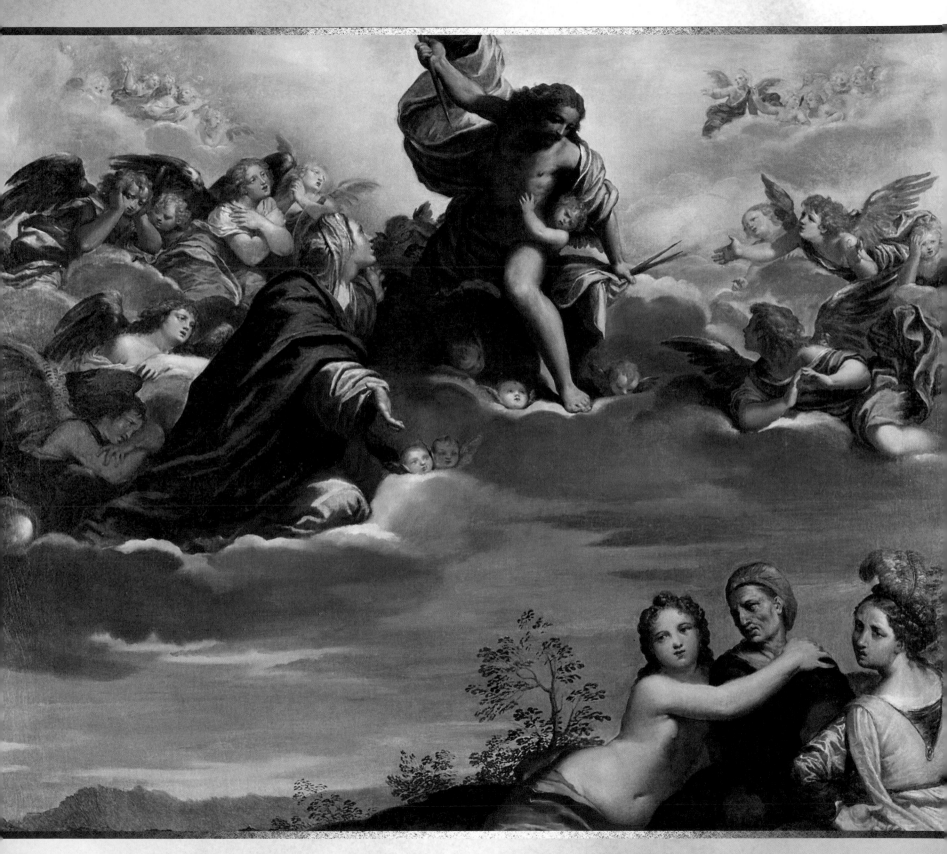

Virgin and Angels Imploring Christ Not to Punish Lust, Avarice, and Pride
by Ippolito Scarsella (called Scarsellino)

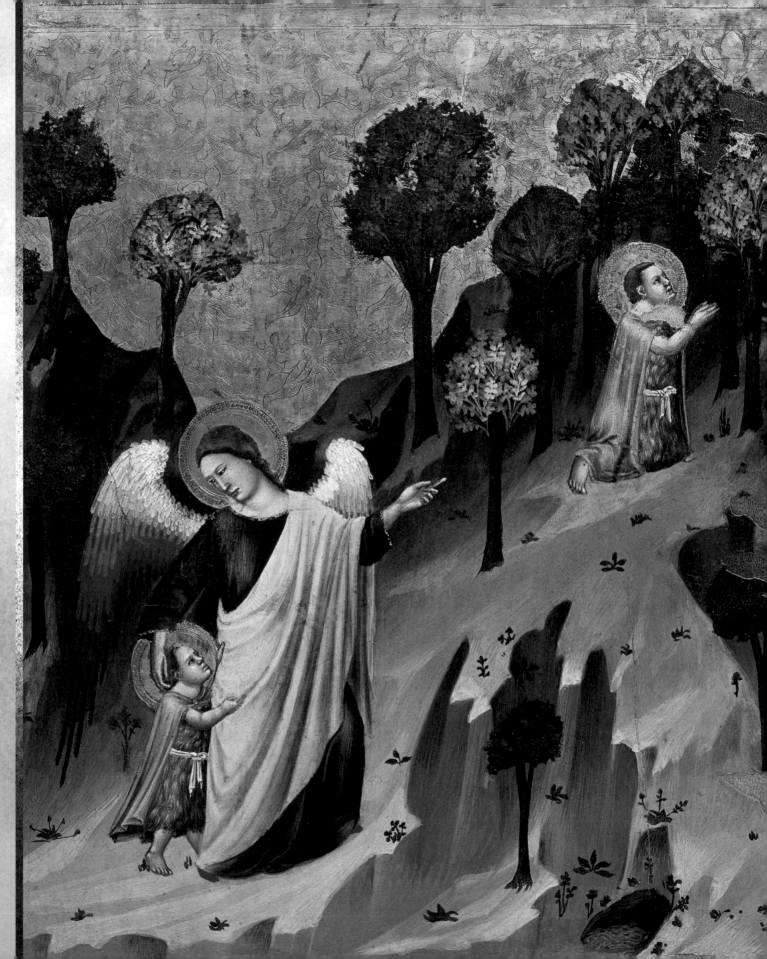

This painting, thought to be by Giovanni Baronzio (d. 1362), is part of a larger altarpiece that was dismantled and dispersed. Art historians have located over time the different panels of this complex ensemble. The work's central panel (currently preserved at the National Gallery of Art in London) shows the Virgin Mary flanked by scenes from the life of St. John the Baptist. The sections of the altarpiece are unified by similar decorative elements on the board and the physiognomy of the angels and personages in each of the panels.

The attribution of this panel continues to be a matter debated among art critics. It is still unclear who authored this masterpiece.

YOUNG ST. JOHN THE BAPTIST

Giovanni Baronzio
1340

THEME: Angels help us when we fail.

FOCUS OF THIS MEDITATION: The path of a Christian is not always easy, but God will provide angelic assistance.

◀ The protagonist of this painting is St. John the Baptist. In the New Testament, he is a prophet, a Jewish itinerant preacher and martyr who worked in Palestine in the late 20s. The Christian tradition considers him a relative of Jesus (his mother, Elizabeth, wife of Zechariah, is thought to be a relative of Mary), and the last of the Jewish prophets, the immediate precursor of the Messiah. John's martyrdom is celebrated on August 29, while his nativity is honored on September 24.

John the Baptist's preaching was centered on the idea of an upcoming turning point in the history of salvation and the announcement of the "stronger," identified with Jesus in Christian tradition. Baptism, the ablution he practiced in the waters of the Jordan River as a sign of repentance, was received by Jesus at the beginning of his ministry and implemented by him and his disciples. John was beheaded by order of Herod Antipas, probably shortly before the year 30.

In this painting, it is possible to see the encounter between John the Baptist and Uriel the archangel, who leads him on the Mount of Penitence in Jordan, recognizable from the source of water that flows in the lower right corner, and John's vocational call at seven years old. These episodes are not common in Western religious culture. The author of this painting probably has been inspired by Byzantine writers who hand down episodes from the proto-gospel of St. James.

On the left side of the painting is Uriel, who is approaching the young John and gesturing to the scene taking place further up the hill, presumably the future calling of young John. An adult John the Baptist appears praying on top of a mountain in a hermitic state of mind filled with peace and contemplation.

SCRIPTURE MEDITATION

JOHN 1:19–23

And this is the testimony of John. When the Jews from Jerusalem sent priests and Levites [to him] to ask him, "Who are you?" he admitted and did not deny it, but admitted, "I am not the Messiah." So they asked him, "What are you then? Are you Elijah?" And he said, "I am not." "Are you the prophet?" He answered, "No." So they said to him, "Who are you, so we can give an answer to those who sent us? What do you have to say for yourself?" He said: "I am 'the voice of one crying out in the desert, "Make straight the way of the Lord,"' as Isaiah the prophet said."

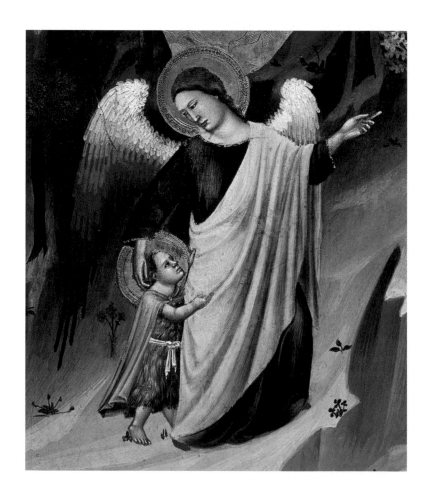

The life of a Christian is often like this painting: a journey in the desert. Now that Jesus has gone into heaven and sent us his Spirit, we must journey on toward him. The angels are there to point us toward our mission to bring the Gospel to the ends of the earth. Today's painting comes from an altarpiece from the 1350s. Other parts of this altarpiece on the life of St. John the Baptist are found in the National Gallery of Art in Washington (D.C.), in the Metropolitan Museum in New York City, and in museums in Florence, London, and Seattle. So John the Baptist's life and messages *are* reaching the ends of the world.

This panel focuses on a moment in the Baptist's life taken from the proto-gospel of St. James. According to this early text, John would have received his vocation to be the precursor to Christ at the age of seven. He wandered into the desert and there Archangel Uriel, who only appears in this apocryphal gospel, revealed John's future calling to him and eventually clothes him with a camel skin. And so John would have stayed in the desert preparing for his mission as Jesus would do later. This story was picked up and retold in one of the earliest books published in Italian in the 1330s titled *Vernacular Lives of the Holy Fathers* by Domenico Cavalca.

This book's retelling of the story could explain the two scenes in our painting. There is the young St. John being directed by an angel and another figure of the Baptist praying in the wilderness. The angel with his fiery wings gently cradles the head of the toddler and, with a kind gesture, points up toward the future scene. He playfully tugs on the angel's mantle as he covers him under the protection of his wing. These tender gestures couch the call and prophesy over the young John as expressions of love and tenderness. God's plans for us are always for our good.

These gestures can also refer to the tenderness with which God reached out to his Chosen People. John, the last and greatest prophet, comes to bring to fruition these plans of a future full of hope by ushering in the time of the Messiah. But in his infancy, there is no way the young John knows the fullness of his mission, and so the angel announces it to him and encourages him toward it. Perhaps you can think of moments when God pointed you toward your vocation or calling. Was it an inspiration received or a comment someone made or maybe a book that fell into your hands? God and his providence are always there, and he often uses his "angels," who come in different forms, to lead us.

The upper scene of the young child kneeling in prayer, dressed in his camel skin and looking like a young Franciscan friar, shows the way the angel extends to John to prepare for his prophetic mission. He went into the desert and lived in solitude and fasting, much like the monks of the Middle Ages. Just as it was for John the Baptist, prayer is always the best way to prepare for our mission. God forms us in prayer and sets us up for success. If there is any part of your life that overwhelms you or seems to be a bigger cross than you can handle, prayer is the best refuge and preparation.

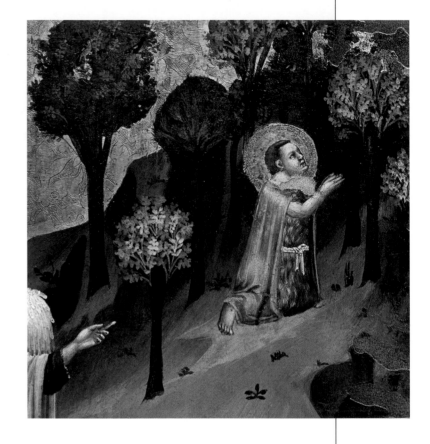

According to an ancient story, the angel meeting young John in the desert and pointing him toward the preparation in the desert happened on the Mount of Penitence near the Jordan River. At the far lower right you can see the small pool that comes from under the rocky mountain. This water source recalls the rock that was struck to give water in the desert (Exodus 17:1–7). It also points to the river where John would realize his mission to baptize, and finally it can speak to us about the baptism with the Holy Spirit that Jesus would come to bring. In all three cases, the water is a source of new life, new strength, and it gives us the power to continue following the Messiah, which John the Baptist would point out to us.

The typical golden background shows the Byzantine influence and reminds us of the spiritual context. Gold speaks of the divine, the eternal, and the heavenly. This event in John the Baptist's life is enveloped in the providential plan of God. All the events of salvation history, even those events of our own lives, have the golden lining of the divine plan. Placing faith in this spiritual context in which our lives are always playing themselves out helps us tremendously. No event, no matter how small, escapes the loving and providential plan of the Father.

PRAYER AND REFLECTION

Dear God, help me to be more like John the Baptist, to cultivate a life of prayer, reflection, and peace and to let everyone who comes across my path know about your Son. Send your angels to guide me when I stray and strengthen me when I fall. Amen.

- How old were you when you felt called toward a particular vocation, job, spouse, or religious life? How could you tell this was what God was pulling you toward?

- What would you do if an angel gave you a vision of your mission in life? Would you follow that path? Be afraid? Question? Feel relief?

- How can you help others discern their path in life?

Spiritual Exercise

- Spend some time "in the desert" with John the Baptist.

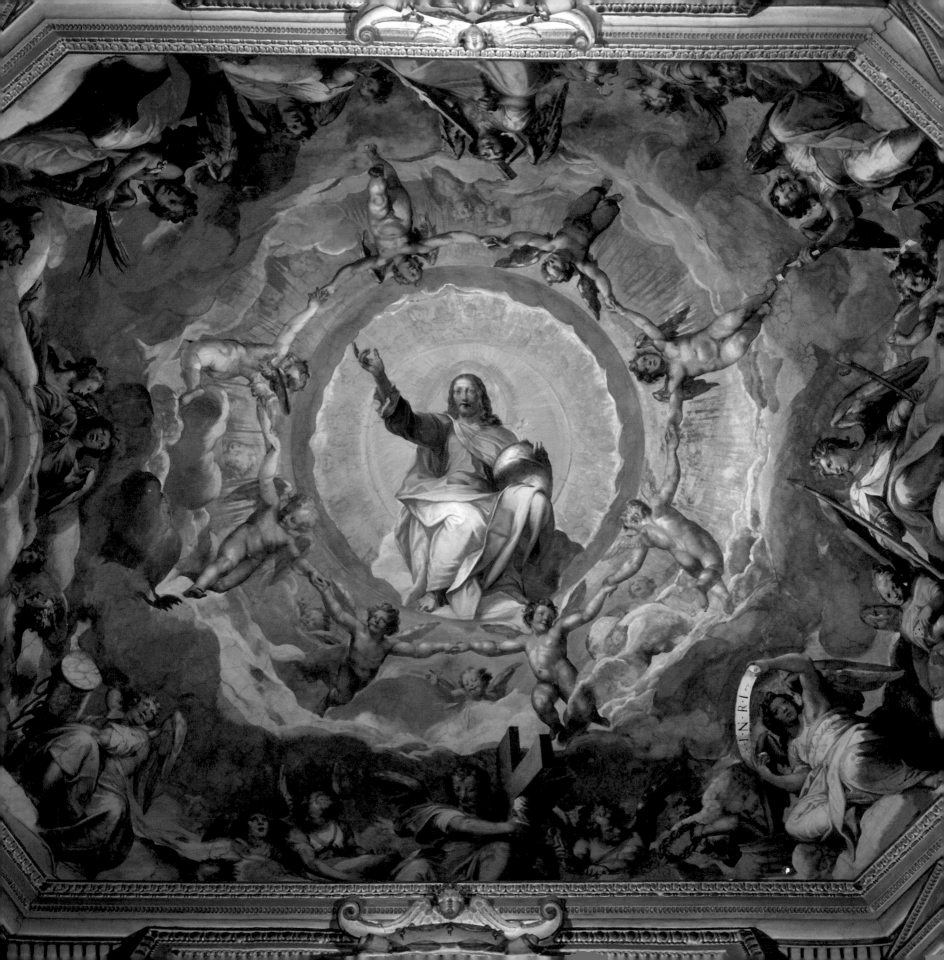

DAY 22

CHAPEL OF ST. LAWRENCE

Ceiling Vault
Lorenzo Sabbatini and assistants
Sixteenth century

THEME: Jesus ascends into heaven and leaves his apostles on earth to carry out his mission.

FOCUS OF THIS MEDITATION: We should contemplate the glorious ascension of Jesus into heaven, but even more so, focus on our mission on earth.

◄ At the center of the fresco painted by Lorenzo Sabbatini (circa 1530–1576) and his assistants on the vault of the chapel of St. Lawrence sits "Christ Pantocrator," a symbolic depiction of Jesus that presents him as the organizing principle of the cosmos, the Incarnate Logos and only begotten Son of the Father. The pantocrator representation of Jesus is intended to communicate that Christ is the key to understanding reality and the answer to the mystery of existence, and that, as such, human desire for order finds its consummation in him. In the fresco, a majestic, severe, cosmic Christ sits enthroned on clouds surrounded by concentric rows of jubilant angels, blessing the viewer with

his right hand while holding a *globus cruciger* with his left. In the Middle Ages, Christian kings used the *globus cruciger* symbol, a sphere crowned by a cross, on coins, icons, and royal regalia in order to represent Christ's rule of the universe. When the globus is held by Christ himself, as in this fresco, the subject is known in Western iconography as the *Salvator Mundi* ("Savior of the World"), and it is a composition that traditionally carries eschatological connotations. Although depicted in the work of a few Italian artists—including Sabbatini, Tiziano, and da Vinci—it is primarily associated with the work of Northern painters such as Jan van Eyck and Albrecht Dürer, who popularized the theme.

SCRIPTURE MEDITATION

ACTS 1:6–11

When they had gathered together they asked him, "Lord, are you at this time going to restore the kingdom to Israel?" He answered them, "It is not for you to know the times or seasons that the Father has established by his own authority. But you will receive power when the holy Spirit comes upon you, and you will be my witnesses in Jerusalem, throughout Judea and Samaria, and to the ends of the earth." When he had said this, as they were looking on, he was lifted up, and a cloud took him from their sight. While they were looking intently at the sky as he was going, suddenly two men dressed in white garments stood beside them. They said, "Men of Galilee, why are you standing there looking at the sky? This Jesus who has been taken up from you into heaven will return in the same way as you have seen him going into heaven."

Italian painter Lorenzo Sabbatini, a pupil of Prospero Fontana's, was inspired as a young artist by the work of Pellegrino Tibaldi and Parmigianino. He was also heavily influenced by the Tuscan-Roman Mannerist painter Giorgio Vasari, with whom he collaborated in decorating the Palazzo Vecchio in Florence (1565) and in preparing the equipments for the 1566 wedding of Francesco I de' Medici. Between 1566 and 1573, he lived in Bologna, painting the church of S. John Major (1566–1570), *the Dispute of St. Caterina* (1566–1573), and the Madonna and Child *Enthroned With Saints* (1572). Moving to Rome in 1573, he subsequently executed frescoes in the Vatican's Sala Regia and Pauline Chapel as well as the Pietà in the sacristy of St. Peter's Basilica, a work inspired by a group of Michelangelo sculptures located in the Florence Cathedral.

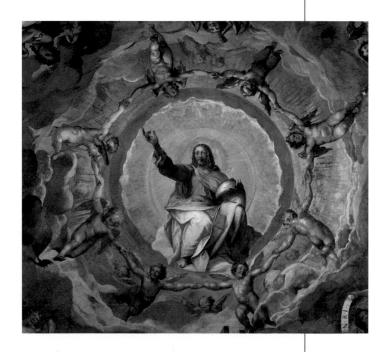

The beginning of the Book of Acts presents a summary of the life of Christ and how he called and taught the apostles in the power of the Holy Spirit. It summarized that after his resurrection, Christ kept the apostles in Jerusalem, and they prayed together with the Virgin and awaited the coming of the Holy Spirit, which would give them power to witness to him beyond the city and into the outlying countries and regions. This spirit was going to be a spirit of mission and witness. When Jesus was finished speaking, when his revelation had finished, he was taken up to heaven. The apostles were left standing there, looking up after him.

That looking up can be interpreted as a longing for or a desire for Jesus' presence, which was no longer going to be in the form it had been in before. Things had radically changed. Jesus' earthly mission had finished. The apostles' mission was now beginning.

The vision the apostles, standing with the Virgin, experienced could have been something like this ceiling scene painted by Sabbatini in St. Lawrence Chapel. Jesus is taken up into the clouds as he blessed them. There are beautiful angels bordering the heavens like spheres. The cupids in the first ring hold hands and circle around Jesus like children dancing in a park. They celebrate the return of the king, their fearless leader who stared death in the face and battled all the forces of hell and emerged victorious. He was now taking his rightful throne, and they are rejoicing at having him back. He also opens the gates of heaven so all the just of the Old Testament and all those deserving of heaven can now parade in and populate the mansions prepared for them from the beginning of time.

The angels who form the outer ring seem to almost sit on the ledges of the chapel walls as they hold symbols of the passion. This is a common theme, and we already saw it in *The Last Judgment*. These instruments of torture are now trophies, signs of his victory, spoils of war and thus celebrated symbols in heaven! So it will be with what bothers us most on this earth if we embrace them with love. The signs of our own passion, our own crosses, will be in heaven, our greatest pride!

I will list each of the symbols going counterclockwise, starting with the cross. Pause on each and consider the suffering they caused, but above all notice how Jesus' love and fortitude helped

him embrace each. The symbols are the cross, the pliers used to remove the nails, the crown of thorns, the INRI sign, the cards from the games played by the soldiers, the spear of Longius, the sponge on a hyssop stick, the hammer, the nails, the coffer of water with which Pilate washed his hands, the ladder, the ropes to lower his body, the palm branches from the entry into Jerusalem, two angelic figures that represent Mary and John (who were at the foot of the cross), and the pillar of the flagellation.

After contemplating this angelic scene, we are also mesmerized like the apostles. Staring up into the heavenly court, we also want to go and be with him. Yet we, like the apostles, are invited by the angels to get about our mission of evangelization until Jesus returns again. "Men of Galilee," our Scripture says, "why are you standing there looking at the sky? This Jesus who has been taken up from you into heaven will return in the same way as you have seen him going into heaven."

These angels shake the apostles from their contemplation and affirm a truth of faith. Jesus will come back just as he left. The king has left each of his servants with talents to administer in his absence (Matthew 25:14–30). The Second Coming of Jesus is a fact that the angels told the first apostles about, and they tell us. And so this little group of eleven priests and lay women return to Jerusalem to pray with Mary, who was given to them at the foot of the cross, and to await the power of the Holy Spirit. This is also a necessary step for each of us: to hear the voice of the angels that tells us Jesus will return. For now we are to be close to the apostles and Mary, pray, and get ready to receive the Holy Spirit, who will send us as witnesses!

PRAYER AND REFLECTION

A Prayer for One's Calling

Jesus, Divine Caller of vocations,
You invite some to chosen professions,
Others to distinctive spiritual work!
Your call may reflect one's ambitions,
Or may be a command to a special calling.
Inspire me to always know within my heart,
What particular type of work is fitting
To do Your will at that particular time.
Your many callings vary immensely.
They are all reflections of Your Holiness.
Thank you for my heavenly calling and
For maintaining the vocation of Your choice!

- What have you done recently to further the mission of Jesus? In what ways have you answered the call to spread the Good News?

- Is Jesus asking something new of you now that he wasn't asking before?

- Consider the reflections of the figures in this painting. Which one best reflects your expression of faith? Are you confused, saddened, eager? Which of these figures do you aspire to be like and how can you learn from their example?

Spiritual Exercise

- Consider where you fit into the mission of Jesus and what your role has been. Pray that you may hear his call and serve him in whatever way he sees fit.

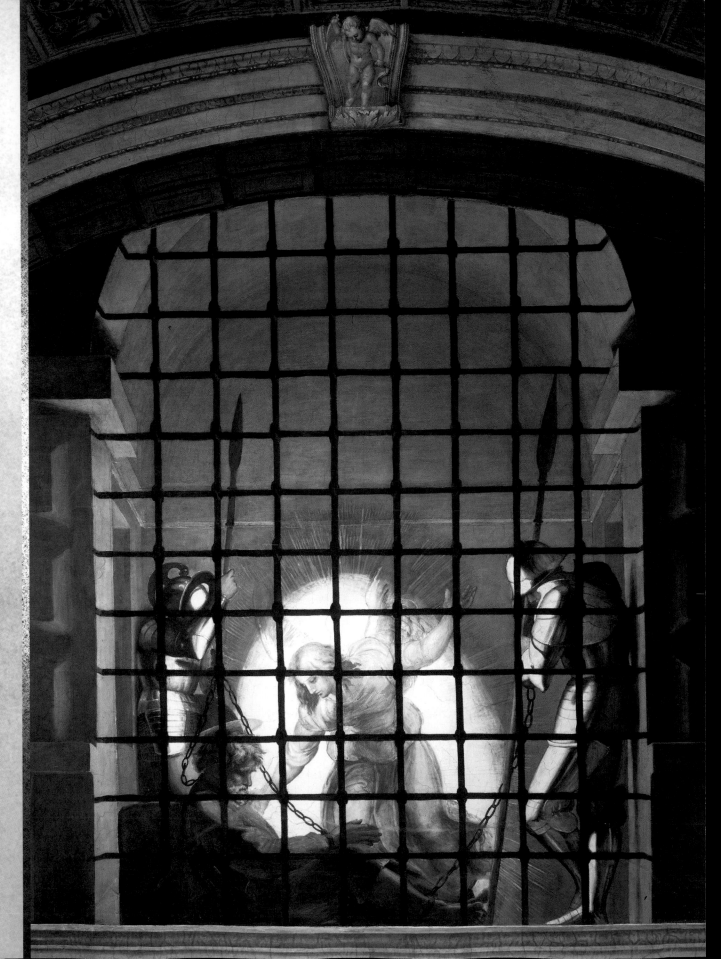

The Deliverance of St. Peter is a pendant to two other frescoes working to demonstrate the spiritual and temporal supremacy of the Catholic Church, manifested by a special divine intervention: *The Expulsion of Heliodorus From the Temple of Jerusalem*, from which he wanted to steal the sacred vessels, and *The Meeting Between Leo the Great and Attila*. Leo the Great is depicted with the same features of Leo X (1513–1521), the successor of Julius II (1503–1513).

In this second room, Raphael abandons the harmonic style and muted tones of the previous room, creating a dramatic pathos and using dark colors, which seem to draw a comparison with the work of Michelangelo. In this fresco, there is not only an obsessive reach toward perfection and geometric perspective but also a certain originality of style in the use of light and shadow—one of the first known nocturnal paintings in Italian art.

THE DELIVERANCE OF ST. PETER

Raphael Sanzio
1514

THEME: God protects the apostles, including the pope.

FOCUS OF THIS MEDITATION: God protects the Apostle Peter, the first pope. He sends his angels to help and deliver him.

◄ *The Deliverance of St. Peter* is a wall fresco painted by Raphael and his assistants and completed in 1514. It is situated in the Room of Heliodorus, one of his famous frescoed Vatican Rooms. Raphael had already prepared the first drawings for these frescoes in the summer of 1511, even before the painting of the first room, the Room of the Signatures, had been completed. The Church had recently suffered a loss against the French, which gave them the city of Bologna and was under constant threat of foreign armies. Thus, Julius II suggested to Raphael the subject matter of miraculous interventions to protect the Church. *The Deliverance of St. Peter*, in particular, represents the triumph of the first pope by divine intervention at the height of his tribulations.

For this fresco, Raphael (1483–1520) planned a strongly unified scene, despite the articulation of the wall into three zones due to the interruption of a window in the wall. Each zone is a scene in the story. At the center, beyond a grate and between dark and massive curtained walls, a radiant angel appears in the prison, where Peter sleeps deeply, bound by chains. The appearance of the bright, glowing angel backlighting the dark, grated prison walls generates a stunning effect of spatial depth.

SCRIPTURE MEDITATION

ACTS 12:3–5, 7

And when he saw that this was pleasing to the Jews he proceeded to arrest Peter also. (It was [the] feast of Unleavened Bread.) He had him taken into custody and put in prison under the guard of four squads of four soldiers each. He intended to bring him before the people after Passover. Peter thus was being kept in prison, but prayer by the church was fervently being made to God on his behalf.[…] Suddenly the angel of the Lord stood by him and a light shone in the cell. He tapped Peter on the side and awakened him, saying, "Get up quickly." The chains fell from his wrists.

*God will surely work miracles
in our lives and set us free,
like he did for St. Peter.*

The bright flames in the background reach forth to illuminate all the elements of the scene, including the prison walls, displaying a reddish glow. Peter looks old and tired, depicted in this way perhaps to allude to the 1513 death and release from earthly prison of Julius II, or perhaps to commemorate the liberation of Leo X, a cardinal at the time, from captivity following the Battle of Ravenna.

On the right, an angel leads the apostle out of the prison in an atmosphere that seems somewhere between dream and reality, evoked by the presence of the guards, who miraculously fall into a deep sleep. On the left of the scene, other soldiers are depicted in the moment they discover the escape, illuminated by moonlight and the glow of their torches reflecting upon their armor. Notice the soldiers are dressed like Swiss Guards; notice how realistic the light appears as it falls on their armor.

Many people who visit me in Rome ask and are concerned about the pope's security. I tell them not to worry, not just because Vatican Police and the Swiss Guard are the first-class outfits that they are, but because the pope has an army of angels protecting him. The Vatican Police and Swiss Guards would be the first to affirm that they have seen things that only divine protection could explain. I remember a story about St. John Paul II's trip to Bosnia in 1997. The bridges his motorcade would cross were inspected routinely, including on the night before his arrival. On the day his plane landed, police found mines under a bridge on the route—thanks to a citizen's tip. Yes, angels protect the Holy Father, just as they have been since St. Peter.

Saint Peter and the other apostles became courageous proclaimers of the good news after the power of the Holy Spirit came down upon them. Peter even told the Jewish authorities that he had no other option but to proclaim his faith, for it was more important to obey God than to obey men. Subsequent Holy Fathers and many Christians have followed St. Peter's advice. And for many, it has cost them their lives. The angels have always been busy protecting the bold apostles. Are you bold enough to need a little more angelic backup?

Peter's preaching finally leads to his arrest, and it is at this point we pick up today's passage and the Raphael fresco that helps us envision it. Peter is locked up in the prison and could have let fear or concern overcome him. He might have wondered if it was better for the fledgling Church that he steer clear of trouble in order to dedicate more time to accompany its adherents. The painting can inspire you to reflect on his fear, doubt, concerns, and the "now what do I do" thought that might fill his heart. Admire Peter's response and ask if yours would be the same. After being there for a few days, on the night before his trial before the same man who tried Christ his Lord and condemned him to death, he sleeps peacefully between the soldiers. He seems to have not a care in the world!

What brings him peace? He is doing all he can by asking the Church to pray and then simply awaits his chance to testify about his Savior, Jesus Christ. He applies the adage of controlling what he can and accepting things he cannot change.

And before this trust and abandonment, God answers the prayers by sending his angel. Read the Scripture passage again and notice the parallels with Jesus' own trial and resurrection.

Arrested because it pleased the people, Jesus was captured before Passover, placed under soldiers' guard, condemned, and taken into custody. His resurrection differs from Peter's story, of course, for Jesus had to give up his life for many. In the Raphael painting, it is not time for Peter's death, although the artist depicts the act of God's power like a resurrection. As happened with Jesus, Peter, slumbering, lies in a tomb as the angel of God enters into this sealed space. With a glorious burst of light, the angel walks Peter out of the grip of death while the soldiers sleep.

Peter can hardly believe what is happening, which leads us to believe he fully expected to go to his trial. He didn't anticipate such a powerful act of intervention! Then when he arrives at the church united in prayer, the people can't believe it either. They think they are seeing his angel and not really him! It's funny that all are praying for his release and protection, then when God frees and guards him, they can hardly believe. Again, just like the resurrection of Jesus. We often pray and then are surprised to see our prayers answered as we hoped. We don't often expect God's power to be so evident, but we should. If we trust and pray with openness, then God will surely work miracles in our lives, like he did for Peter and the early Church. He wants to set us free and send us back to our task of preaching and extending the kingdom, just like Peter did.

It is beautiful to read Peter's testimony once he gets inside and talks with the praying family. He credits the Lord, even though the angels appeared to him and did the work. This reinforces what the Church already believed about angels. God sends them, and all the credit and glory goes to him. They are merely doing their jobs. If we honor them, pray to them, and write books about them, it is merely to honor and bless God, who sends us such glorious creatures for our protection. The Church and the pope are under *their* protection because the Church and the pope are under *God's* protection.

Jesus promised us that the gates of hell would not be strong enough to withstand the attack of the Church. In the first battle, Lucifer attacked Michael. Ever since, God has battled to get back what is rightfully his, as shown by the first pope's miraculous escape from jail with angelic assistance. Renew your faith in God's action in the world through the Church and the pope. Call on the angels to protect the pope and all apostles of God.

PRAYER AND REFLECTION

Hear us, O holy Lord, Almighty Father, eternal God, bestow your favor on us and send your angels from heaven to guard, cherish, protect, visit, and defend all of your people; through Jesus Christ, our Lord. Amen.

—Adapted from *The Angel of Prayer* (1861)

- How do you find peace in the stressful or frightening situations you face?

- Think of a time God answered your prayer in the way you expected. Why is it hard for us to believe God really is in our lives?

- God constantly seeks to protect and defend our souls. Perhaps you haven't noticed. Name some ways you can protect yourself from temptation and evil.

 Spiritual Exercise

- To make your next Mass or time of prayer even more special, thank Jesus for the angelic protectors in your life. In addition, thank a priest, religious, or lay minister in your church for leading you toward Christ.

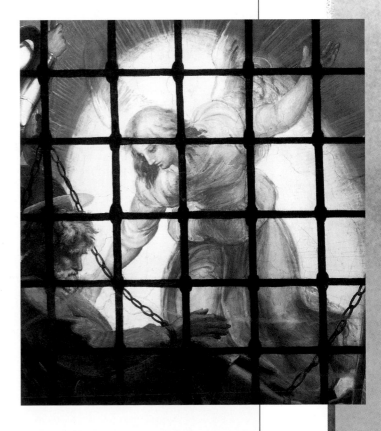

DAY 24

ST. MATTHEW AND THE ANGEL

Guido Reni
1635–1640

THEME: God inspires the first apostles to spread the faith.

FOCUS OF THIS MEDITATION: God inspired the first apostles in a special way, and he inspires each of us. We need to let that grace and inspiration govern our lives as we follow his plan and transform ourselves into what he has in store for us.

◀ Guido Reni (1575–1642) was one of the greatest artists of his time, widely appreciated by his contemporaries. He worked in Rome and Naples but especially in his hometown, Bologna. Reni's style is close to the classicism of Carracci, but with a more personal and controlled interpretation, which, beyond the study of the classics, conveys a real appreciation of the fullness of the Baroque, employing an elegant, rigorous structure and a high use of color.

He was first a pupil of the Flemish painter Denys Calvaert from 1585 to 1594, and then he entered the Academy of the Carracci. In his early works *(Coronation of the Virgin)*, Calvaert's teaching is still visible, together with the influence of Annibale and Ludovico Carracci. However, in later works *(Resurrection)*, Reni steps away from merely

following his learned technique, and the results are images in stark contrast to those of his teacher, and they achieved fame almost immediately. In 1601, he was called to Rome by Paolo Cardinal Sfondrato to execute paintings for the church of St. Cecilia in Trastevere *(Martyrdom of St. Cecilia* and *Coronation of Cecilia and Valerian)*. He remained in the city with brief absences before heading back to Bologna in order to decorate the cloister of S. Michele in Bosco in 1614. He returned to Rome in 1621 and 1627.

Spending time in Rome enriched Reni's artistic experience: He encountered Caravaggio's *Crucifixion*, among other works. Reni picked up on the stylistic manner of Caravaggio, blending it into his own techniques and balancing it with his own personal and idealizing style.

Starting in 1608, the artist began working for the Borghese family in Rome, where he carried out many important commissions—frescoes in the Aldobrandini wings of the Vatican: *St. Andrew Led to Martyrdom* in St. Gregory al Celio (1609); paintings in the Chapel of the Annunciation at the Palazzo del Quirinale (1609–1610); decorations of the Pauline Chapel of Santa Maria Maggiore (1610–1612); and *The Aurora* in the casino of Palazzo Rospigliosi (1613–1614). Meanwhile, he also managed to complete projects in Bologna, including *Massacre of the Innocents* in 1610.

In Bologna, Reni established himself as the greatest artist of the time, due to his personal interpretation of Carracci's developed classicism based on his study of Raphael, Correggio, Rubens, and Veronese, and elements of contemporary sculpture. His paintings are characterized by an elegant yet tight structure paired with a masterful use of color. In the third decade of his career, Reni introduced the application of silvery, light, and precious tones in his paintings, which can be seen in his *The Annunciation* and *Christ Giving the Keys to St. Peter* (1620s).

With the help of Bernardino Cardinal Spada, he painted the *Abduction of Helen* around 1630; for Maria de Medici, the altarpiece of the plague about 1631; and *St. Michael the Archangel* in St. Mary of the Immaculate Conception in Rome in the 1630s. His later works (for example, *Cleopatra*) have a free and feathered brush stroke that recalls sketching, in part due to the absence of their effective finish, caused by the death of the artist.

While one of the most important and admired artists in the history of Italian painting, Guido Reni is at times forgotten or condemned by critics. The artist's fall from favor began during the Romantic era. It was not until the twentieth century that his painting was critically reviewed for its undisputed value.

The essential core of Reni's work centers on his constant aspiration toward achieving an ideal inner beauty in which he invested his feelings and thoughts. Reni's idealism expressed, through the beauty of his forms, not so much the perfection of human reason as the perfection of the divine. In fact, in his painting Reni had a tendency to deify forms, to touch upon an unearthly perfection.

However, as an artist is always shaped by his period of influence, Reni's classic forms and idea of beauty were coupled and fused with Baroque aesthetics. Behind his proud and ostentatious ambition to capture perfection, harmony, and beauty lies a hidden contradiction. Antinomies of that time—the ideal and the real, nature and fiction, classicism and Baroque, paganism and Christianity—are present in his work. Reni commonly featured the apostles and the evangelists several times in his career. There are two copies of his series of the evangelists, one in Rome and one in Naples. The Vatican Painting Gallery features his *St. Matthew and the Angel*, which was acquired in 1924 as part of a donation of the Castellano collection.

SCRIPTURE MEDITATION

MARK 2:14–17

As he passed by, he saw Levi, son of Alphaeus, sitting at the customs post. He said to him, "Follow me." And he got up and followed him. While he was at table in his house, many tax collectors and sinners sat with Jesus and his disciples; for there were many who followed him. Some scribes who were Pharisees saw that he was eating with sinners and tax collectors and said to his disciples, "Why does he eat with tax collectors and sinners?" Jesus heard this and said to them [that], "Those who are well do not need a physician, but the sick do. I did not come to call the righteous but sinners."

*Jesus comes
not to cast down
but to lift up.
Not to throw out
but to purify.*

oday's image is one of our most simple. Just two basic colors—white and shades of brown. Just two subjects—an angel and an elderly man. Just two objects—a book and a pen. But simplicity favors depth.

Christ called Matthew, a tax collector, to be one of his twelve apostles. Ancient written testimonials from the first century—matching Christian tradition since the year 200—recognize Matthew as the author, in Aramaic, of the Gospel in which he is also called Levi, or tax collector (Matthew 9:9, 10:3). As a tax collector, Matthew was a member of one of the most hated groups of the Jewish people. These traitors paid taxes to the Roman tax authorities in advance and then collected taxes from the people in order to get their money back, and then some. By being so steeped in the handling of pagan coinage—which bore the image of the emperor—they were judged by the priests as constantly breaking the First Commandment of not having or honoring graven images.

Matthew, in Reni's painting, is depicted as an elderly man with a beard. He is rugged, strong, tested, yet delicate, refined, and attentive. In the simplicity of the composition, Reni is able to focus on the dialogue between Matthew and the angel that will end up upon the parchment. As a tax collector, Matthew would have been looking at a fellow Jew and jotting down in his ledger the taxes the person paid. He would have been meticulous, precise, demanding, and attentive. His information had to be real and correct, for his job depended on it. He also had to have a thick skin to handle the daily insults and suspicion. In the painting he is depicted doing the same thing he used to do, but in a new way. Once this despised man, enemy of the people, and collaborator with the occupying forces, encountered Jesus Christ (as Caravaggio's famous painting of the *Call of Matthew* depicts), who said, "Follow me," everything changed! He discovered someone who didn't condemn him but wanted to give him a higher calling. "For God did not send his Son into the world to condemn the world, but that the world might be saved through him" (John 3:17). This new love harnessed all his qualities for a new mission and a new passion.

This same thing can and does happen to us. Christ has not come to condemn your qualities, your gifts, your passions, what you love to do. He has come to save what is beautiful in them and set you free to use all your talents and abilities to build his kingdom. He wants you to bear fruit

in abundance! And not only now, but forever. "It was not you who chose me, but I who chose you and appointed you to go and bear fruit that will remain" (John 15:16). So Jesus comes not to cast down but to lift up. Not to throw out but to purify. What is Jesus asking you to use or do in a new way with or through him?

The other figure also has a lot to tell us. This older man humbly and attentively looks into the eyes of the golden-haired angel who innocently but decidedly stares back at him. There is no escaping this angel's message. It may be innocent but it is by no means weak. The white of the lovely cotton toga that covers his shoulder morphs so realistically into his feathered wing. He is utterly realistic, is truly of this world, but just as certainly comes from another. Angels are real, they are powerful, and they are here firmly inserted into our world. And they have a serious mission that should be taken seriously. Matthew took the inspiration of God so seriously that the angel has become his symbol. Spend a few moments reflecting and praying over the innocent yet firm invitation God is placing squarely before you in this period of your life.

Now that we have meditated briefly on Matthew and then on the angel, let's meditate on the conversation between them. Doesn't the way Reni depicts this intimate moment of inspiration make you want to lean in and listen? In fact, the open space between Matthew's chest and shoulder almost invites you to move right into the picture, for we would not disturb the balance. So move in, listen, imagine what he hears, think of moments you have been inspired by God.

Reni shows us the essence of the conversation through the hand gestures. The angel is holding his pointing finger as if re-"counting" to the accountant the points he should insert into his Gospel balance sheet. In so doing, Reni fulfills a mission he held in his heart and which the Council of Trent encouraged artists to embrace—communicate the truth through your creative gifts. Reni is simply communicating an important truth of the Counter-Reformation. Namely, that God inspired the human authors of the sacred books. "To compose the sacred books, God chose certain men who, all the while he employed them in this task, made full use of their own faculties and powers so that, though he acted in them and by them, it was as true authors that they consigned to writing whatever he wanted written, and no more" (*CCC* 106).

And one final point is important. The painter uses the folds and lines of Matthew's shirt to tell us something. The V-neck tunic points us right to his heart and onto the empty page. The angle of the quill also supports this relation. Thus the action of the Holy Spirit symbolized by the light and the angel works on his intellect (his head), his beard (wisdom), and flows through his heart (chest) and work (hand) to arrive onto the paper (Scripture). The inspiration of God touches all areas of our person and involves all our skills and capacities to make us able instruments of his salvation for others. You can also pray about how your life is an empty page onto which God wants to write his inspirations.

The name Matthew means "gift of God." Some suppose his name was changed as a way to indicate the change in his life (just as Simon became Peter and Saul became Paul). But more than his name, Christ changed his heart. He went from being a fisher of money to a fisher of men. He went from counting money to recounting good news. God can work that same transformation in your life as well. Listen to him speaking to you and then follow him.

PRAYER AND REFLECTION

[You know] where lies the goal of my desire, and for Whose sake I would climb the Mountain. You know who possesses the love of my heart. For him only I set out on this journey; lead me by the paths of his choosing: my joy shall be full only if he is pleased. Amen.

—Adapted from Thérèse of Lisieux's *L'Histoire d'une Ame* (1898)

❧ How are you already working to communicate God's truth in your everyday life?

❧ How can you use your skills and talents to better serve God?

❧ Is God calling you to follow him in a new way at this stage in your life? How can you begin to transition onto this path?

❧ If you could step into this scene, what kind of conversation do you think you would overhear? What kind of conversation would the angel have with you?

 Spiritual Exercise

❧ Get a journal or, if that is too intimidating, a sheet of paper. Write down your reflection on this painting. Let God inspire your words.

Day 24: St. Matthew and the Angel

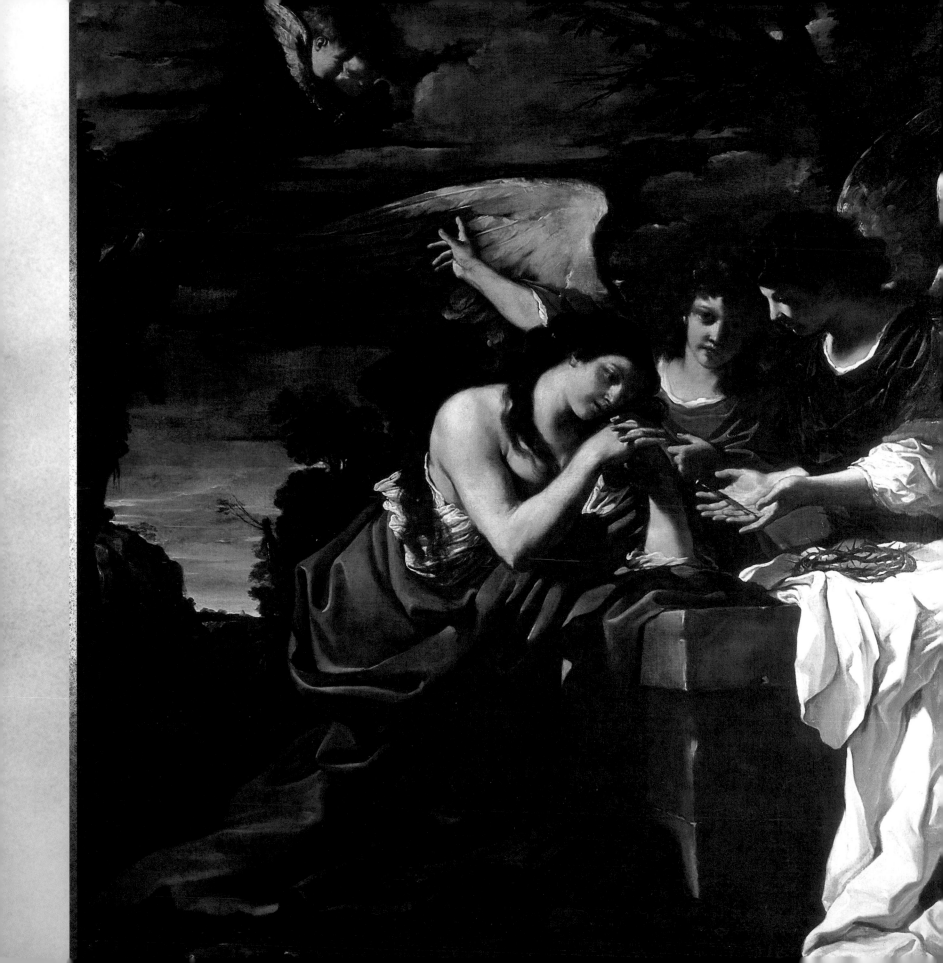

THE PENITENT MAGDALENE

Giovanni Francesco Barbieri (called Guercino)
1622

THEME: Angels help us when we fail and need to repent and renew our love.

FOCUS OF THE MEDITATION: Allow God's merciful love to reach into your soul and call you up higher and higher. He isn't worried about your past as much as your present search for him, humble admittance of your sins, and the fullness to which you embrace his mercy.

◀ Giovanni Francesco Barbieri, known as Guercino (1591–1666), is considered one of the most representative artists of the High Baroque period. His technical ability and originality had a considerable impact on the evolution of decoration during the seventeenth century. The work of Guercino is completely devoid of the heaviness and opacity that burdened the work of his contemporaries. Guercino used strong contrasts of light and airy shades in his work, not to build out his drama as Caravaggio did but rather to create a level of freshness and transparency in his images.

In 1621, Pope Gregory XV and his nephew, Ludovico Cardinal Ludovisi, called Guercino to Rome to paint, among other things, the Mary Magdalene in the Painting Gallery in the Vatican, *The Burial of St. Petronilla* in the Capitoline Museums, and the admirable decoration of the *Aurora* in the Casino Ludovisi. The influence of Guido Reni became clearer in his work, and with it the art of Guercino turned toward an academic style, in composition and color, construction, and even in themes and motifs. By this time, Caravaggio's influence on the first style of Guercino was nonexistent or, at least, weak. The total transformation of Guercino's painting is the most powerful evidence of the artistic and cultural crisis at hand, around 1630, which led to the triumph of the so-called "Baroque classicism."

SCRIPTURE MEDITATION

JOHN 20:15–18

Jesus said to her, "Woman, why are you weeping? Whom are you looking for?" She thought it was the gardener and said to him, "Sir, if you carried him away, tell me where you laid him, and I will take him." Jesus said to her, "Mary!" She turned and said to him in Hebrew, "Rabbouni," which means Teacher. Jesus said to her, "Stop holding on to me, for I have not yet ascended to the Father. But go to my brothers and tell them, 'I am going to my Father and your Father, to my God and your God.'" Mary of Magdala went and announced to the disciples, "I have seen the Lord," and what he told her.

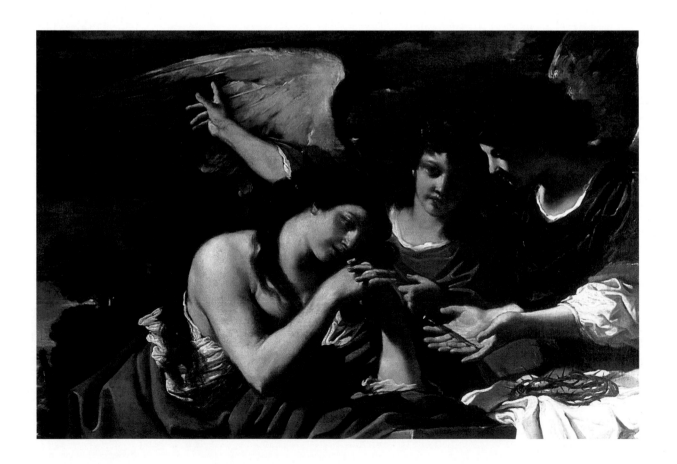

This painting of Guercino presents the penitent Magdalene, one of the most popular subjects depicted in Christian worship. The figure of Mary Magdalene has a range of different interpretations in the Christian tradition: The most widespread belief identifies her as the penitent Mary from whom seven demons were cast out (Luke 8:2 and Mark 16:9) and who cried upon the feet of Jesus in the house of Simon the Pharisee. There is a second popular Mary in the Gospels who could be the same Mary or different. She is the sister of Martha and Lazarus, at whose house Jesus often stopped to rest. This Mary was often included in the list of the twelve apostles, especially in the last hour of his passion and death. She is also remembered as the first to testify to the resurrection of Jesus.

In his painting, Guercino portrays the Magdalene with shoulders uncovered due to her loosely fitting tunic. Her disheveled hair reminds us of her former life. Yet in strong contrast to her past, she is at present meditating on the symbols of the passion of Christ and prayerfully leaning on the altarlike tomb of our Lord. This could be the very moment when she is mourning the disappearance of our Lord and the empty tomb. Our passage tells us she encounters two angels dressed in white. "And they said to her, 'Woman, why are you weeping?' She said to them, 'They have taken my Lord, and I don't know where they laid him'" (John 20:13).

Yet here the artist breaks from the historical moment just before she sees our Lord and focuses on the penitent spirit from which her love for him springs. The angels hold out the symbols of the passion: the nails that held his feet and hands as well as the crown that caused him so much pain. The sinful Mary who had been forgiven so much is also one who has loved much (Luke 7:47).

She was not so ashamed of her sins that she wasn't willing to offer a public act of humility and break into the dinner party of Simon and sob over the feet of Jesus. She bathed his dusty feet with her tears of pure repentance and then dried them with her long and lovely hair. Guercino shows those same long locks as they drape over her neck and shoulder. What once was a means to attract impure attention is now consecrated to her new Beloved!

The symbols of the passion that the angels hold out before the saint could mean two things. First, they signify the instruments that inflicted the horrendous suffering by which Mary Magdalene is forgiven. They could also be held up before her as evidence of the angels, that he

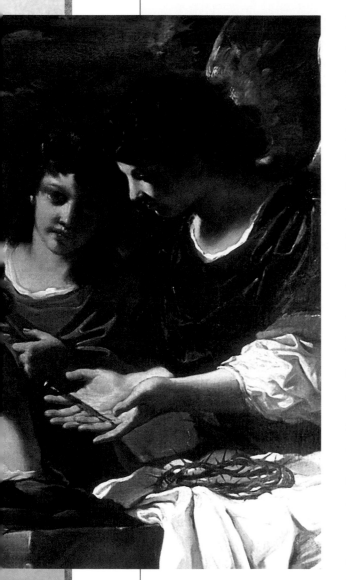

is no longer suffering these torments, for he is risen and up in heaven, where one of the angels points.

In either case, by reverently returning to the tomb, symbol of his suffering, she is placing herself once again at his feet. She wants to repeat the experience she had the first time she encountered him. In another first encounter with Christ, often attributed to Mary of Magdalene, a woman had been caught in her weakness by accusing priests and was dragged out into the public, facing certain stoning. Christ, with a simple gesture and phrase, confounded her enemies and sent them away. "'Woman, where are they? Has no one condemned you?' She replied, 'No one, sir.' Then Jesus said, 'Neither do I condemn you. Go, (and) from now on do not sin any more'" (John 8:10–11).

She is aided in this moment of prayer and devotion by the angels. The whole coupling of the scene and arrangement of the figures is called the "penitent" Magdalene because the composition looks strangely like a person kneeling in confession. Speaking with head downcast, she recalls her littleness. And as in confession, the representative of God sits on the other side, encouraging her to consider God's love and mercy. The angel in the center who is pointing up to heaven shows us to whom she is really confessing and is reminding us that all forgiveness and mercy comes from God above. The cost of her sins is already paid with the instruments before them both.

In our passage, Jesus reveals himself to Mary. Thus she is the first one to receive the good news of the resurrection. The angels prepare her and us to understand and accept this most amazing proclamation. As soon as he calls her name, she is filled with love and throws herself at his feet. Let us also throw ourselves at his feet and embrace him for the love he has shown us!

PRAYER AND REFLECTION

God, we ask you to flood our hearts with your grace, that we—to whom the Incarnation was made known by the message of an angel—may by his passion and cross be brought to his glory and resurrection. Amen.

—Adapted from *The Angel of Prayer* (1861)

- Which "Mary" do you most relate to? Is your faith strong, or are you just beginning to take steps toward Jesus?

- We cannot weep at Jesus' feet to ask forgiveness in this world, but there are other ways for us to show our repentance. How can you show God you truly want his forgiveness?

- No matter your past, you can transform yourself into a stronger follower of Christ. How will you start (or continue) that transformation?

Spiritual Exercise

- Think of someone you may have wronged or slighted recently and go to that person joyfully to ask for forgiveness.

ANGELS WALKING WITH US

ANGELS, PRESENT SINCE time began, remain with us today. The same angelic protection and company provided to Jesus, Mary, and the first apostles is there for each of us.

Whether by the holy conversations we can develop with our saintly brothers and sisters who have gone before us or by turning to our own guardian angel, the power of these pure spirits who worship the Father are there to come to our aid and help us as we grow in our faith.

The role of these holy ones is not to distract us from Christ but lead us to him. Even if we find it hard to imagine the angelic nature or understand what exactly they do and how they do it, we can have no doubt that their sole goal is to lead all souls back to God the Father, in obedience to God the Son, and in union with God the Holy Spirit. The angels are his messengers sent from him to lead us back to him.

The protection of the angels is not a magical solution against the perils of the world. Through Sts. Peter and Paul, we see that angelic consolation and help did not ultimately keep them from martyrdom but gave them the grace to continue living their faith and accept what God had planned. The role of angels is not to make our lives easy or leisurely but to help us see God's will for us and trust in him even when he gives us crosses to bear.

Our guardian angels watch over and protect us, but they can never take away our free will. We still have to choose Christ and his plan. They can only help make that choosing easier. They are part of the chain of love that links each of us to God. Because they love God, our guardian angels love us, God's beloved creation, and because they love us, they pray for our salvation.

Jesus did not reject the angel's consolation in the Garden. Mary did not ignore their annunciation. Mary Magdalene learned from them of the resurrection. St. Peter and St. Paul followed the angels out of their chains. These guardians are there for your good and your salvation. So why not turn to your angels and get all the help you can get!

Angel in the Night by Felice Casorati

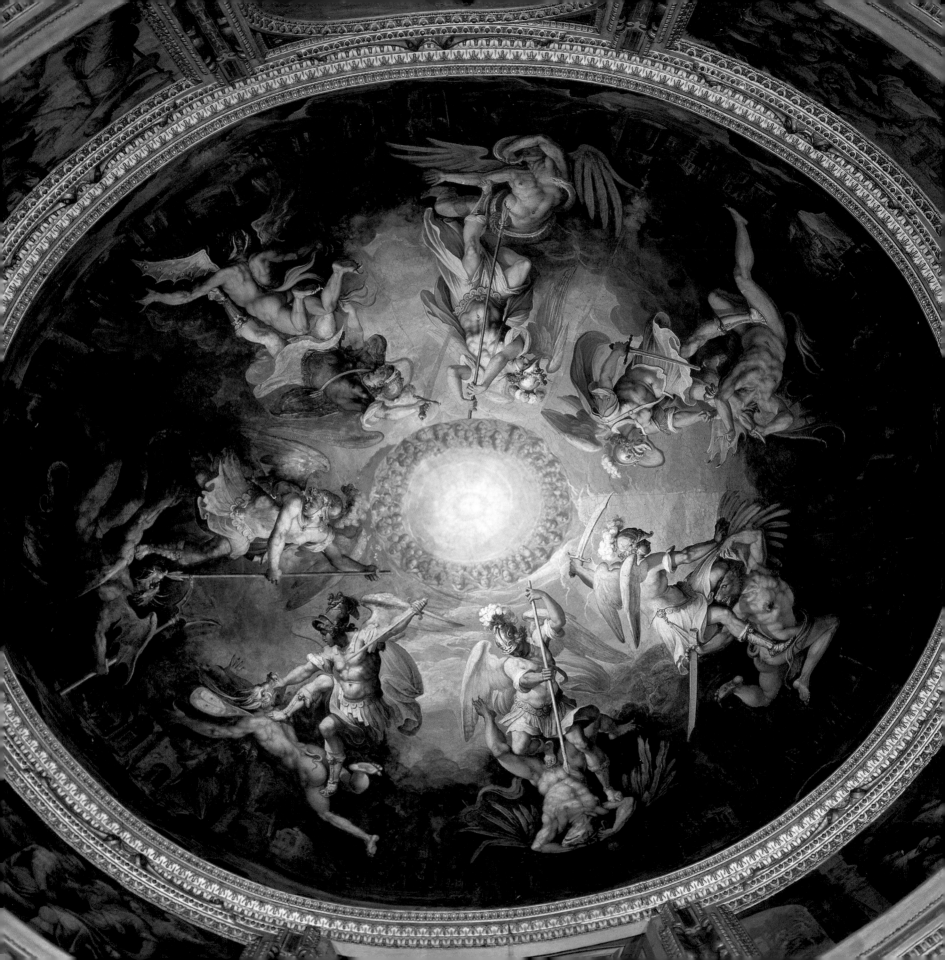

THE FALL OF THE REBEL ANGELS

Giorgio Vasari and Jacopo Zucchi
1524–1530

THEME: Angels defend the Church and help us when we need to repent.

FOCUS OF THIS MEDITATION: Allow God's merciful love to reach into your soul and call you up higher and higher. No matter where we're coming from, we can turn our talents and skills to use in glorifying God's kingdom.

◀ Today we have a work of art, painted by multiple artists, where we know the individual artists who contributed to it. The first artist is perhaps the more famous of the two. Giorgio Vasari (1511–1574) was an Italian painter, architect, and art historian strongly influenced by Michelangelo and Andrea del Sarto. His artistic training was based on early Mannerism, Michelangelo, Raphael, and Venetian artistic culture. In his architectural career, he was a key figure in the initiatives supported by Cosimo I de' Medici. Vasari greatly contributed, thanks to the protection of Sforza Almeni, to a number of great construction projects in Florence and Tuscany, including the construction of the Uffizi and the restructuring of the Palazzo Vecchio.

The second artist, Jacopo Zucchi (circa 1542–circa 1596), was a pupil of Giorgio Vasari's and eventually became his main collaborator. He participated in the decoration of the Salone dei Cinquecento and the Studiolo of Francesco

I in the Palazzo Vecchio in Florence. In 1572, he settled in Rome, where he painted frescoes for the palace and villa of Ferdinando Cardinal de' Medici. He also produced many works with religious subject matter for the churches of the capital, including the vault with *The Fall of the Rebel Angels* in the Chapel of Michael of the apartments of Pope Pius V.

The execution of the theological theme of this fresco is closely tied to the themes commonly found in works of other artists of the Counter-Reformation. Specifically, these artists were encouraged to paint Bible stories guided by sacred text. This cupola decoration is marked by concentric bands. The outer part of the fresco, closest to the walls, presents an architectural perspective of a city in flames. This could very well refer to the sack of Rome, which was still a very dramatic memory for those who lived in Rome at the time. Proceeding toward the center, angels are armed with swords and spears, fighting diabolical figures.

SCRIPTURE MEDITATION

REVELATION 13:5–8

The beast was given a mouth uttering proud boasts and blasphemies, and it was given authority to act for forty-two months. It opened its mouth to utter blasphemies against God, blaspheming his name and his dwelling and those who dwell in heaven. It was also allowed to wage war against the holy ones and conquer them, and it was granted authority over every tribe, people, tongue, and nation. All the inhabitants of the earth will worship it, all whose names were not written from the foundation of the world in the book of life, which belongs to the Lamb who was slain.

I want to look at this particular moment in Scripture in order to recall that this is not an event of the past, even if the fall of the angels chronologically happened at the beginning of history. Rather, it is a reality going on right now. The Church is engaged in a battle with the enemy of Christ right now, in our lifetime. The battle began long ago. And the power of the devil was most fiercely unleashed on Christ at the cross. Having been conquered at Golgotha, the devil has gone away to work more subtle deceptions until the final battle.

As the *Catechism* states, "Victory over the 'prince of this world' was won once for all at the Hour when Jesus freely gave himself up to death to give us his life. This is the judgment of this world, and the prince of this world is 'cast out.' 'He pursued the woman' but had no hold on her: the new Eve, 'full of grace' of the Holy Spirit, is preserved from sin and the corruption of death….'Then the dragon was angry with the woman, and went off to make war on the rest of her offspring'" (*CCC* 2853).

That battle that began in the beginning of time has only become more intense since the coming of Christ. The Church and all those who work for good will discover the resistance of the evil one and shouldn't be surprised by it.

These two Counter-Reformation artists depict the fallen angels with human bodies but feral faces, including details that foreshadow their transformation into fallen angels. Their horrific physiognomies owe part of their inspiration to the Book of Revelation, where our passage for today is from. Admittedly, the descriptions there seem to be the stuff of sci-fi movies or a *Lord of the Rings* battle scene. Yet these ghastly descriptions have a theological root. They want to reveal that the moral monstrosity of demons is reflected in their physical deformity, obtained by unnaturally fusing parts from various beings into one—reptiles, insects, amphibians, mammals, and humans. In our painting, some have already sprouted bat wings and serpentine queues, while others still have their angelic wings intact.

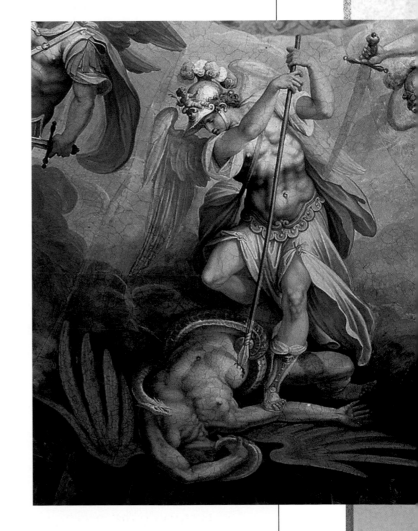

At the center of the vault, cherubs form an oval, observing the scene and illuminating the struggle with a warm light. Its colors are iridescent and rich in variety, truly capturing the scene of the fall.

The fresco contains a high level of meticulous detail, even though it is seen from below at a considerable distance. Many of the painstaking details can only be seen in these up-close digital photos, but it's obvious the artists paid great attention to the scene even though they thought these details were never going to be seen. They were attentive and precise because they didn't just work for pay or to get work done as cheaply and as quickly as possible. They were artists who loved what they did. For an artist, one does beautiful things for no pragmatic end, but rather because it is right and beautiful to do right and beautiful things. And they were painting a chapel—a place for God, who would see each detail. God invites you to be a detailed person who does things for love of him and not just to be seen on earth. Offering up these acts of love also means conquering the evil one.

St. Luke explained that when the disciples returned to the master full of joy for the fruits they harvested in their first missionary activity, Jesus utters, "I saw Satan fall like lightning from heaven" (Luke 10:18). With these words, the Lord proclaims that the work of the apostles in favor of the kingdom of God has effects in the spiritual realm. When the Gospel is preached and sinners convert and the sick are healed, the devil and evil spirits lose ground. Jesus also implies that the inverse is also true: The building up of the kingdom is continuously exposed to attack by evil spirits, and we must not be blind to this fact.

The fallen angels have been cast into this world, as the *Catechism* reveals, and so there should be no surprises when the Church, the body of Jesus Christ, suffers resistance. The "fall" extends from the free choice of these created spirits who radically and irrevocably rejected the Creator and his kingdom, usurping his sovereign rights and attempting to subvert the plan of salvation and creation.

We need to put on the armor of God and get ready to help ourselves and the Church resist the challenges posed by the fallen angels. The first step is to be aware of their existence and not to be naïve about their active work to lead us away from our Savior. The next is our continual work to grow closer to Christ and his Church.

PRAYER AND REFLECTION

O Glorious Prince of the heavenly host, St. Michael the Archangel, defend us in battle and in the struggle, which is ours against the princes of powers, against the rulers of the world of these shadows, against the spiritual beings of worthlessness, in the heavens. Come to the aid of men, whom God created inextinguishable, and made to the image of His own likeness, and bought from the tyranny of the devil at a great price. Amen.

—Adapted from *Prayer to St. Michael the Archangel* by Pope Leo XIII (1886)

- How often do you, like our fresco painters, give your best work to be seen and appreciated only by God? Is it difficult to give up that earthly credit?

- When do you feel "resistance" on your journey to grow closer to Christ? Is that resistance internal or external?

- If you do feel an external force trying to pull you off the correct path, what are some things you can do to overpower it? What if that voice comes to you from inside yourself?

～ *Spiritual Exercise* ～

- Whatever the talents and skills God has given you, use them to create something beautiful. Then give it back to God.

The *Madonna di Foligno* was the first Roman altarpiece painted by Raphael. It was placed above the high altar of the church of Santa Maria in Aracoeli in Rome, in whose apse the tomb of Sigismund was placed. The painting was, in fact, commissioned by Sigismund de' Conti, personal secretary *(scriptor apostolicus)* of Pope Julius II, as a votive offering for a miracle. The story goes that his house in Foligno survived after a quake while all the other houses around were destroyed.

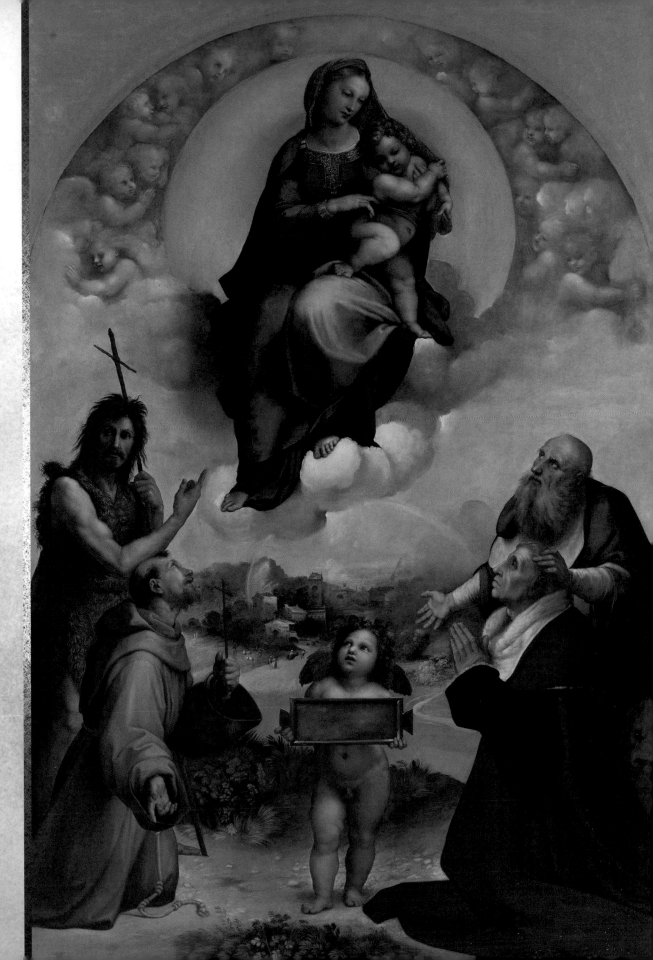

DAY 27

MADONNA DI FOLIGNO

Raphael Sanzio
1511–1512

THEME: Holy conversations inspire us toward our goal of heaven.

FOCUS OF THIS MEDITATION: The angels are there to guide, accompany, and inspire us along the path to heaven. The Church Militant (us) needs the help of the Church Triumphant (angels)!

◀ The work is dated to 1511–1512, while Raphael (1483–1520) was working on the Room of Heliodorus in the Vatican Apostolic Palace and is the closest precedent to the Sistine *Madonna.* In 1565, Anna Conti, a nun and niece of the donor, transferred the painting from the church of St. Anna at Foligno to the Monastery of the Countess of Blessed Angelina of Counts of Marsciano. In 1797, it was requisitioned during the French occupation and taken to Paris, where it resided in the Great Napoleonic Museum of the Louvre. Due to the precarious state of conservation of the painting, it was decided to transfer it onto canvas. Francois Toussaint Hacquin was the restorer who carried out the delicate work from 1800 to 1801. Following the Treaty of Tolentino, the painting returned to Italy (1816), and Pope Pius VII decided to place the masterpiece in the Vatican Picture Gallery, where it could be appreciated by all and seen near other works Raphael had done in the same period.

The iconography of the altarpiece was developed in connection with a preexisting fresco (now destroyed) by Pietro Cavallini in the same basilica of Santa Maria in Aracoeli. It represented the apparition of Mary and Child, wrapped in a circle of light, on the Capitoline Hill in Rome, which emperor Augustus had on the very day Jesus was born. The painting of the *Madonna di Foligno*, originally placed under this fresco, would resume the theme of the work of Cavallini, adapting it to the sepulchral epitaph of the client, who died before it was completed at the ripe old age of eighty. This could explain the hollow face of the patron, which appears as a sort of death mask.

Similarly, the *tabula ansata* with no inscriptions held by the angel proposes an early Christian funerary iconography, which is also present in tombs of the fifteenth century as well as the tomb of Pope Sixtus IV.

SCRIPTURE MEDITATION
LUKE 1:41–47

When Elizabeth heard Mary's greeting, the infant leaped in her womb, and Elizabeth, filled with the holy Spirit, cried out in a loud voice and said, "Most blessed are you among women, and blessed is the fruit of your womb. And how does this happen to me, that the mother of my Lord should come to me? For at the moment the sound of your greeting reached my ears, the infant in my womb leaped for joy. Blessed are you who believed that what was spoken to you by the Lord would be fulfilled." And Mary said: "My soul proclaims the greatness of the Lord; my spirit rejoices in God my savior.

One of the main roles of the angels now is to accompany the members of the Church on their path toward heaven. We often talk about the Church Triumphant in heaven helping the Church Militant here on earth. We are still fighting the good fight of faith as we strive toward the heavenly family that awaits us. They, on the other hand, are there in the celestial grandstands looking down, cheering us on and lending us a helping and intercessory hand when we call on them.

Today we meditate on a famous painting of Raphael that helps us imagine the communion that exists between the whole Church, those on earth and those in heaven. The classification for these types of Renaissance paintings is called a *sacra conversazione*—a holy conversation. These paintings normally include a heavenly figure, usually the Virgin, and then a mix of saints and patrons in the lower register. There is one conversation with various participants, those already in heaven and some still below.

Our prayer now is a sort of holy conversation. You are sitting in God's presence, with our Lady attentively listening to everything her divine Son wants to say. Your protector angels are here, as are the saints to whom you have devotion. All are discussing and contemplating a fantastic

conversation. That is why I picked the passage of the visitation. Mary and her cousin, Elizabeth, have a holy conversation as they discuss the great things God has been doing in their midst. Holy conversations that build up the soul are so important in our spiritual growth, and we would do ourselves well to invest in those relationships that give this kind of spiritual nutrition. A diet of too much tabloid talk makes us spiritually slow and lethargic.

Now let's meditate on the painting itself. The Madonna, dressed in red, the color of the mother, and in blue, the color of the queen, appears seated on clouds and surrounded by an areolar disk. The verse from Revelation 12:1 ("A great sign appeared in the sky, a woman clothed with the sun") is not lost on Raphael. In turn, she is surrounded by a ring of blue seraphim taking shape from the clouds. At Mary's feet, a natural landscape expands, from which emerges a small town dominated by a rainbow. This rainbow is the sign of God's fidelity, the promise to Noah that he would never again destroy the world due to its sin. Mary and the Savior Son in her lap are the fulfillment of that promise.

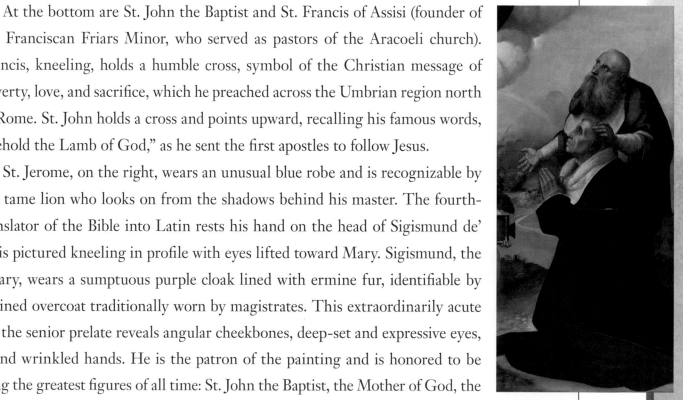

At the bottom are St. John the Baptist and St. Francis of Assisi (founder of the Franciscan Friars Minor, who served as pastors of the Aracoeli church). Francis, kneeling, holds a humble cross, symbol of the Christian message of poverty, love, and sacrifice, which he preached across the Umbrian region north of Rome. St. John holds a cross and points upward, recalling his famous words, "Behold the Lamb of God," as he sent the first apostles to follow Jesus.

St. Jerome, on the right, wears an unusual blue robe and is recognizable by the tame lion who looks on from the shadows behind his master. The fourth-century translator of the Bible into Latin rests his hand on the head of Sigismund de' Conti, who is pictured kneeling in profile with eyes lifted toward Mary. Sigismund, the papal secretary, wears a sumptuous purple cloak lined with ermine fur, identifiable by a long, fur-lined overcoat traditionally worn by magistrates. This extraordinarily acute portrayal of the senior prelate reveals angular cheekbones, deep-set and expressive eyes, with bony and wrinkled hands. He is the patron of the painting and is honored to be placed among the greatest figures of all time: St. John the Baptist, the Mother of God, the

Father of Scripture study, and the most famous Italian saint (Francis). Raphael knew how to flatter—and how to challenge. He might be saying to Sigismund, Are you worthy to be in this company? What would you be conversing about with them? Or perhaps, what would these conversationalists think of all your other conversations? Being in heavenly company always challenges us to be worthy of heaven.

The landscape, characterized by a foggy and trembling atmosphere, is full of light effects of great originality. The connection between the two sections is intensified by the color-light orchestration and by the numerous exchanges of gestures and gazes: John, Francis, and the angel

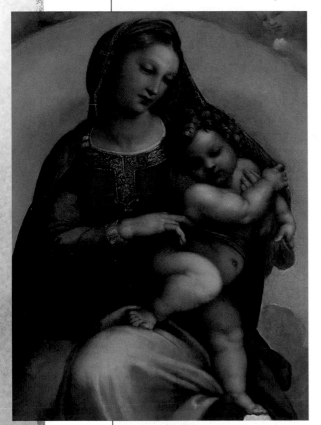

direct the viewer's eye to Mary, who caters to the donor. The group of the Madonna and Child, unified in an oval under the protective mantle of Mary, is characterized by natural beauty. The Child, for example, is not portrayed as a statuesque divinity imparting a blessing but as a real playful or fidgeting child who seems to break free from the embrace of the mother to cover himself under the veil. The Son—beautiful, serene, sleepy—rests his right leg bent on the thigh of the Mother, while his left leg, straight, stands on a cloud. Mary holds the Infant with her left arm, and he wriggles gracefully in a torsional twist. The middle finger of the right hand of the Mother seems to tickle the Baby with playful affection.

This reminds us that our holy conversations with our Lord and our Lady need not always be serious and dour. In dealing with them, we should be real, spontaneous, and even playful. If your dealings with God are only formal, add sincerity, honesty, and joy.

Finally, at the center, a little angel turns a dreamy look toward the heavenly apparition and holds in his hand an antique tablet with no inscription that almost jumps off the painting. Perhaps the empty epitaph indicates that the painting was unfinished, or perhaps Raphael wanted to leave a space for the viewer to add his or her own epitaph.

PRAYER AND REFLECTION

August Queen of Heaven! Sovereign Mistress of the Angels! You who from the beginning has received from God the powers, and mission, to crush the head of Satan, we humbly ask you to send the Holy Legions that, under your command and by your power, pursue evil spirits and drive them into the abyss of eternal woe. —Adapted from *Our Lady Queen of Angels*

✠ If you were part of this heavenly conversation, what would you discuss with Mary and the saints?

✠ What would this heavenly group think of the earthly conversations you normally have?

✠ How can you try to have more spiritually inspiring conversations?

~ *Spiritual Exercise* ~

✠ With your family tonight, or the next time you are all together, turn the conversation to edifying things and work to strengthen everyone's faith.

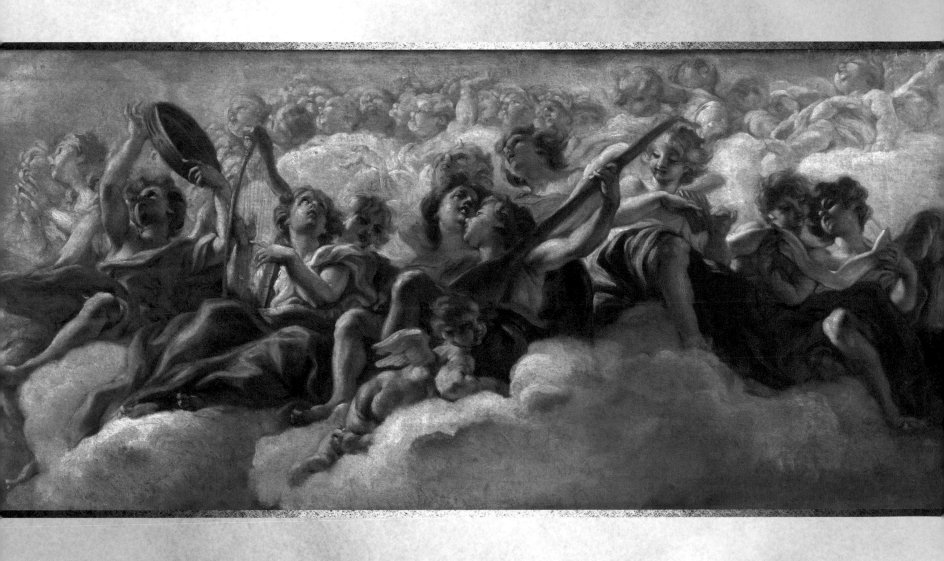

CONCERT OF THE ANGELS

Giovanni Battista Gaulli (called Baciccia)
1672

THEME: The hierarchy of angels

FOCUS OF THIS MEDITATION: Scripture mentions nine classes of angels and gives each a particular mission. This separation helps us to appreciate their diversity and call on their aid.

◀ Giovanni Battista Gaulli, nicknamed Baciccia (1639–1709) was an Italian painter who studied in Luciano Borzone's studio, where he encountered the art of Rubens and Anthony van Dyck. Inspired by the styles of these two greats, he adopted a very free brushwork as well as a predilection for using a wide range of colors. Baciccia settled in Rome in 1657 and entered into the entourage of Gian Lorenzo Bernini. Because of his balanced temperament and similar tastes to Bernini himself, he quickly became one of Bernini's most gifted collaborators. In fact, Bernini himself recommended the artist for the decoration of the spandrels in the dome of Sant'Agnese in Agone (1668 to 1669) and introduced him to the Jesuits. This landed Baciccia the job of decorating the Church of the Gesù (1674–1679), with frescoes in the vault, the chancel, and the chapel of St. Ignatius.

After a brief return to his homeland, Baciccia triumphantly returned to Rome, where he painted the ceiling of the Basilica dei Santi Apostoli with the *Triumph of Franciscan Order* (1707). He then began a series of cartoons for the mosaics of the baptismal chapel of the Basilica of St. Peter, which were never executed and were replaced after his death with the work of Francesco Trevisani.

Concert of the Angels entered into the Vatican Museums collection in 1924 as a gift from Cavalier Antonio Castellano of Naples. This painting, depicting a concert of angels, is characterized by a swirling Baroque movement that animates both the figures and drapery of the angels. The angels in the foreground are depicted in typical gestures of praising the Lord. Some are singing hymns, others are playing musical instruments. Bright clouds line the background of the empyrean, the place in the highest heaven that, in ancient cosmology, was supposed to be occupied by the element of fire. Here it serves as the passageway toward closeness to God.

SCRIPTURE MEDITATION

REVELATION 4:1–3, 10–11

After this I had a vision of an open door to heaven, and I heard the trumpetlike voice that had spoken to me before, saying, "Come up here and I will show you what must happen afterwards." At once I was caught up in spirit. A throne was there in heaven, and on the throne sat one whose appearance sparkled like jasper and carnelian. Around the throne was a halo as brilliant as an emerald....The twenty-four elders fall down before the one who sits on the throne and worship him, who lives forever and ever. They throw down their crowns before the throne, exclaiming: "Worthy are you, Lord our God, to receive glory and honor and power, for you created all things; because of your will they came to be and were created."

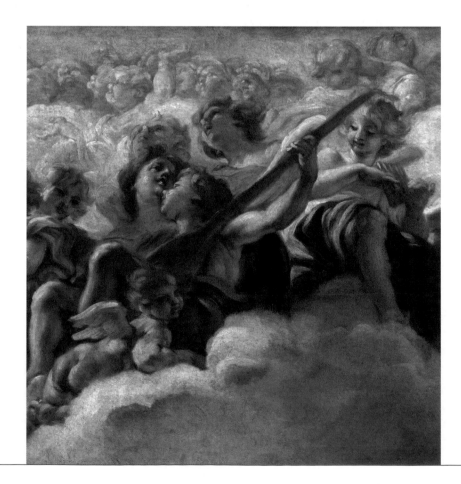

*I*n contrast with the fallen angels of day 26, here we have the heavenly angels engaged in the heavenly liturgy. It is important to meditate on this point because when we worship with the Church, we are also taken into the heavenly liturgy, attended by thousands upon thousands of angelic choirs.

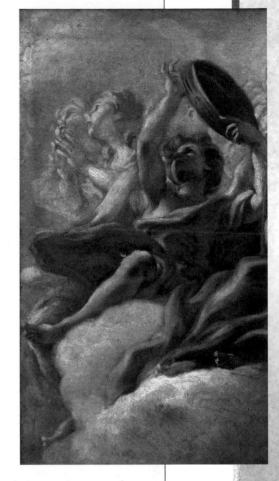

Here we have the beautiful arrangement of an angelic choir. Each member of the band plays an instrument, as we have seen in other paintings. The point we could first focus our meditation on is the idea of harmony. The angels in heaven have each fully and totally embraced the divine will, and so each of their actions and missions are united in a divine harmony. Each angel is like an instrument that, when played by the divine will, makes an exact sound, with proper pitch and tone, in perfect rhythm and timing. There is something sublime and celestial about classical music, and part of the reason lies in this idea of harmony amidst amazing multiplicity. There are many instruments and musicians playing notes, each measure in exact and utter harmony with the whole, in rapt attention to the conductor. An orchestra moves the soul like few things can.

Beautiful liturgy is like a concert as well. When each movement of the ministers is paused, measured, elegant, directing our attention beyond themselves and into the mystery they are celebrating, a beautiful harmony is the result. When beautiful music is inserted into beautiful liturgical prayer along with the respectful participation of both ministers and the laity, it really is a slice of heaven. The Extraordinary form of the Oriental Rite Liturgies are particularly gifted windows into the divine in this way.

Medieval theology and the artistic representations it spawned divided the angels into nine levels or choirs. Their love for putting order into creation and making mental distinction can seem artificial to those of us not accustomed to this way of "dividing" reality. Nonetheless, it has its interior logic and can help us understand that, just as the natural realm is unique and complex (which is not the same as complicated), so is the spiritual world. This term "choir" and the many

references to angels in liturgical functions in heaven led many painters to depict these otherwise spiritual creatures as angels playing musical instruments.

Scripture mentions nine ranks of angels throughout the Old and New Testaments. And Scripture has them being "sent" to do multiple tasks and errands. If you were to make a database of angelic passages using their names and the tasks medieval theologians discovered, they parse out into nine categories subdivided into three groups of three.

The first three classes of angels see and adore God directly—his angelic "board of directors." First, the seraphim are the highest choir and closest to the throne of God; they see him clearest. They are called seraphim because the word means "the burning ones," closest to the flame of divine love. Next, the cherubim contemplate God, but less his person and more his providential

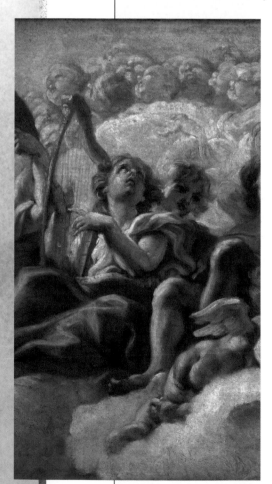

action. Finally are the thrones; they contemplate God's power and judgment.

Angels in the second class are like middle management and focus on carrying out or fulfilling God's providential plans. The dominations or dominions command or rule over the angels who serve under them. Then come the virtues (meaning power or energy), who run the universe and the heavenly bodies. Finally this triumvirate finishes with the powers, who fight against evil influences seeking to thwart the plans of the virtues.

The final group is directly involved with human affairs—like an angelic sales force on the ground. The principalities care for cities, nations, and kingdoms. The archangels are the middle group and carry God's important messages to humanity, as we have seen in our meditations. Finally, each person is assigned a guardian angel.

Again, this can seem arbitrary at first sight since angels are just up there doing their thing. Yet if meditating on Scripture, artistic creation, and angels has taught us anything, it is that the spiritual world is real and far from being "just up there." It is markedly in and around us "down here." Angels are in and around God the Father in heaven but also in and around the world and, even more, in and around each of us.

PRAYER AND REFLECTION

They see their Savior face to face, and sing the triumphs of [God's] grace; him day and night they ceaseless praise, to [Christ] the loud Thanksgiving raise. Alleluia! Amen.

—From *Lo! Round the Throne a Glorious Band*, Rowland Hill (1783)

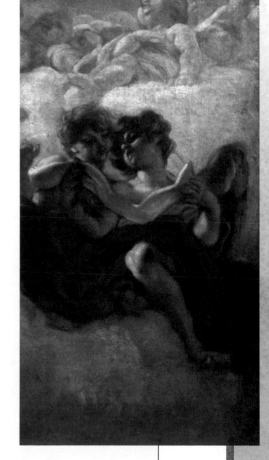

⚜ When you participate in liturgical prayer, how often do you consciously unite yourself with angelic prayers.

⚜ How do you participate in the heavenly choir here on earth?

⚜ Where in your life do you enjoy the harmony and togetherness God wills for you? Are there ways you could work to build that harmony and community?

～ *Spiritual Exercise* ～

⚜ Next time you participate in the liturgy, sing out with joy, knowing the angelic choirs are singing with you. (It doesn't matter how you sound. Just do it for the joy and love of God!)

The complex composition of the painting illustrates the offering of the young St. Luigi's own heart, in exchange for the cross and a lily—a symbol of purity, given to the saint by the young Jesus. The composition of this painting eschews rigid and schematic symmetries, proposing a decentralized structure and placing the main characters on the diagonal. The palette is characterized by fresh colors, cooled at times by the tones of clothing, which are shown in great detail. The artist's insistence on details and on the use of bright colors enriches this painting with a considerable expressive power.

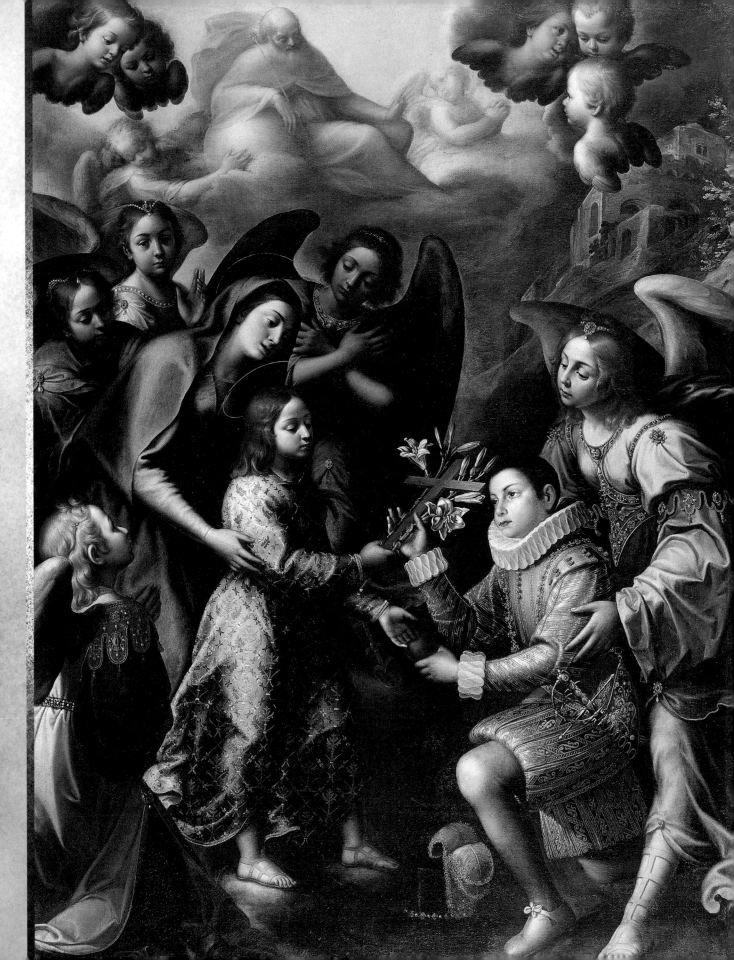

ST. LUIGI GONZAGA, WITH HIS GUARDIAN ANGEL

Anonymous Italian
Seventeenth century

THEME: The guardian angel

FOCUS OF THIS MEDITATION: Each of us has a guardian angel assigned to us! This angel is a great spiritual ally to whom we should turn frequently to receive help and inspiration.

◀ Aloysius Gonzaga, called Luigi, was born in Castiglione delle Stiviere and was baptized April 20, 1568. As the first of eight children, and therefore heir to the title of marquis, he received a military education from his early childhood. At the age of seven, however, he underwent a conversion from the world to God.

He felt a calling to consecrate his life to the Lord; he intensified his prayer regimen, kneeling and reciting the seven Penitential Psalms and the Office of Our Lady every day. In 1576, due to a feudal epidemic, he and his younger brother, Rodolfo, were relocated to Florence under the care of the Grand Duke Francesco I de' Medici. While in Florence, at the Basilica of the Santissima Annunziata, he made a vow of chastity.

Luigi studied literature, science, and philosophy, read spiritual texts and reports from missionaries, and prayed constantly, finally realizing his call to become a Jesuit. Despite the initial opposition of his father, at the age of seventeen (November 25, 1585), he entered the novitiate of the Society of Jesus in Rome. From 1590 to 1591, a number of infectious diseases killed thousands of people in Rome, including popes (Sixtus V, Urban VII, and Gregory XIV). Luigi Gonzaga, along with St. Camillus de Lellis and some fellow Jesuits, devoted themselves to assisting those most in need. Luigi threw himself into his work with intensity. One day, he found a leper in the street and carried him to the hospital. A few days later, Luigi died at only twenty-three years of age.

His body is buried in the church of St. Ignatius in Rome, at the Baroque altar painted by Andrea Pozzo and Pierre Le Gros.

SCRIPTURE MEDITATION

MATTHEW 18:7, 9–14

Woe to the world because of things that cause sin!....If your eye causes you to sin, tear it out and throw it away. It is better for you to enter into life with one eye than with two eyes to be thrown into fiery Gehenna. See that you do not despise one of these little ones, for I say to you that their angels in heaven always look upon the face of my heavenly Father. What is your opinion? If a man has a hundred sheep and one of them goes astray, will he not leave the ninety-nine in the hills and go in search of the stray? And if he finds it, amen, I say to you, he rejoices more over it than over the ninety-nine that did not stray. In just the same way, it is not the will of your heavenly Father that one of these little ones be lost.

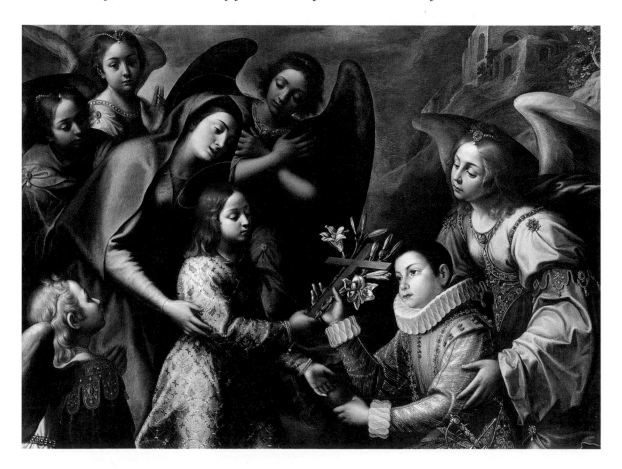

*I*n the only major writings of his young life, St. Luigi wrote on the holy guardian angels. In his book, St. Luigi imagines the role of the guardian angel in the moment the soul exits the body. He explains that the guardian angel accompanies the soul before the judgment seat of God. He finds this angelic intercession only logical, since Jesus affirms that our angels are before God while they are on earth. As Matthew states, "See that you do not despise one of these little ones, for I say to you that their angels in heaven always look upon the face of my heavenly Father" (Matthew 18:10). If they were before God during the life of their charges, would they not be there when these souls are finally brought before the Father? If they protected them in life, would they not protect them in death?

Souls in purgatory, St. Luigi states, are visited by their guardian angels who comfort them and inform them of their earthly support. In life, the guardian angel accomplishes his mission by favoring the union of the soul with the heavenly bridegroom and introducing the soul to the supreme Jerusalem, where it is received with celebration and joy by all the angels and saints. Finally, the guardian angel brings the soul to the Father to receive the crown of glory. So our guardian angel has exactly this mission: to deliver us and protect us from cradle, to grave, to a triumphant heavenly coronation.

In this painting, Luigi Gonzaga is presented in an intense and emotional way. He kneels as a soldier receiving a commission from his commander. In elegant and royal postures, we witness an exchange of gifts. The young Aloysius reaches out to receive the cross from the hand of the Christ Child, who is supported by the Blessed Virgin, encouraging her Son forward. The young kneeling saint offers Jesus the symbol of his love, his heart aflame with love for the Lord. A strong heroic angel supports Luigi's arm as the saint takes the cross. Indeed, our guardian angels do not solve all our sufferings and problems but sustain us in our ability to embrace them with love. The angel's foot steps forward clearly into view so his leg gives the kneeling saint someone to lean against. The saint is strong because he is protected and supported.

On the floor one can see the elegant feathered hat, which symbolizes the renunciation of the noble title young Gonzaga was due to receive. Luigi preferred to dedicate himself to God and the things of God. In a vaguely defined architectural background, we can also see a castle and fortress, which the patron of youth generously rebuffs in favor of eternal rewards. What indeed would it

profit the young Italian to gain the whole world but lose his soul in the process? Jesus himself warned that the cares of the world and attraction to riches could choke the seed (Matthew 13:22).

The scene is unmistakably presented as a marriage proposal. The young, chaste teenager is opting for the forever love of the cross over the passing loves of this world. He gives up immediate gains for long-term profit. He makes the real investment that gives returns in this life and the next.

To the left, a group of angels observes the scene. One folds his hands across his chest, two clasp their hands together in admiring prayer. Another, looking toward the viewer, raises a hand in greeting. The angels surround the romantic scene and rejoice at the purity of the exchange. One could imagine that there are always angels around us each moment of our day, and they rejoice at every act of love we commit. No matter how small or insignificant, our guardian angel rejoices in the purity of our love and calls all his angel friends to gather 'round and enjoy the scene. No sincere act of love ever goes unnoticed or unpaid. Your guardian angel will make sure of that, as will God the Father, who views the scene from above, sitting on clouds and surrounded by hosts of cherubs (Hebrews 6:10).

So knowing that your angel is constantly before the face of God, be devoted to him to maintain his protection, live to make him proud, and call on him to keep him busy!

PRAYER AND REFLECTION

O Holy Angel! God has put me in your care, and you assist me in all my wants and console me in all worries. You support me when I am depressed and obtain favors for me from God. Now I give you thanks and ask that you continue to keep me in your care and defend me against my enemies. Keep me on the path to heaven, protect me, and at the hour of my death lead me to heaven. Amen.

—Adapted from "To Our Angel Guardian," from *The Angel of Prayer* (1861)

⚜ How are you inspired by the life and painting of St. Luigi?

⚜ How do you see the role of the guardian angel in your life?

⚜ What special graces and protections do you need to ask of your guardian angel?

～ *Spiritual Exercise* ～

⚜ Say a prayer to thank your guardian angel for his help in your journey toward Christ and ask him to assist you in something specific.

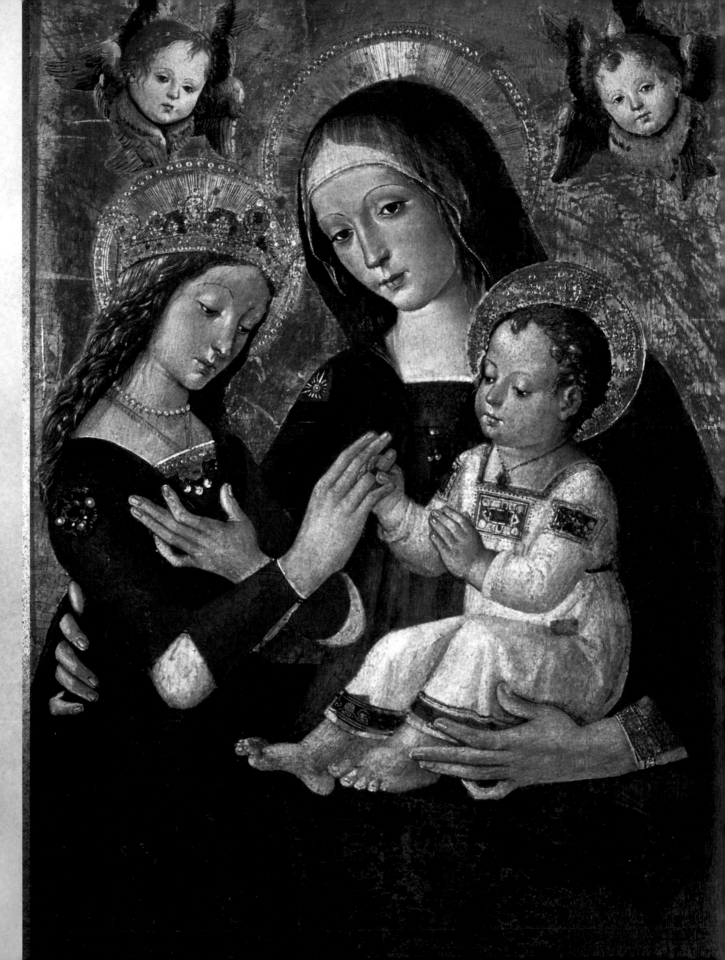

In the scene of this painting, the Virgin holds the Child on her knees while he gently slides a ring on the finger of St. Catherine of Alexandria, who stands in front of him dressed in fine clothes, richly decorated with jewels, pins, and a golden crown. Even her long hair has the typical attributes of aristocratic women. The witnesses can be identified in the upper corners of the work: two little winged cherubs. The background features golden crowns and halos that were created using pastiglia, or paste work—a low-relief decorative technique of great refinement that had much success in courts of that time.

THE MYSTICAL MARRIAGE OF ST. CATHERINE

Bernardino di Betto (called Pinturicchio)
1513

THEME: The mystical marriage

FOCUS OF THIS MEDITATION: The angels will be with us when we are forced to defend our faith. They will help us be steadfast in our convictions.

◀ Bernardino di Betto, better known as Pinturicchio, was born in Perugia around the year 1454. As a collaborator of Pietro Perugino, Pinturicchio accompanied him to Rome, serving as his assistant during the creation of the *The Journey of Moses in Egypt* fresco as well as *The Baptism of Christ* in the Sistine Chapel. In Rome, the young artist came into contact with the paintings of Ghirlandaio and Botticelli, which highly influenced the formation of his personal style. Around 1486, Pinturicchio was commissioned to decorate the Bufalini Chapel in Santa Maria in Ara Coeli in Rome, where he painted a series of frescoes depicting the stories of San Bernardino of Siena.

A few years later, between 1492 and 1494, Pope Alexander VI summoned Pinturicchio to fresco the Borgia Apartments, a suite of six rooms in the Apostolic Palace. Between 1502 and 1507, the artist was commissioned by Francesco Piccolomini

to decorate the library of the Cathedral of Siena. Here, Pinturicchio painted false arches in perspective that frame magnificent scenes, stories from the life of Pius II, realizing one of the major works of his artistic career.

Pinturicchio's style is elegant, sometimes narrative, in the language of genre painting; it sides toward the decorative and tends to give off dramatic effects, exploiting the brightness of the colors. He was one of the first painters of the Italian Renaissance to draw upon the ornamental painting of classical antiquity and incorporate it into his work.

He was a well-versed painter, able to master both the art of painting on wood and that of the fresco and the miniature, working for some of the most important personalities of his time. He died in Siena in 1513.

SCRIPTURE MEDITATION

ISAIAH 61:10

I will rejoice heartily in the LORD,
my being exults in my God;
For he has clothed me with garments of salvation,
and wrapped me in a robe of justice,
Like a bridegroom adorned with a diadem,
as a bride adorns herself with her jewels.

The play of lines, the delicate match of colors, the variety of details exhibit Pinturicchio's deep personal investment in this work. The precious gems, delicate faces of the women, the Christ Child's lively curls are all hallmarks of this exquisite artist. This painting is also characterized by the way its subjects engage the onlooker. Mary, in particular, looks outside the composition, and the two angels innocently catch our gaze.

Catherine and Jesus are beautiful in their gestures and how they "touch" one another. There is no forcing, using, or pressuring. One perceives a pure love, just as one sees in spouses on their wedding day. The respect and care they have for one another is evident. Like a bride and groom, there is gentle anticipation of a love not yet fully consumed. This marriage gesture is the fullest act of love between Jesus and St. Catherine, like a crown of so many acts of love before it.

Saint Catherine offers a simple gesture that also helps us interpret the sense of the scene. With her free hand, she reaches to her breast and holds the area of her heart between her thumb and forefinger. She is almost presenting her heart to Jesus.

The legend of St. Catherine of Alexandria (287–305), virgin and martyr, venerated as a saint by both the Catholic Church and the Orthodox Church, might have taken place in 305. At this time, Rome's emperor held a celebration to honor himself in Alexandria. Although the Golden Legend speaks of the emperor Maxentius, many believe this note was a clerical error, citing instead Maximinus Daia, proclaimed Caesar in 305 for the east part of the tetrarchy, as the emperor in question.

Catherine reportedly went to the palace in the middle of these imperial festivities, during which people celebrated pagan rites with animal sacrifice. In this time, many Christians, for fear of persecution, agreed to worship pagan gods, but Catherine would not and asked the emperor to recognize Jesus Christ as the Redeemer of mankind, arguing her case with philosophical depth.

The emperor, who, according to the Golden Legend, impressed by both the beauty and culture of the young noblewoman, convened a group of rhetoricians to convince her to honor the pagan gods. But by the eloquence of Catherine, they themselves had been converted to Christianity!

The emperor ordered the death sentence of all the rhetoricians, again rejecting Catherine and condemning her to die on a gear wheel. However, when this instrument of torture and condemnation broke, emperor Massimino was forced to behead St. Catherine.

This moment of her martyrdom was the exclamation point on an act of love that began between her and her Jesus many years before. Catherine was supposedly converted to Catholicism by a hermit who showed her a picture of Infant Jesus in his Mother's arms, telling her this was the only bridegroom worthy of her noble lineage, beauty, and wisdom. Mature love is not the love of our first "yes" but rather the love of the many yeses in between. How many yeses have you uttered up to this day and how many more does Jesus want you to give?

The angels, and especially our guardian angels, have the role of preserving us in our "yes" to Jesus. They are charged to bring us to the day when we are totally his as he is ours. They pray and work so that we fall as much in love with Jesus as they are who contemplate his face directly in heaven. They can see that his love is worth everything and so they do everything so that we can see that, too!

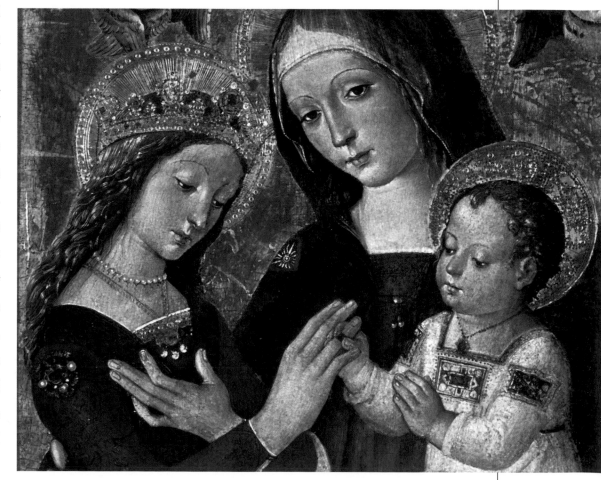

PRAYER AND REFLECTION

Saint Catherine, please help us to grow in purity, love, and courage as we struggle to become closer to Jesus. May you and all the angels share with us the joy you feel in contemplating the face of God so that we may share a fraction of that love with others here on earth. Amen.

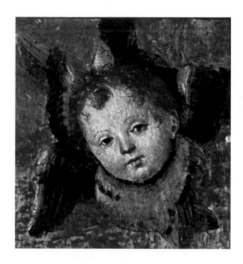

- ⚜ How many wholehearted "yeses" have you given to Jesus? Do you sometimes find yourself saying, "Yes, but?"

- ⚜ What traits of St. Catherine of Alexandria do you most want to cultivate in your life?

- ⚜ Are there opportunities to defend the faith in your own life? Do you take them when they come?

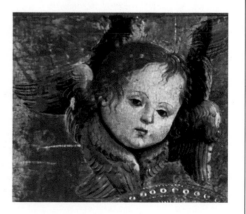

⟜ Spiritual Exercise ⟜

- ⚜ Like Catherine of Alexandria, stand firm in your faith, and share the joy you feel in Jesus with someone still searching for his or her spiritual path.

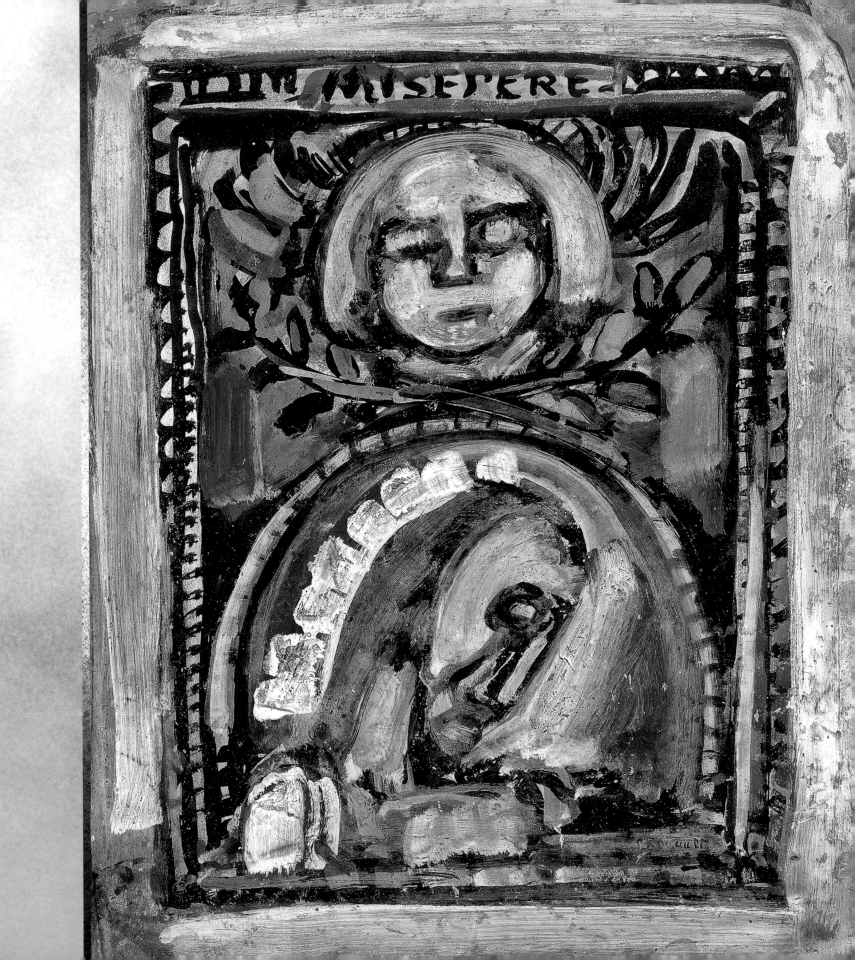

DAY 31

MISERERE

Georges Henri Rouault
1939

THEME: Angels and Divine Mercy

FOCUS OF THIS MEDITATION: All angels are witnesses to God's Divine Mercy. In particular, our guardian angel can help us experience his mercy.

◀ Georges Henri Rouault (1871–1958) was born into a family of humble origins. His grandfather was an art appassionato and passed on his love for created beauty to his grandson.

From 1885 to 1890, he was the apprentice of a painter and restorer of stained glass; at the same time, he took evening classes at the School of Decorative Arts in Paris. In 1891, he entered the École des Beaux-Arts under the guidance of Gustave Moreau. Rouault became his favorite pupil, and upon the death of Moreau in 1898, he was appointed curator of the Moreau Museum in Paris.

Rouault's main focus was the human figure and the inspiration form can cause in the viewer. Contorted figures communicate agony, upraised hands symbolize joy, celebration, or pleading. A subtle change in the tilt of a head can go from meaning thought to despair. He found that these thousands of shades of meaning communicated by posture, hand gestures, and the like reflected the infinite variations in the human soul. It is the spirit that speaks through the body and communicates to our spirits.

During World War I, from 1914 onward, Rouault looked for inspiration in religious subjects, especially in the theme of the passion of Christ. Pain was the main sentiment he thought the world evoked, and tears were the physical reality this pain produced. Tears on the cheeks of children left without parents, tears of wives who lost their husbands, tears of soldiers as they agonized on the battlefields. Yet he firmly believed that tears alone didn't tell the full story. Rather, tears were on faces and those faces expressed souls and many souls were still full of hope. For Rouault, the tears of the women at the foot of the cross were the perfect archetype for sorrow and hope because these tears symbolized the presence of pain in the world, but they were on faces full of hope for the resurrection. "I believe in pain," Rouault once wrote. "It is not fiction for me."

SCRIPTURE MEDITATION

PSALM 51:3–9

Have mercy on me, God, in accord with your merciful love; in your abundant compassion blot out my transgressions. Thoroughly wash away my guilt; and from my sin cleanse me. For I know my transgressions; my sin is always before me. Against you, you alone have I sinned; I have done what is evil in your eyes So that you are just in your word, and without reproach in your judgment. Behold, I was born in guilt, in sin my mother conceived me. Behold, you desire true sincerity; and secretly you teach me wisdom. Cleanse me with hyssop, that I may be pure; wash me, and I will be whiter than snow.

Miserere is Latin and the opening word of Psalm 51. The complete phrase in the Vulgate is: *Miserere mei Deus secundum Magnam misericordiam tuam* (Have mercy on me, O God, according to thy great mercy). This psalm is the cry of King David for God's mercy after he falls into the sins of betrayal and murder.

It is a lesson in God's mercy that he is not ashamed to share with us the weaknesses of his greatest saints. Think of David, but also of Peter, Magdalene, and Saul. We learn some indispensable lessons from their mistakes, such as the divided nature of our hearts, the horrible consequences of our sin, and the unfathomable depths of God's infinitely merciful grace.

The new king of the people of God also undergoes a passion but not because of his own guilt. Rather, he takes our sin upon his shoulders. Spend time thanking God for the many moments of mercy in your life, and if there is something for which you need to ask his forgiveness, do so now.

In this painting taken from the series *Miserere*, the dark tones usually employed by the artist are replaced by bright colors that delineate the angel, located in the upper part of the painting. The fluidity of the design produces sweet, balanced chromatisms, and the angels stretch out their protective veil across the figure of the penitent and resigned Jesus. There is a heavenly hope that hovers over the mystery of pain and sin. We must always recall, even in our darkest hours, that God is working out his salvation if we but let him.

Our artist lived in a time of particular suffering. He witnessed both world wars and saw the monstrosities of which humans are capable. These iniquities called out for God's mercy. Yet he was not crushed. He saw in the tears of humanity a sign of hope. In your own life, God always wants to begin again. His angels are agents of his mercy! Just like in our painting where the angel is a sign of heavenly presence watching over us even in our weakness, so do God's angels want to communicate his mercy to you!

Looking on history with faith, we can see that God's response to the sins of the nineteenth and twentieth centuries was to raise up great saints to promote devotion to his mercy. There was St. Thérèse of Lisieux, Mother Teresa, St. John Paul II, St. Maximilian Kolbe, and St. Mary Faustina Kowalska, who brought us the Chaplet of The Divine Mercy.

St. Faustina was an angel of God's mercy, and taking up the habit of praying her Chaplet of The Divine Mercy could be the perfect response to these meditations on angels in Vatican art. Angels watch over us, accompany us, and protect us. But they do it above all as agents of God's mercy. They want nothing more than for us to experience the beauty of the love of God that has captivated them and which is the sole object of their eternal vision.

PRAYER AND REFLECTION

Saint Mary Faustina Kowalska, pray for us.

- How are you reminded of God's mercy in the world?

- How do you reconcile God's mercy with earthly suffering? Is it easy for you, like Rouault, to see how the two go together, or do you struggle to make sense of this mystery?

Spiritual Exercise

- Pray the Chaplet of The Divine Mercy (page 198) for anyone you feel needs to be reminded of God's mercy.

The Chaplet of The Divine Mercy

HOW TO RECITE THE CHAPLET

The Chaplet of The Divine Mercy is recited using ordinary rosary beads of five decades. The Chaplet is preceded by two opening prayers from the *Diary of St. Maria Faustina* and followed by a closing prayer.

1. Make the Sign of the Cross

In the name of the Father, and of the Son, and of the Holy Spirit. Amen.

2. Optional Opening Prayers

You expired, Jesus, but the source of life gushed forth for souls, and the ocean of mercy opened up for the whole world. O Fount of Life, unfathomable Divine Mercy, envelop the whole world and empty Yourself out upon us.

(*Repeat three times*)
O Blood and Water, which gushed forth from the Heart of Jesus as a fountain of Mercy for us, I trust in You!

3. Our Father

Our Father, Who art in heaven, hallowed be Thy name; Thy kingdom come; Thy will be done on earth as it is in heaven. Give us this day our daily bread; and forgive us our trespasses as we forgive those who trespass against us; and lead us not into temptation, but deliver us from evil. Amen.

4. Hail Mary

Hail Mary, full of grace. The Lord is with thee. Blessed art thou amongst women, and blessed is the fruit of thy womb, Jesus. Holy Mary, Mother of God, pray for us sinners, now and at the hour of our death. Amen.

5. The Apostles' Creed

I believe in God, the Father almighty, Creator of heaven and earth, and in Jesus Christ, His only Son, our Lord, who was conceived by the Holy Spirit, born of the Virgin Mary, suffered under Pontius Pilate, was crucified, died and was buried; He descended into hell; on the third day He rose again from the dead; He ascended into heaven, and is seated at the right hand of God the Father almighty; from there He will come to judge the living and the dead. I believe in the Holy Spirit, the holy catholic Church, the communion of saints, the forgiveness of sins, the resurrection of the body, and life everlasting. Amen.

6. The Eternal Father

Eternal Father, I offer you the Body and Blood, Soul and Divinity of Your Dearly Beloved Son, Our Lord, Jesus Christ, in atonement for our sins and those of the whole world.

7. On the Ten Small Beads of Each Decade

For the sake of His sorrowful Passion, have mercy on us and on the whole world.

8. Repeat for the Remaining Decades

Saying the "Eternal Father" (6) on the "Our Father" bead and then ten "For the sake of His sorrowful Passion" (7) on the following "Hail Mary" beads.

9. Conclude With Holy God

(*Repeat three times*)
Holy God, Holy Mighty One, Holy Immortal One, have mercy on us and on the whole world.

10. Optional Closing Prayer

Eternal God, in whom mercy is endless and the treasury of compassion—inexhaustible, look kindly upon us and increase Your mercy in us, that in difficult moments we might not despair nor become despondent, but with great confidence submit ourselves to Your holy will, which is Love and Mercy itself.